ARTEMISIA GENTILESCHI AROUND 1622

DISCOVERY SERIES

About the Discovery Series

Innovative and generously illustrated, books in the Discovery Series focus on a single impor-
tant work of art, artist, or theme in the history of art. Each is distinctive for the richness of
detail and insight it conveys in a concise format, and each is written in prose that appeals to
both specialists and general readers.

I. *The Devil at Isenheim: Reflections of Popular Belief in Grünewald's Altarpiece,*
 by Ruth Mellinkoff, 1988

II. *The Forgotten Hermitage of Skellig Michael,* by Walter Horn, Jenny White Marshall, and
 Grellan D. Rourke, 1990

III. *The Arnolfini Betrothal: Medieval Marriage and the Enigma of Van Eyck's Double Portrait,*
 by Edwin Hall, 1994

IV. *Made in God's Image? Eve and Adam in the Genesis Mosaics at San Marco, Venice,*
 by Penny Howell Jolly, 1997

V. *Michelangelo's "Last Judgment": The Renaissance Response,* by Bernadine Barnes, 1998

VI. *The French Revolution as Blasphemy: Johan Zoffany's Paintings of the Massacre at Paris,
 August 10, 1792,* by William L. Pressly, 1999

VII. *The Portraits of Madame de Pompadour: Celebrating the Femme Savant,* by Elise Goodman,
 2000

VIII. *My Laocoön: Alternative Claims in the Interpretation of Artworks,* by Richard Brilliant, 2000

IX. *Behind Closed Doors: The Art of Hans Bellmer,* by Therese Lichtenstein, 2001

X. *Hand and Head: Ernst Ludwig Kirchner's "Self-Portrait as Soldier,"* by Peter Springer, 2001

XI. *Artemisia Gentileschi around 1622: The Shaping and Reshaping of an Artistic Identity,*
 by Mary D. Garrard, 2001

ARTEMISIA GENTILESCHI AROUND 1622

The Shaping and Reshaping of an Artistic Identity

MARY D. GARRARD

UNIVERSITY OF CALIFORNIA PRESS

Berkeley · *Los Angeles* · *London*

*The publisher gratefully acknowledges the
generous contribution to this book provided
by the Art Book Endowment of the Associates
of the University of California Press, which
is supported by a major gift from the
Ahmanson Foundation.*

University of California Press
Berkeley and Los Angeles, California

University of California Press, Ltd.
London, England

Library of Congress Cataloging-in-Publication Data

Garrard, Mary D.
 Artemisia Gentileschi around 1622 : the shaping and
reshaping of an artistic identity / Mary D. Garrard.
 p. cm.
 Includes bibliographical references and index.
 ISBN 0-520-22426-4 (cloth : alk. paper) —
 ISBN 0-520-22841-3 (pbk. : alk. paper)
 1. Gentileschi, Artemisia, 1593–1652 or 3 —
Criticism and interpretation. I. Title.
ND623.G364 G368 2001
759.5 — dc21

 00-056385
Manufactured in the United States of America
9 8 7 6 5 4 3 2 1 0
10 9 8 7 6 5 4 3 2 1
The paper used in this publication meets the minimum
requirements of ANSI / NISO Z39 0.48-1992 (R 1997)
(Permanence of Paper). ♾

FOR NORMA

CONTENTS

List of Illustrations ix

Acknowledgments xv

Preface xvii

INTRODUCTION: Connoisseurship in a New Key I

Gender and the Social Construction of Artistic Identity 6

Gender and the Personal Formation of Artistic Identity 18

1. A NEW MAGDALEN 25

A Tale of Two Pictures 25

Artemisia and Mary Magdalene 35

The Example of Caravaggio 42

The Example of Michelangelo 48

Artemisia as the Allegory of Painting 55

The Magdalen as Melancholy 64

The Reappropriation of Gendered Melancholy 72

2. THE BURGHLEY HOUSE SUSANNA 77

 A Problem Picture 77

 Susanna in the Garden of Love 81

 Susanna as Social Scapegoat 84

 The Picture: Technical Analysis and Documentation 86

 Collaboration or Unauthorized Alteration? 97

 Artemisia and Susanna, Public and Audience 108

CONCLUSION: The Shaping of a Complex Identity 115

Notes 125

Works Cited 159

Index 169

ILLUSTRATIONS

Photographic source and location are the same unless otherwise noted.

PLATES (following page 72)

1. Artemisia Gentileschi, *Mary Magdalene as Melancholy,* ca. 1621–22. Cathedral, Sala del Tesoro, Seville, Spain (photograph: Arenas)

2. Artemisia Gentileschi, *Mary Magdalene as Melancholy,* early 1620s. Private collection (photograph courtesy Arts Finans G. Trust)

3. Artemisia Gentileschi, *Mary Magdalene as Melancholy,* ca. 1621–22. Cathedral, Sala del Tesoro, Seville, Spain. Detail of head (photograph: Arenas)

4. Artemisia Gentileschi, *Mary Magdalene as Melancholy,* early 1620s. Private collection. Detail of head (photograph courtesy Arts Finans G. Trust)

5. Artemisia Gentileschi, *Lucretia,* ca. 1621. Collection Piero Pagano, Genoa

6. Artemisia Gentileschi, with alterations by another artist, *Susanna and the Elders,* signed and dated 1622. The Burghley House Collection, Stamford (Lincolnshire), England

7. Artemisia Gentileschi, *Corisca and the Satyr,* early 1640s. Private collection

8. Artemisia Gentileschi, with alterations by another artist, *Susanna and the Elders,* signed and dated 1622. The Burghley House Collection, Stamford (Lincolnshire), England. Detail of head

FIGURES

1. Pierre Dumonstier le Neveu, Drawing of the hand of Artemisia Gentileschi with paintbrush, 1625. © The British Museum 8

2. Artemisia Gentileschi, *Allegory of Inclination,* 1615–16. Casa Buonarroti, Florence (photograph: Soprintendenza per I Beni Artistici e Storici delle Provincie di Firenze, Pistoia e Prato) 10

3. Artemisia Gentileschi, attributed to. *Madonna and Child.* Museo de Pintura y Arquitectura de El Escorial, Spain (photograph: Patrimonio Nacional, Madrid) 11

4. Artemisia Gentileschi, attributed to. *Madonna and Child.* Galleria Spada, Rome 12

5. Artemisia Gentileschi, attributed to. *Madonna and Child.* Palazzo Pitti, Florence (photograph: Soprintendenza per I Beni Artistici e Storici delle Provincie di Firenze, Pistoia e Prato) 13

6. Michelangelo, *Deposition,* 1547–55. Cathedral, Florence (photograph: Alinari/Art Resource) 19

7. Caravaggio, *David with the Head of Goliath,* 1605–10. Rome, Galleria Borghese (photograph: Alinari/Art Resource) 20

8. Artemisia Gentileschi, *Judith Slaying Holofernes,* ca. 1620. Florence, Galleria degli Uffizi (photograph: Soprintendenza per I Beni Artistici e Storici delle Provincie di Firenze, Pistoia e Prato) 21

9. Artemisia Gentileschi, *Mary Magdalene as Melancholy,* ca. 1621–22. Cathedral, Sala del Tesoro, Seville, Spain. Detail of central section (photograph: Arenas) 26

10. Artemisia Gentileschi, *Cleopatra,* ca. 1621–22. Formerly Milan, Amadeo Morandotti (photograph: Boccardi) 28

11. Artemisia Gentileschi, *Mary Magdalene as Melancholy,* ca. 1621–22. Cathedral, Sala del Tesoro, Seville, Spain. X-ray: (a) head, shoulder, and right hand of figure; (b) left hand of figure (photograph: Arenas) 30

12. Artemisia Gentileschi, *Mary Magdalene as Melancholy,* early 1620s. Private collection. X-ray: (a) head and right hand of figure; (b) left sleeve of figure (photograph courtesy Arts Finans G. Trust) 31

13. Artemisia Gentileschi, *Penitent Magdalen,* ca. 1617–20. Palazzo Pitti, Florence (photograph: Soprintendenza per I Beni Artistici e Storici delle Provincie di Firenze, Pistoia e Prato) 36

14. Justus Sustermans, *Maria Maddalena of Austria as Mary Magdalene,* 1625–30. Palazzo Pitti, Florence (photograph: Alinari/Art Resource) 37

15. Titian, *Penitent Magdalen,* 1530s. Palazzo Pitti, Florence (photograph: Alinari/Art Resource) 40

16. Orazio Gentileschi, *Penitent Magdalen,* 1605. Fabbriano, S. M. Maddalena. (photograph: Soprintendenza per I Beni Artistici e Storici delle Provincie di Firenze, Pistoia e Prato) 41

17. Valerio Marucelli, attributed to, *Saint Mary Magdalene in the Desert,* 1609. Palazzo Pitti, Florence (photograph: Alinari/Art Resource) 42

18. Caravaggio, *Repentant Magdalen,* ca. 1596–97. Galleria Doria-Pamphilj, Rome (photograph: Alinari/Art Resource) 43

19. Caravaggio, *Death of the Virgin,* 1601–2. Detail of Magdalen. Musée du Louvre, Paris (photograph: Réunion des Musées Nationaux) 44

20. Caravaggio, *Conversion of the Magdalen,* ca. 1598. Detroit Institute of Arts, Gift of the Kresge Foundation and Mrs. Edsel B. Ford 45

21. Louis Finson, copy of Caravaggio's lost *Magdalen in Ecstasy* of 1606. Musée des Beaux-Arts, Marseilles (photograph: Jean Bernard) 46

22. Léon Davent, *Michelangelo at the Age of Twenty-three,* etching, mid–sixteenth century. © The British Museum 49

23. Marcantonio Raimondi, *Saint Helena,* engraving, early sixteenth century. Metropolitan Museum of Art, New York 49

24. Jean Duvet, *Revelation of Saint John Evangelist,* engraving, 1561. National Gallery of Art, Washington, D.C. (photograph © Board of Trustees) 50

25. Walther von der Vogelweide, miniature from the "Grosse Heidelberger Liederhandschrift," early fourteenth century. Heidelberg, Universitäts-bibliothek, Codex Palatinus germanicus 848, 124r 51

26. Marcantonio Raimondi, *Raphael Sanzio of Urbino,* engraving, sixteenth century. Graphische Sammlung Albertina, Vienna 52

27. Michelangelo, *Notte,* 1519–33. Tomb of Giuliano de' Medici, Medici Chapel, Florence (photograph: Alinari/Art Resource) 53

28. Albrecht Dürer, *Melencolia I,* engraving, 1514. National Gallery of Art, Washington, D.C. (photograph © Board of Trustees) 53

29. Paolo Veronese, *Saint Helena,* 1570s. © National Gallery, London 54

30. Fabrizio Boschi, *The Allegory of Painting Awakened by Grand Duke Cosimo II de' Medici,* fresco, 1620–23. Corte d'Appello (formerly Casino Mediceo), Florence (photograph: Anna Rosa Masetti, "Il Casino Mediceo e la pittura fiorentina del seicento, I," *Critica d'Arte* 9 [1962]) 56

31. Florentine artist (G. B. Guidoni?), *Portrait of Artemisia Gentileschi as the Allegory of Painting,* 1614–20. Private collection (photograph: Sotheby's) 58

32. Jérôme David, *Portrait Engraving of Artemisia Gentileschi,* ca. 1628. © The British Museum 59

33. Unknown artist, *Portrait of Artemisia Gentileschi as Pittura,* ca. 1630? Galleria Nazionale d'Arte Antica, Palazzo Barberini, Rome (photograph: Gabinetto Fotografico Nazionale, Rome) 61

34. Diego Velázquez, *A Woman as a Sibyl (Artemisia Gentileschi as Pittura?),* 1630–32. © Museo del Prado, Madrid 62

35. Vincenzo Carducho, engraved end-piece to *Diálogos de la Pintura,* Madrid, 1633 (photograph: Warburg Institute) 63

36. Guercino, *Notte,* fresco, 1621. Rome, Villa Ludovisi (photograph: Alinari/Art Resource) 65

37. Photograph of lost copy of Guercino's lost *Jael and Sisera* of ca. 1619–20. Fondazione Giorgio Cini, Venice 66

38. Artemisia Gentileschi, *Jael and Sisera,* 1620. Szépmüvészeti Museum, Budapest 67

39. Domenico Fetti, *Melancholy,* ca. 1618. Musée du Louvre, Paris (photograph: Réunion des Musées Nationaux) 68

40. Giovanni Battista Castiglione, *Melancholy or Meditation,* etching, ca. 1645–46. Städelsches Kunstinstitut, Frankfurt am Main 69

41. Michelangelo, *Lorenzo de' Medici, Duke of Urbino,* 1519–33. Tomb of Lorenzo de' Medici, Medici Chapel, Florence (photograph: Alinari/Art Resource) 70

42. Artemisia Gentileschi, *Self-Portrait as the Allegory of Painting,* 1630.

Collection Her Majesty the Queen, Kensington Palace, London (photograph: Royal Collection Enterprises) 71

43. Artemisia Gentileschi, with alterations by another artist, *Susanna and the Elders,* signed and dated 1622. The Burghley House Collection, Stamford (Lincolnshire), England 78

44. Artemisia Gentileschi, *Susanna and the Elders,* signed and dated 1610. Schloss Weissenstein, Pommersfelden (photograph: Graf von Schönbornische Kunstsammlungen) 79

45. Annibale Carracci, *Susanna and the Elders,* etching and engraving, ca. 1590. National Gallery of Art, Washington, D.C. (photograph © Board of Trustees) 80

46. Mariotto di Nardo, *Garden of Love, desco da parto,* ca. 1420. Private collection 82

47. Master of the Bargello Tondo, *Susanna and the Elders,* salver, ca. 1447. Serristori Collection, Florence (photograph: Alinari/Art Resource) 83

48. Artemisia Gentileschi, with alterations by another artist, *Susanna and the Elders,* signed and dated 1622. The Burghley House Collection, Stamford (Lincolnshire), England. X-ray of upper and left parts of painting (photograph courtesy David A. Miller, Indianapolis Museum of Art) 88

49. Artemisia Gentileschi, with alterations by another artist, *Susanna and the Elders,* signed and dated 1622. The Burghley House Collection, Stamford (Lincolnshire), England. Infrared reflectogram of figures and balustrade (photograph courtesy David A. Miller, Indianapolis Museum of Art) 90

50. Artemisia Gentileschi, with alterations by another artist, *Susanna and the Elders,* signed and dated 1622. The Burghley House Collection, Stamford (Lincolnshire), England. Reconstruction of the first version of the painting (photograph: author) 91

51. Artemisia Gentileschi, with alterations by another artist, *Susanna and the Elders,* signed and dated 1622. The Burghley House Collection, Stamford (Lincolnshire), England. X-ray of Susanna's face and shoulder (photograph courtesy David A. Miller, Indianapolis Museum of Art) 92

52. Artemisia Gentileschi, *Susanna and the Elders,* 1649. Moravská Galerie, Brno, Czech Republic 93

53. Ludovico Carracci, *Susanna and the Elders,* 1616. © National Gallery, London 98

54. Titian, *Venus and Organist,* ca. 1550, detail of satyr fountain. © Museo del Prado, Madrid 100

55. Guercino, *Elijah Fed by Ravens,* 1620. Collection Sir Denis Mahon, on loan to the National Gallery, London (photograph © National Gallery, London) 103

56. Guercino, *Cleopatra,* ca. 1621. The Norton Simon Foundation, Pasadena, California 104

57. Artemisia Gentileschi. *Tarquin and Lucretia,* late 1640s. Stiftung Preussische Schlösser und Gärten Berlin-Brandenburg, Potsdam, Neues Palais 120

ACKNOWLEDGMENTS

Of the many friends and colleagues who have helped me in one way or an-other in the investigations of this book, I would particularly like to thank Jonathan Brown, Brendan Cassidy, William Jordan, Frederic Lajoie, DeCourcy McIntosh, Judith A. Mann, David A. Miller; Michael Cowell, Jon Culver-house, and John Somerville at Burghley House; Ann Guité and Frances Beatty at Richard L. Feigen and Company; Enrique Valdivieso in Seville; Albert Ysequilla in Stockholm; and at the National Gallery of Art, Dean Beesom, Lamia Doumato, Sarah Fisher, and Gregory Jecmen. At the University of California Press, I am grateful to Stephanie Fay, my editor, for her support of this publication and for her astute editorial advice, and to Ellie Hickerson for as-sisting the production in countless practical ways.

I owe thanks of a different order to my fellow Gentileschista, R. Ward Bissell, whose catalogue raisonné appeared in print just before this book went into production. For many years, I have enjoyed fruitful discussions with him on matters of common concern, and I am grateful, like other art historians, for his contribution to the Gentileschi discourse. Yet although we admire each other's work, Bissell and I have some major differences, both in approach and in judgment about individual works. I have introduced some dialogue with him in this text, particularly at points where our agreement or disagreement on a work or a methodological issue is critical to the discussion. This does not constitute my total response to his book but should give the reader a sense of the different conceptual terrain we occupy.

Finally, I am especially indebted to Norma Broude, as always, for intellectual stimulus and wise counsel. My present debt to her is greater than usual, for it was she who encouraged me to see that these separate investigations might become a book.

PREFACE

This book originated as two independent studies, each given first in lecture form. My investigation of the Burghley House *Susanna* was launched with a paper read at the symposium "Italian Baroque Paintings from Burghley House," held at the Frick Art and Historical Center, Pittsburgh, Pennsylvania, in April 1995. I carried the *Susanna* study further in a paper given at another conference, "Attending to Early Modern Women: Crossing Boundaries," sponsored by the Center for Renaissance and Baroque Studies at the University of Maryland, November 1997. My investigation of Artemisia's two *Magdalens* began with a paper I delivered at the conference "Time and Space in Women's Lives in Early Modern Europe," sponsored by the Istituto Storico Italo-Germanico, in Trento, Italy, in October 1997.

I did not intend to write another book on Artemisia Gentileschi. But as I worked on these new painting attributions, I began to see that the two pictures shared a larger frame of reference. Each posed problems that derived from unarticulated methodological complications in Gentileschi studies. Moreover, although they are probably to be dated around the same time, the two paintings present radically different forms of expression—yet another problem. I decided it might be effective to combine these investigations as related case studies, framed by a broader discussion of both the unexamined gender assumptions that have driven Gentileschi connoisseurship and the relevant social considerations that have been excluded from it.

Taken together, these two nearly contemporaneous paintings problematize Artemisia's artistic oeuvre while offering a way to understand it more fully. They represent the artist at a critical moment, when the identity known as Artemisia Gentileschi was being shaped both by the artist herself and by outside forces and agents. In the *Mary Magdalene* we see a fresh example of how Artemisia interwove her own identity with those of her characters, drawing creative inspiration from the fusion. In my 1989 book I argued that by comparing Artemisia's version of a theme with contemporary and earlier versions, one could detect the individual voice or particular sensibility of the artist—in Artemisia's case it is a gender position—which might then become a touchstone for attribution. Because there is also documentary evidence to support the attribution of the Seville *Magdalen* to Artemisia, this picture serves as a kind of control for judging the viability of the new criteria for connoisseurship I propose.

In the Burghley House *Susanna* we see a more complex process of identity construction at work, one no longer controlled by the artist. New evidence has led me to modify my earlier rejection of this attribution to Artemisia. My change of mind was prompted by the discovery of Artemisia's signature on the picture during its cleaning in preparation for the Burghley House traveling exhibition of 1995. When I examined the painting closely in light of this visual evidence that seemingly confirmed Artemisia's authorship, however, I found technical problems that led to new questions. With the aid of X-rays I was able to reconstruct the picture's complex and inconsistent evolution and to conclude that it betrays two different hands, explainable either by Artemisia's revision of her own picture with the aid of a collaborator or by an alteration of her work by another artist. In neither case, I argue, can attribution be determined without considering a variety of social factors that may have pressed upon the picture's genesis. I intend to show by example that connoisseurship decisions cannot be made in a formalist vacuum, and that we stand a better chance of making the correct decision—and of better understanding the creative process as it takes place in the real world—when we take into account not only formal factors but also social, interpersonal, and gender dimensions.

The introductory and concluding chapters develop this argument more theoretically. I would emphasize, however, that this study is not a theoretical treatise but an exemplary model. Artemisia Gentileschi is an unusually good exemplum for methodological analysis. Her life and oeuvre pose interpretive

problems that are in some respects quintessentially art-historical yet also take us beyond art history's normative framework. As a consequence, they force us to rethink our traditional methods and approaches, which are, inevitably, grounded in the study of male artists. In this sense, the problems that the works here examined pose for Gentileschi studies have relevance for art-historical methodology in general.

A number of recent writers have taken my 1989 book on Artemisia Gentileschi as a basis for methodological quarrel. Although I am glad that my study has fostered a dialogue on Artemisia, it has been disturbing to see my work misrepresented by writers evidently in need of an Other with whom to spar. I will not detail here the ways in which representations of my Artemisia studies have been distorted, perhaps unwittingly, by those who have employed them to differentiate their own methodological aims.[1] I leave that project to students and other readers, with the caveat that they read my work whole, in the original and not in résumé. Yet it is particularly lamentable to see writers professing disdain for work upon which they are intellectually dependent, claiming to break new interpretive ground when that may be not only an inflated claim but one that falsifies its sources. This issue must be addressed here, if only briefly.

There have been three basic critiques of my Gentileschi studies, which come from several quarters and are most recently rehearsed by Griselda Pollock.[2] First is that I read Artemisia's art as simple autobiographical expression. Second is that I essentialize her into a timeless figure whose art represents a monolithic and historically unchanging woman's perspective. In fact these two alleged fallacies are in conflict, for I am accused simultaneously of having reduced Gentileschi to a single individual whose story is entirely personal and lacks wider cultural significance and of having expanded her to stand for the entire category of woman. I am tempted to say, you cannot have it both ways.

Both of these allegations are fundamentally inaccurate, willful misreadings of my 1989 book, whose entire argument is that biographical experience and metaphoric expression are historically and specifically—not universally or deterministically—conjoined in Artemisia's art, an art that, in its radical departure from masculinist convention, not only *may* resonate for women in general but has demonstrably done so for many modern women. Pollock's complaint that Woman is a fiction and myth, that real women are not unitary in class, race, and other respects, or all noble, brave, and good, is perhaps not particularly relevant to art made by women (or men), which *must* consolidate and ide-

alize—in new terms, of course—if it is to present an expressive model of imaginative emancipation both for artist and audiences. Unlike living women, images may have to be essentialist to work, especially when they present fantasized alternatives to real-life experience. When Pollock argues—against me, she says—that Artemisia's art, more than a personal response to trauma, is rather one whose difference represented an important intervention in masculinist culture, or that Artemisia's *Judiths* are not about revenge but instead are models of liberating female agency, and when she claims to historicize Artemisia's art as I have not, I can only refer readers to my Gentileschi book, where the original articulation of these positions she implicitly claims as her own, within at least one historical framework, is to be found.

The two critiques I have named converge as they join the third, my alleged metanarrative of heroism. I am accused of adopting too celebratory a view of Artemisia, of tending to heroize her, in a simple inversion of the masculinist model. In the totalizing critique, I have made this female painter far too much an art-historical inspirational figure, celebrating her personal triumph over gender adversity in life and art as a victory for women in general, and at precisely the wrong cultural moment, since we live in a time when artistic identities are to be deconstructed or problematized, not venerated. My first response to this criticism is to point out, once more, that monographs continue to be written on male artists who are uncritically and unproblematically celebrated; if we are going to abandon heroic metanarratives, let us not start with a woman.[3]

I would also say that hollow or ritual celebration is one thing; the fresh, amazed discovery of an original, creative formal articulation of ideas or emotions new to art is quite another. The sense of excitement that fueled the writing of my earlier book could have come only from my identification as a woman, and although my enthusiasm for her achievement is by now mixed with many other perceptions, I continue to marvel at Artemisia's art, produced seemingly ex nihilo and against the grain of the cultural repression of women. The investigations of this book have brought me face to face with the artist once again at the locus where, under specific psychic and social pressures, artistic creation begins. To explore the creative act in such a context is not celebration, it is art history—a practice that I, unlike Pollock, consider still to be viable in feminist terms. In embracing authorial female subjectivity, I also differ with Pollock, who argues against reading "as a woman" and in favor of Teresa De

Lauretis's recommended "view from elsewhere." Certainly the canon must be "differenced," yet this can happen only if we clarify both the nature and historical value of women's differences, a clarification produced most authentically from our experiential identification with other women rather than from a critical stance of otherness. While that stance has worked well for the feminist critique of masculinism, it would seem—even if it were possible for women to escape gender acculturation—fated to produce, inappropriately, a neo-masculinist perspective on women.

Yet something more important is at stake. So-called personal expression is really nothing of the kind, for as postmodern deconstruction has revealed, the only forms of "private" self-definition in art that are socially allowed are those acceptable to the dominant culture, which reflect and help constitute its basic values. In every individual deviation from the norm lies a sinister wisdom and a potential subversive threat to the larger social fabric, which is why society is so relentlessly self-monitoring. What appears to be a mere inversion of the male hero narrative in my reading of Artemisia Gentileschi must be weighed against the larger culture's recurrent desire to resituate her within the disempowering stereotype of the sexualized feminine. The ways that Artemisia's identity has been and is presently being reshaped and controlled, ways that undermine her creative legacy, pose in my view a real-world danger much greater than that posed by the rarefied theoretical sin of excessively valorizing Gentileschi in a postheroic age. This book is, among other things, an effort to address this problem.

In pointing out the respects in which my work has been misrepresented by Griselda Pollock in particular, I do not mean to disparage her own work. Although this book was already in press when I first saw her *Differencing the Canon,* that book clearly offers much for feminist art historians to consider, and it turns out to have raised some questions that I did not explore in my 1989 book but do take up in this study. Among these is the discrepancy between Artemisia's subversive expression and its apparently enthusiastic reception. As Pollock puts it, "if the work were so deviant, why would it have been painted, bought and hung?" Although not constructed as such, what I have to say here on this subject might be thought of as a response to Pollock's question. Like many colleagues, I view with regret a current tendency toward ideological dogmatism and a compulsion to make one's mark by insisting upon the greater method-

ological correctness of one position over another. These are all the more distressing when they come from feminists who disagree with each other, for feminists above all might be expected to provide models of fruitful collaborative interchange rather than of mandarin theoretical purity.

Not only feminism but art history itself presents such a model, for it is a discrete yet flexible discipline that embraces a range of methodologies, and it has historically been strengthened by its selective alliances with other disciplinary perspectives. While writing this book, I found myself thinking about the methodological questions I have long raised in my classes. I felt my students at my shoulder, pressing me—as I have pressed them—to pose the right questions and provide logical answers, or to justify my reliance on this or that approach. It is true that one's methodological proclivities shape the very questions one asks of art and culture, yet we should not willingly wear blinders. As I have said in the seminar room, the theoretical insistence on the purity of a single "correct" method is both reductionist and impoverishing. In the hope of practicing what I have preached, I here combine a number of methodological approaches: feminism joins hands with connoisseurship and iconography; social and psychological considerations sit down with style analysis. The goal is to answer the questions and address the problems with whatever tools work and to offer new ways of combining old methods, in particular to advance a broadened form of connoisseurship that is both formally responsible and socially aware.

I have wanted to keep the text direct, clear, and unencumbered, so that non-specialists can follow the argument without getting lost in scholarly byways. As a consequence, I must caution readers that the notes are occasionally long. Those specialists for whom the notes exist may find them too brief, yet I hope they will suffice to indicate some of the complexities that the text could not absorb, and to offer my thoughts on certain topics and controversies that are of current interest.

INTRODUCTION

Connoisseurship in a New Key

ARTEMISIA GENTILESCHI is currently enjoying a great deal of public recognition, as the best-known female artist in Western art history before the modern era. When I first began to write on her twenty years ago, she was already becoming a heroic model for modern feminist artists, yet beyond a certain corner of the art world few people could recognize, let alone spell, her name. Today, as the direct or indirect subject of a number of plays, films, and other dramatizations, she has become less famous than notorious, a media figure whose life's story can be interpreted in more than one way.

The artistic identity upon which Artemisia's celebrity rests is both distorted and inchoate. It was distorted from the outset by that scandalous incident in 1612 and its ever-resounding echo, which created Artemisia-the-famous-rape-victim, whose identity as an artist was overshadowed by her lurid sexual reputation. Yet our sense of her individuality as a painter also remains inchoate and undeveloped because the ongoing effort to define her oeuvre has not been guided by the kind of stable and traditional categories of identity that attach to comparable male artists. The absence of a fixed identity for Artemisia other than as "female," as well as sharp disagreement among scholars about the bearing of femaleness on her art, and even whether femaleness is a stable category, has vexed and problematized the connoisseurship of this "woman painter" more than we might have expected.

The problematic state of Artemisia Gentileschi connoisseurship is due in part to the fact that her existing oeuvre is relatively small and, like her life, poorly documented. Few of the core works—some forty paintings generally accepted as hers—are linked to Artemisia by secure provenance, while many of her works named in correspondence or in literary sources are lost or unidentified.

Thus the shape of her oeuvre, more than that of many artists of her stature, resists clear definition. Beginning with the pioneering work of Roberto Longhi and, later, R. Ward Bissell, followed recently by a handful of scholars, art historians have attempted to define the Artemisia oeuvre, both through additions to and subtractions from it. Yet the first monographic studies of Gentileschi to appear—my own book, published in 1989, and the Florentine exhibition catalogue by Roberto Contini and Gianni Papi, of 1991—conspicuously diverge on attributions, with the result that the artistic identity of Gentileschi is far from coherent.[1]

New contributions to the field of Gentileschi studies continue to appear, with the catalogue raisonné by Ward Bissell and the catalogue of an Orazio-Artemisia exhibition now in preparation.[2] Yet it is already evident from informal debates among scholars concerned with Artemisia that perspectives will remain diverse. The new literature, even Bissell's book, will not settle the debates; rather, that catalogue raisonné will take its place in what promises to be a continuing process of defining and shaping the Gentileschi oeuvre. In one sense, this is as it should be. Some artists are pinned down to everyone's satisfaction with the first catalogue raisonné; others, such as Rembrandt, present more complex problems of attribution because a larger, more subtly articulated artistic personality is at stake, one that invites an ever-changing reinterpretation of the creator and the redefinition of the oeuvre by successive generations.

In the case of Artemisia Gentileschi, gender considerations, both those applying in her time and those subsequently imposed, further problematize the issue of oeuvre formation. For this reason, I want to address the issue of Gentileschi connoisseurship in anticipation of the next plateau of definition, outlining considerations that must both guide and caution us in the risky process of constructing and clarifying her artistic identity. I approach these considerations through two case studies, discussing in depth two paintings that present certain attribution problems. In one case I support the attribution to Artemisia; in the other case I question it. In the first example, a uniquely gendered identity position can be discerned, which joins documentary evidence to confirm the artist's hand; in the second instance, gender assumptions and attitudes have accompanied the picture from its inception, complicating the connoisseur's task of arriving at a simple yes or no.

We live in an era when connoisseurship is perhaps the most suspect practice of the art historian. Suspicion has resulted, in part, from postmodernism's

interest in the work of art more as cultural signifier than as the product of individual "genius," and from our skepticism of previous generations' privileging of formalist values and heroizing of individual artists, a mind-set whose consequences included, among other things, phenomenally inflated market valuations. Art history's expanded agenda—for many it is a changed agenda—makes it difficult to argue for connoisseurship as traditionally defined, since it seems to perpetuate distorted values. Yet unless we are willing to give up altogether our interest in identifying individual artists, some form of connoisseurship will always be necessary.

Perhaps the word "connoisseurship" should be retired, smacking as it does of privilege, elitism, and hypersensitivity posing as specialized knowledge. Perhaps we should speak instead of forensic art historians, who identify and authenticate the hands of individual artists on the basis of purely scientific evidence. But merely to pose this possibility brings forth reasons for insisting that connoisseurship is an art, not a science. "Knowing," connoisseurship's root meaning, is in matters of artistic expression linked to taste and, inevitably, to judgments of quality. I mean "quality" here in the sense of "a property that distinguishes a thing," not in the sense of "superior excellence." Yet these two meanings of "quality" overlap, for a connoisseur's ability to distinguish artists has most likely been honed on subjective preferences. Qualitative distinctions may be invidious to some, but they are essential to objective classification, for since artistic techniques are taught and learned, differences between two artists are not always fully detectable at the morphological level. Sometimes they can be recognized only in how the parts are put together, or even how well they are put together—the je ne sais quoi of artistic identity that distinguishes early Leonardo from Verrocchio, or Mozart from Salieri.

To respect and value the personal voice in art is not necessarily to rant about "genius" or to salute the canon, contrary to certain ideologically convenient exaggerations of this position. Difference is simply more interesting than sameness, or rather, collective behavior is interesting only on the sociological level, where its difference from other forms of collective behavior can be taken into account. Of course, one form of today's art history is practiced at precisely that level, by those who argue that the artist is best understood as a product of social forces beyond his or her control, a producer of meaning for an economic market. One can only respond that it would be unnecessarily self-limiting for art history to choose this sort of analysis as its exclusive concern. We may profitably

examine art as the product of conflicting and competing power claims and at the same time recognize that the art of any given period consists of highly diverse visual images made by individuals differentiated by political interests and personal standpoints too subtle for easy categorization, whose personalities are imprinted on their every creation. Some of them have insisted with passion upon the distinctness of their individual visions.

Even so, we are, or should be, long past the simplistic binary that falsely divided the formalist (or, more broadly, old-fashioned humanist) from the social-constructionist position. To formalism is ascribed an attraction to heroic biography, a desire to elevate selected artists to mythic status and find universal signification in their every formal gesture. Social constructionism can be characterized as an art sociology skeptical of claims for unique individual expression (unless such claims are framed in psychological theory); it tends to interpret artistic images primarily as productions within one or another impersonal system: socio-economic, political, or theological. These extremes beg to be reconciled. The postmodern perspective has taught us, among other things, that "the personal is political," in the words of the old feminist slogan, which I would here adapt to signify that the relationship between our social identity and our individuality—whether as congruence or tension—is a primary condition of being human. And since every human situation or experience has both personal and social dimensions, it seems clear that the art sociologists need to face the complicating factor of individualism, while the connoisseurs could profitably include in their work the equally complicating perspective of the social.

The result would be a connoisseurship, and an art history, in a new key. I have argued previously, and show here by further example, that problems of attribution can sometimes be most effectively addressed through a combination of formal and psychosocial considerations. How an artist treats a given theme, what extra-narrative factors are introduced, may provide as telling and intimate a sign of authorship as the personal brushstroke. The artist's hand is revealed not only through touch and gesture but also through iconographical choices and compositional emphases. These critical decisions—which themes to depict (assuming the artist has a free hand in choosing them), how to stage them, how to present the characters—can be strongly affected by psychological and social factors.

Some time ago, I drew upon this form of connoisseurship to confirm the attribution of the Pommersfelden *Susanna and the Elders* (see Fig. 44) to Artemisia

rather than to Orazio Gentileschi, arguing that the painting's formal arrangement, by expressively deviating from the conventions of narrative presentation that held for this particular theme, bespoke the social perspective of a sexually beleaguered female protagonist and hence was more likely to have been designed by Artemisia than Orazio.[3] The interpretive technique of comparing forms of narrative—regularly practiced by historians of Scripture, myth, and folklore—might enable students of visual images to separate speakers from their stories, in order to lay bare the personal voice of the narrator (artist). There is, to be sure, no "pure" form of a thematic narrative, for it exists only in the myriad variations that represent the multifarious interests of diverse narrators. Nevertheless, there are in visual thematic traditions what historians call "rhetorical norms," against which an attentive eye might measure individual inflections. The identifiable features of an individual personality may be as immediate as a handwriting or as abstract as an attitude, but they constitute a voice or identity position of an individual, one that is distinctive enough to be recognized when it echoes his or her known interests over the course of an artistic career.

Since individual voices change over time, however, there remains the problem of balancing the competing claims of consistency versus range. In its early years, connoisseurship tended to assume consistency: *this* is the artistic profile of Raphael in general, and to be a Raphael, a given drawing or painting must conform to the homogeneous and consistent ideal of Raphaelness. The Raphael example is perhaps apposite, for beginning in the 1960s, scholars facing the vexing problem of the Raphael workshop began to broaden the idea of what Raphael himself might have done, to expand the range of what was considered possible for the later Raphael, and consequently to take back for him certain works that had been handed off to his pupils, Giulio Romano and others.[4] Here was an instance of refinement in connoisseurship methodology built upon an increasingly mature understanding of the interplay between essential identity and the evolution or remaking of identity that goes on in most lives over time.

The artistic profiles we construct today must be further modified by knowledge of the artist's social history. How the artist was perceived by his or her peers, the artist's relation with patrons, success or lack of it, gender orientation, or personal religious preferences—all these and more can be ingredients in the temperamental mix that constitutes artistic identity, elements that can help us detect a particular voice. To return to the matter at hand, Artemisia Gentileschi

presents an example rare in her period, of a female artist functioning profession-ally in a nearly all-male and masculinist art world. I have argued that Artemisia's distinctive social experiences and affinities as a woman (I do not mean biologi-cally determined identity) conditioned her preference for and presentation of narrative themes with dominant female and subordinate male characters, setting up her equally distinctive proto-feminist narrative voice. I did not propose a predictive formula, for a narrative voice can only be recognized, not foreseen. I did not argue that a painting with a pro-female viewpoint could only have been painted by a woman, or that all works by women display a feminist per-spective, or that gender dynamics have a universal or permanent character. Rather, I suggested that we can use gender identification as one interpretive consideration among others,[5] one that in some instances carries particular weight. Otherwise, we face the untenable proposition that there is no connec-tion between art and life, no relation between psychology and behavior.

GENDER AND THE SOCIAL CONSTRUCTION OF ARTISTIC IDENTITY

Gender considerations, as Panofsky once said of theory, must be welcomed di-rectly at the front door of art history, or else they will come in through the chimney like a ghost and upset the furniture.[6] Taking gender into account in the study of Artemisia Gentileschi involves not only recognizing the artist's devia-tion from a rhetorical norm in her reinvention of female characters but also re-alizing the risk of imposing gender-stereotyped expectations upon her.

The fitting of Artemisia to preconceptions of what a woman artist should be began in her own time. For example, Filippo Baldinucci's comment that she was known especially for portraits and still-life paintings has puzzled modern scholars, who have scurried to find portraits beyond the known handful or any still lifes at all.[7] Without necessarily doubting that examples of these genres by Artemisia remain to be discovered, one can observe that Baldinucci's remark may have been prompted by the assumption that as a woman she was likely to have been proficient in those genres disproportionately practiced by, and stereotypically associated with, female artists, who lacked access to the "higher" genres of history and large-scale religious painting.

In modern times, other assumptions about natural limitations for women

artists have crept into judgments about what Gentileschi might have painted. In 1991 Mario Modestini proposed (as reported and enthusiastically endorsed by John Spike) that the *Judith* in Naples, which X-ray analysis has revealed to be an original composition and to have preceded the better-known Uffizi version (Fig. 8), must have been painted by Orazio, not Artemisia. Modestini deemed the Naples *Judith* a masterpiece of urgency and *terribilità,* and therefore the creative production of the father. The Uffizi replica, by contrast, described as merely a dry and uncreative copy, could safely be left in the Artemisia oeuvre.[8]

This is an argument girded by unstated gender-stereotyped assumptions (not to mention the ludicrous association of Orazio Gentileschi with *terribilità*). Since the Renaissance, theorists and other writers have declared that women are incapable of artistic originality. Mere declaration does not make it true, and the masculinist claim that only males possess the powers of design and invention has proved as easy to deconstruct as the Aristotelian notion routinely invoked to support it, that males uniquely provide the spark of life in human generation.[9] A similar presumption that women are constitutionally deficient in invention appears to have guided Spike's revival of the wish-that-never-dies: that the Pommersfelden *Susanna* (see Fig. 44), despite its prominent signature, must have been a collaborative production, which Orazio designed.[10] Late in her life, Artemisia battled that very presumption when insisting in a letter that "never has anyone found in my pictures any repetition of invention, not even of one hand."[11]

Another gender-distorted assumption traceable to Artemisia's own time is that the artist and her art, as exempla of feminine beauty, constitute a seamless whole. Renaissance connoisseurs sometimes claimed to admire self-portraits by women as "double marvels," of the painter's art and her own beauty.[12] The concept of double beauty most likely fueled the desire of male collectors for Artemisia's self-portraits; in a letter to her patron Don Antonio Ruffo, she offers him a self-portrait, "which you may keep in your gallery, as all the other princes do."[13] Artemisia's beauty was frequently extolled by her contemporaries as something inseparable from her artistic themes. We see this in Dumonstier's 1625 drawing of her hand (Fig. 1), whose dedication links the artist's hands with those of her painted Aurora. We see it again in verses addressed to Artemisia published in Venice in 1627, in which the artist's beauty

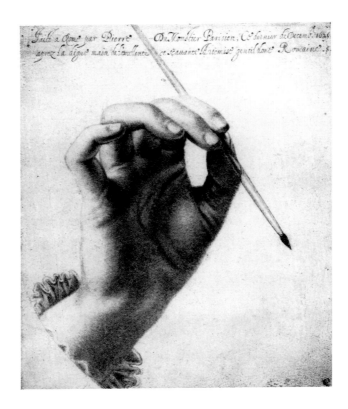

FIGURE I. Pierre Dumonstier le Neveu, Drawing of the hand of Artemisia Gentileschi with paintbrush, 1625. British Museum, London.

is described as interchangeable with that of her subjects and as her own special, separate, path to glory.[14]

The few known portraits of Artemisia (see Figs. 32, 42) tend to belie the notion that she was especially beautiful. Her characterization as a great beauty—a constant leitmotif in texts ranging from her period to ours—is suspect, for we find a similar preoccupation with other female artists' physical beauty in Renaissance texts.[15] The name "Artemisia," however, became a sign of something remote from the living artist and her paintings; it represented a constructed ideal of imaged feminine beauty, which in sixteenth-century art theory could stand for art itself—a possessable commodity.[16] To possess an Artemisia was on one level to own a cultural trophy, a token of feminine self-creation validated and

shaped by masculine judgment, and on another, a way of containing a rather frightening and independent artist by making her, too, symbolically possessable—a point to which I will return.

This graceful and glamorous "Artemisia" survives even today as the artist's icon in the popular imagination. For example, it was the lovely *Allegory of Inclination* (Fig. 2), not Judith the assassin, that became the emblem of the Casa Buonarroti exhibition, appearing on posters, T-shirts, and the back cover of the catalogue.[17] An angelic beauty who inclines in pious deference, the allegorical figure could function as a sign of the artist because it reified the appealingly feminine aspects of her imagined identity. An analogy can be seen in magazine advertisements for an exhibition of paintings by Rosa Bonheur in 1997 that featured, not one of Bonheur's paintings, but another artist's portrait of *her*, in this case conflating Bonheur's artistic identity with a rather sweetened version of her physical appearance. When we consider that Bonheur deliberately masculinized her self-images,[18] we can recognize in this substitution a fairly desperate effort to refeminize the artist.

The inexorable association of a woman artist with feminine beauty survives as well in Gentileschi connoisseurship. The less credible attributions to Artemisia that have cropped up in recent years show a persistent preference for delicate, feminized images and wimpy Madonnas and saints, as well as for a certain softness of style.[19] Attributions of longer standing also present these features. A small *Madonna and Child* in the Escorial, painted on copper (Fig. 3), presents the Virgin as Artemisia never depicted any female character—as a petite, smiling young girl dressed in bright primary colors and rendered in a tightly brushed, enamel-like technique. Astonishingly, considering its remoteness from Artemisia, both in style and figure type, this work is signed with Artemisia's name. As I argue in the Conclusion, however, there is reason to believe that works not by Artemisia may have been falsely signed with her name to enhance their particular value.[20] If the Escorial *Madonna* is such a work, its unquestioning general acceptance in the Gentileschi oeuvre suggests that modern art historians no less than seicento *gentiluomini* have had reason to perpetuate the inflated construct of Artemisia-the-beautiful.

The opposite face of this tendency is that Artemisia's inelegant and unglamorous women, such as the *Cleopatra* and *Lucretia* (see Fig. 10, Plate 5), have attracted little critical commentary. In the case of the *Cleopatra* and the *Madonna and Child* in the Spada Gallery, Rome (Fig. 4), the heroine's physical plainness

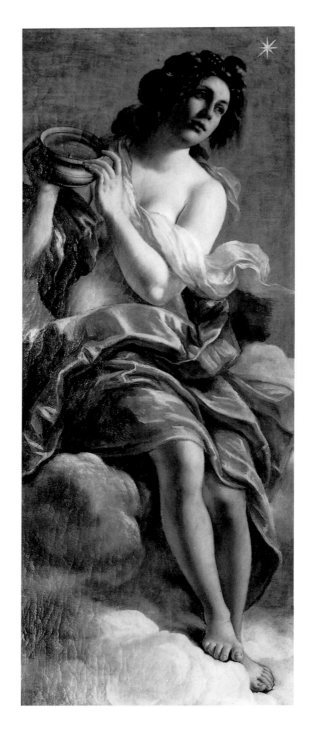

FIGURE 2. Artemisia Gentileschi, *Allegory of Inclination*,
1615–16. Casa Buonarroti, Florence.

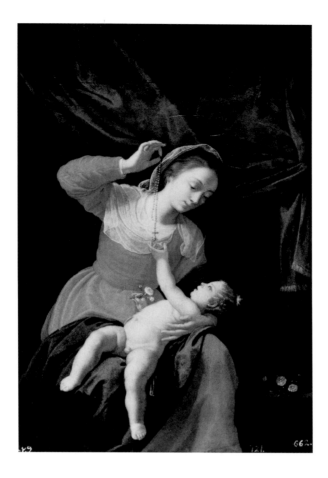

FIGURE 3. Attributed to Artemisia Gentileschi.
Madonna and Child. Museo de Pintura y Arquitectura
de El Escorial, Spain.

has tended to erode support for Artemisia's authorship. Bissell now reattributes the *Cleopatra* to Artemisia's father, Orazio, arguing that its ponderous, awkward, and unbeautiful body diverges significantly from three "physically attractive" reclining nudes Artemisia produced in the 1620s.[21] He would also remove the Spada *Madonna*—which he deems "homely"—from Artemisia's oeuvre, assigning it instead to the circle of Giovanni Baglione and supporting the attribution to Artemisia of the related *Madonna* in Palazzo Pitti (Fig. 5). In so doing

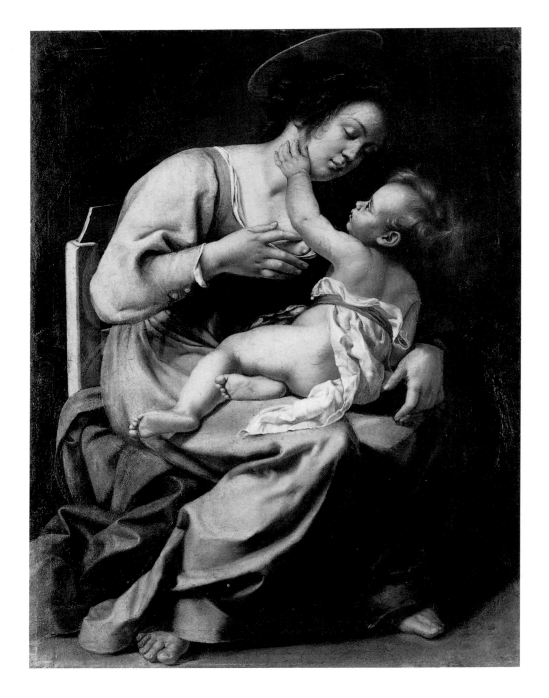

FIGURE 4. Attributed to Artemisia Gentileschi. *Madonna and Child*. Galleria Spada, Rome.

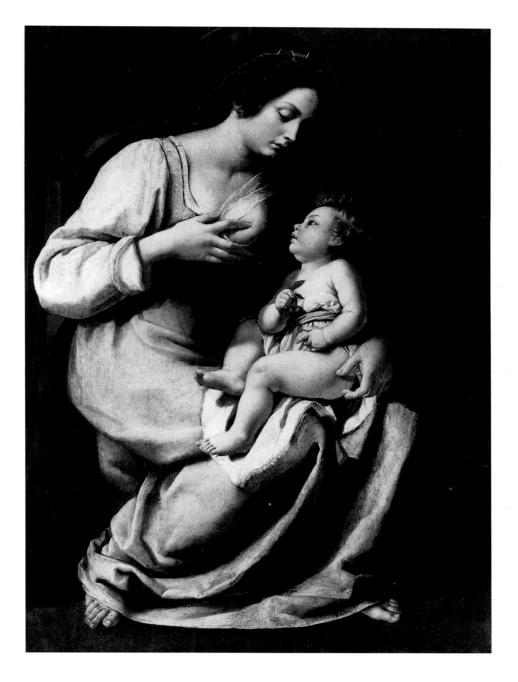

FIGURE 5. Attributed to Artemisia Gentileschi. *Madonna and Child*. Palazzo Pitti, Florence.

Bissell joins a majority, for more scholars have chosen the Pitti *Madonna* than the Spada *Madonna* as the work by Artemisia. Since most scholars also agree that the Pitti picture derives from the Spada example, we can also see at work here the bias against female originality.[22]

New evidence has emerged, however, that almost certainly confirms the attribution of the Spada *Madonna* to Artemisia. Gianni Papi has found in a 1637 inventory of paintings owned by Alessandro di Biffi, a collection that went directly to the Spada family, mention of a Madonna and Child by Artemisia Gentileschi, along with a Saint Cecilia also by her hand, of similar dimensions.[23] The latter work is the Spada *Lute Player,* a painting whose attribution to Artemisia has also been doubted.[24] Inasmuch as the protagonists of the two Spada pictures share in their divergent physiognomies a stocky plainness of features, we can recognize one source of the resistance to the homely Spada *Madonna* picture as Artemisia's own—particularly irrational in the face of the picture's strong stylistic links with documented works of her early years[25]— as well as the eager embrace of the refined and comparatively elegant Pitti *Madonna* as hers despite its utter foreignness to her style. These critical choices effectively exemplify the subtle but persistent expectation that Artemisia's art should present paragons of female beauty.

This is not to say that Artemisia eschewed feminine beauty, for she produced many images of graceful, lovely women. Yet she also specialized in a more naturalistic and earthy figure type that writers have been uncomfortable acknowledging, much less explaining (beyond the perfunctory nod to Caravaggism). The problem lies in the projected expectation that as a woman she had a special relationship with beauty, so that one thinks of her when confronted with a beautiful female image, or vice versa, that her name evokes an ideal of feminine beauty. Such projections situate Artemisia exclusively within discourses of femininity, flattening her variegated oeuvre into one with a single characteristic, fixed by masculinist constructs of beauty.

The desire to assign to Artemisia a stable feminine identity was—at least in the seventeenth century—consistent with the gendered norms of identity construction in the Renaissance. Males no less than females were guided in their self-formation by rules of gender behavior such as those found in conduct books or those imaged in art, where, as Valeria Finucci puts it in *The Lady Vanishes,* "the ideological aim of representation is the construction of fixed identities

in an ordered world."[26] In this respect, Artemisia was as vulnerable to prevailing ideological systems as to the threat of rape. Under such circumstances, in which people typically responded and acted in gendered ways, the possibility that she may have compromised with culture in certain respects—for example, by capitalizing on her ability to depict beautiful women—is unremarkable. The miracle is that she resisted gender classification as much as she did, both in life and art. Artemisia spent most of her adult life as an independent professional woman, working entirely on her own, with few buffers between herself and the masculine art market. Biographers who extol her lovely female images or her still lifes do not mention this, nor do they note that she enlarged the very category of femininity to represent beautiful women who protest rape and kill men.

The modern tendency to reduce Artemisia's artistic identity to an appropriately feminine model thus perpetuates and extends an overdetermined identity constructed for the artist in her own time. Simultaneously, a less directed, more accidental process of identity formation is taking place today as a result of the critical neglect of identity issues. When attributions are proposed or defended, the grounds remain narrowly stylistic, with no consideration of the expressive nature of an image, or its relation to the whole of Artemisia's oeuvre. Because the artist's motivation is not considered, even by those who aim for consistency, the collective attributions add up to an incoherent identity, an Artemisia whose artistic expression seems chaotically diverse. She remains a cipher, the sum of influences upon her from a variety of male artists.[27] Reasons for this lack of interest in the motivations or inner development of a woman artist, even one as dramatically rich as Artemisia, are not hard to find. It is an old story that the lady vanishes. But I believe that something else is involved, namely, a denial of Artemisia's core feminism, without which her oeuvre would indeed be incoherent.

Resistance to Gentileschi's feminism is the hidden face of the desire to reclaim her to femininity. It is becoming regrettably common to see feminist readings of Artemisia's art characterized as artificially imposed, extrinsic perspectives, contrasted implicitly with more natural practices that capture everything art history supposedly needs to know about the artist.[28] Such characterizations are both strange and surprising, since scholarship of the past two decades has made abundantly clear that gender considerations were a very real part of early modern culture, articulated in a wealth of writings and in images as well.[29] "Feminist"

is a modern word, yet it describes a historical standpoint detectable at least since the fourteenth century: a pro-female position or bias in an overwhelmingly pro-male world. Given the sustained and often intense debate throughout the Renaissance between feminists and masculinists, including a prolonged effort by feminist polemicists to rectify the excesses of masculinist bias, the characterization of modern feminist scholarship as dogmatic politics poking its nose irrelevantly into the practice of art history is simply not grounded historically.

An analogy for the application of the modern word "feminism" to a premodern era can be found in the field of science. The word "science" was not yet used in its modern sense in the seventeenth century, although the fundamental concepts and practices of modern science are traced to that period and are included in histories of science. When I describe Artemisia's art as feminist, I am well aware that she did not know the word; I use it as we use "scientist" to describe Galileo and Newton, even though they considered their work a branch of natural philosophy.[30] Sadly, the misunderstanding of "feminist" in this broader historical sense has recently been perpetuated by Ward Bissell's argument against Artemisia as "a woman of feminist convictions," on the grounds that her art failed to change men's behavior; Bissell claims "it is only in our own day that a feminist outlook or agenda has been detected [in her work]."[31]

It is Bissell who falls into anachronism here, for he interprets "feminist" in entirely modern terms, as a deliberate political campaign to effect change. Even today, a feminist outlook is not the same as a feminist agenda, and what might count as a feminist impulse in the seventeenth century probably involved no call to action. Bissell, while acknowledging that Artemisia may have affirmed her sense of female self-worth in her allegorical self-portraits, says that this "does not in itself point to feminist sympathies." Nor, in his view, do Artemisia's own words support the argument that she held feminist convictions. Not even her triumphant declarations to a patron: "You will find the spirit of Caesar in this soul of a woman" or "I will show Your Most Illustrious Lordship what a woman can do"?[32]

Surely, any assertion of female worth or capability that goes against cultural norms must be counted as a feminist gesture, even though that assertion might not resonate as especially feminist to us today. The feminist of the seventeenth century would not have questioned many elements of the societal repression of women that came to be challenged in later eras. Feminism has never been a static or monolithic orthodoxy; it has evolved over time, and we

should properly speak of feminism*s*. Yet a certain commonality of viewpoint—that pro-female cast of mind—has linked women across time and makes it possible to speak of a history of feminism. To call the word anachronistic or the concept irrelevant to the art-historical study of earlier centuries, is, ironically, to resist the larger historical framework that is meaningful here and to insist upon a disjunction that would separate women from their history.

For Artemisia Gentileschi, the question is not whether but how feminism enters her work. Yet the tendency to regard the feminist perspective as alien lingers. Bissell fears that interest in Artemisia as a woman painter "threatens to situate the artist outside the mainstream of the Italian Baroque . . . to confer isolated status on her. And to shift the focus away from the creative act."[33] Here he errs, I believe, not only in conceiving the "mainstream" as implicitly a purely masculinist canon but also in finding a feminist perspective at odds with a study of creativity. Far from that, the consideration of feminism as a factor can shed new light on the creative process itself, augmenting our repertory of the available forms of artistic expression and helping us to discover another way of "proclaiming the power of art," in Bissell's own final words.

It will seem to some that I am fighting a battle that has long been won, yet I note with dismay a current tendency to drain the feminism from Artemisia's art, to deny both the originality of her images and the broader cultural signification of their autobiographical component, and to define her as just another artist who turned out products for a market.[34] Tellingly, this approach continues, though in the opposite direction, exactly the practices of the artist's masculinist contemporaries, who sought to normalize her within the subcategory female. Certainly, Artemisia was and wanted to be an artist like other artists, and a proper historical perspective must ground her in the social fabric of her culture. But by virtue of being female, she could never have been a normative artist; her exceptional position is also part of her history. Thus defining Artemisia as part of an art economy, who provided a specialized product (images of women), in no way contradicts the recognition that her female images, generated from a different kind of firsthand knowledge, offered a subversive critique of dominant cultural values.

The latter part of this definition derives largely from a *trans*historical perspective of Artemisia's accomplishments, some of which may have been invisible to her contemporaries. This perspective, also known as the judgment of history, is the one that created a Piero della Francesca who could inspire modern

formalism, the one that produced a sympathetic understanding of mannerism from the standpoint of expressionism. Such critical judgments are a two-way street: we selectively create a usable past, yet the elements we select were there to begin with, shaping our very choice of them. If modern feminism has led us to value the uniqueness of Artemisia's achievement in her time, it must be acknowledged that she had something to do with our discovery. And there are clear signs, even in her oeuvre as presently known, of Artemisia's awareness of, and desire to negotiate, the gender discourse to which she was subject.

GENDER AND THE PERSONAL FORMATION OF ARTISTIC IDENTITY

The concept of art as autobiography is also not a modern projection. According to a topos of Italian art history, attributed first to Cosimo de' Medici, "Every painter paints himself." [35] Painting oneself can mean a number of things, from a literal self-portrait to the unconscious projection of one's features onto a depicted figure. Or an artist might depict a fictional character who is a fantasized alter ego, a character who becomes a means of developing the artist's own identity. Recently, some scholars of Renaissance art have taken up the latter meaning, connecting it with the Lacanian concept of the "mirror stage" and the idea that ego formation advances by the projection of one's self-image onto real or fictional characters one would like to resemble. [36]

There are well-known examples of the projected self. In his Florentine *Deposition* of 1547−55 (Fig. 6), Michelangelo gave his own features to Nicodemus, who supports the dead Christ. In doing so he probably expressed his personal devotion to Christ and perhaps also his covert support of a heretical theology. [37] Caravaggio, in his Borghese *David* of 1605−10 (Fig. 7), depicted the stunned decapitated head of Goliath as recognizably his own, evidently as a form of imagined self-punishment, though whether for the murder he committed or in the context of a private drama, we cannot be sure. [38]

In these penitent or meditative self-images, Michelangelo and Caravaggio offered dimensions of their personalities that opposed other aspects of their personae. Michelangelo's gentle, devoted Nicodemus is a figure in sharp contrast with the sculptor's heroic, autonomous *David,* which has also been seen as, among other things, a self-image. [39] The Borghese *David* may present an image of Caravaggio in conflict with himself, for it has been claimed that he projected

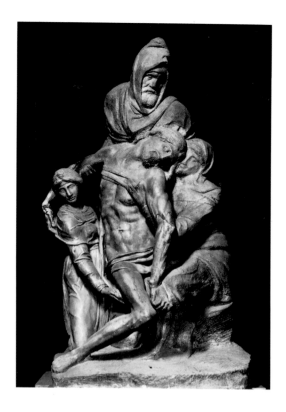

FIGURE 6. Michelangelo, *Deposition,* 1547–55.
Cathedral, Florence.

himself onto both the avenging David and the punished Goliath;[40] but in any
event, the painting's iconic expression of meditative remorse is distinctly at odds
with the artist's flamboyant and impulsive public personality. These examples
are consistent with the Renaissance cultural norm that permitted contradiction
in masculine identities;[41] indeed, conflicting aspects of personality pointed to
deeper, more complex and even tragic figures, as Hamlet perfectly exemplifies.

Artemisia Gentileschi, who was manifestly influenced by the art of both
Michelangelo and Caravaggio, also practiced self-projection in her art. In her
four independent conceptions of the theme of Judith and Holofernes, from
about 1612 to 1625 (Fig. 8), she depicted the biblical Judith as the heroic agent
of retributive justice who killed the Assyrian tyrant, oppressor of Israel and in-
tended sexual oppressor of Judith herself. In Artemisia's fantasized inversion of

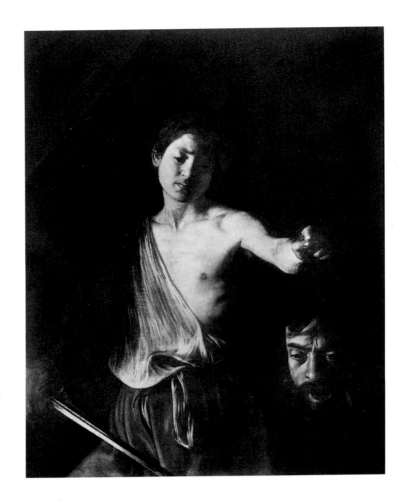

FIGURE 7. Caravaggio, *David with the Head of Goliath*, 1605–10. Rome,
Galleria Borghese.

gender stereotype, Judith is a socially liberated woman who punishes mascu-
line wrongdoing. Although none of Artemisia's Judiths is literally a self-portrait,
the artist seems to have embedded coded self-references in each of her versions
of the theme.[42] The heroine's easy dispatch of Holofernes clearly provided
fictional compensation for the frustration and paralysis that Artemisia experi-
enced in her own life, both in the singular event of her rape and the ensuing trial,
and in her general experience as a woman in a social system that deeply dis-
couraged female agency.[43]

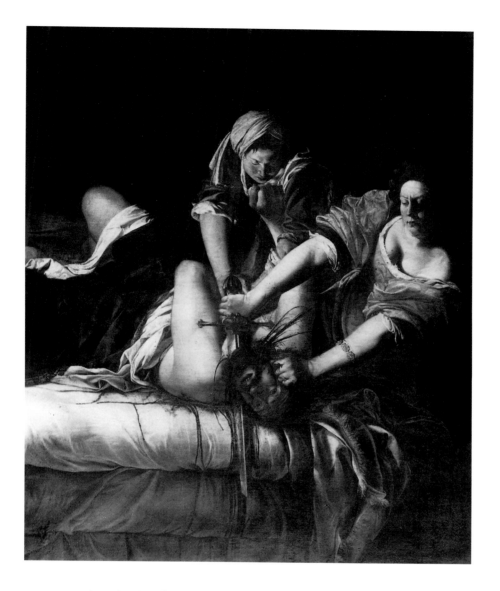

FIGURE 8. Artemisia Gentileschi, *Judith Slaying Holofernes,* ca. 1620. Florence, Galleria degli Uffizi.

Diverging from the meditative or penitent cast of Caravaggio's and Michelangelo's self-images, Artemisia drew instead on the active identities of her chosen female characters, exaggerating their energy and mobility as if to compensate for the largely passive personalities of women depicted in art and suppressed in life. In this respect, she marshaled her forces to combat the cultural definition of woman as passive, offering in its place a fantasy construction of woman as free and heroically empowered. Considering, however, that women were expected to present a unitary social identity, as the subordinated Other to the differentiated masculine identity, Artemisia's replacement of one female type with its opposite may not have been her most radical gesture. I suggest that this was instead her appropriation of the masculine prerogative of a contradictory nature.

Artemisia's contradiction took two forms. She deliberately broadened female typology by exploring various modes of female being through characters that she created and inhabited. In her early years especially one sees her trying on personae like hats, playing each time with the discrepancy between the character as traditionally depicted and as reinvented by herself: a suffering Susanna, an argumentative Lucretia, a commanding Cleopatra, a virile Judith, a queenly Esther. The other form of contradiction was self-contradiction, probably unconscious, the result of a head-on collision between her feminist ambitions and the exploitative misogyny of the society in which she was obliged to function. It surfaces in her art as an apparent division of identity in two expressive directions.

Artemisia's artistic identity was shaped not only by professional experience but also by a spectrum of attitudes about the relationship between her personal history and her art. The most conspicuous and widely known event in her life was the rape trial of 1611–12. This event cast a long shadow on Artemisia's subsequent reputation, which it ultimately deformed, defining her as a woman in primarily sexual terms.[44] Of greater importance, notably to the painter herself, was her ambition to succeed as an artist. Yet these two salient markers were interconnected in a complicated way. Too little documentary or literary evidence survives for us to reconstruct that relationship in full, but we can draw certain logical inferences. The rape experience gave Artemisia-the-woman a certain notoriety, which drew attention both to and away from her art. Artemisia-the-artist had to deal with this problem, which was also an opportunity. She was

both obliged and entitled to negotiate with her patrons and buyers from a position of special identity, which was a compound of the image publicly constructed for her and the image that she held of herself. The two components of that identity, however, did not entirely cohere.

Over the course of her career two contradictory forms of autobiographical presence can be detected in Artemisia's art. One continues the expansive experimentation with uncharacteristic forms of female identity, figures with whom she pointedly and sometimes proudly identifies herself through images that bespeak the artist's invisible presence. The other form—to be examined later in this book—reverses that direction to cope with the problematized identity imposed upon her, by vacating or emptying a character with whom she was or might be identified without directly countering that identification. This mode puts the artist in the work, not as an implied presence, but, more ambiguously, as both present and absent, an absent presence.[45] In one mode, Artemisia desires to be her character; in the other, she desires to be free of her, yet—perhaps for practical reasons—cannot entirely give her up.[46]

The contradiction between these two forms of self-presentation emerges in microcosm in the two paintings considered in the chapters that follow. One is a previously unknown but surely authentic composition by Artemisia that exists in two versions; the other is a picture whose standing attribution to her is now subject to reconsideration from new technical evidence. The paintings come from the same period in her life, one assignable to the years 1621–22 for formal and contextual reasons, the other signed and dated 1622. Produced at nearly the same moment in the course of the artist's life and critical fortunes, they nonetheless point in opposite directions. I treat these paintings as independent case studies that can sharpen our understanding of Artemisia's artistic identity— the first, because it presents an aspect of identity at a moment of self-formation; the second, because it exemplifies the pressures exerted by gender ideology and other social factors upon that formative process.

ONE

A NEW MAGDALEN

A TALE OF TWO PICTURES

Thanks to the prominence of the early *Susanna* and the *Judith*s, Artemisia's female characters are best known as forceful women who energetically protest their circumstances or do something radical to improve them. A composition that exists in two versions offers a very different female protagonist, yet one who also has autobiographical resonance for Gentileschi. In the painting that undoubtedly represents Artemisia's original composition, now in the Sala del Tesoro of the cathedral of Seville, Spain, Mary Magdalene is seated in a chair, her head slumped to one side, her cheek resting on her wrist (Fig. 9; Plate 1). A nearly identical picture (Plate 2) was on public exhibit in New York in the spring of 1998.[1] Until recently, it had been in the hands of a single family in France for about 150 years, known to its owners, but not to the world, as a work of Artemisia Gentileschi.[2]

This chapter argues for the iconological expression of the *Magdalen* composition as a sign of authorship, and as a demonstration of that broader form of connoisseurship discussed in the Introduction. It focuses upon the Seville version. Because there is a strong probability that the second version is Artemisia's own replica of the Seville *Magdalen,* however, it is necessary at the outset to employ a form of traditional connoisseurship to account for the two versions, for it is likely that they offer a rare glimpse of the artist's way of creating slightly altered copies of her own pictures.

In 1987 Jonathan Brown and Richard Kagan identified the Spanish version of this composition with a documented work by Artemisia. A "Magdalene seated in a chair sleeping on her arm" by Artemisia Gentileschi is recorded

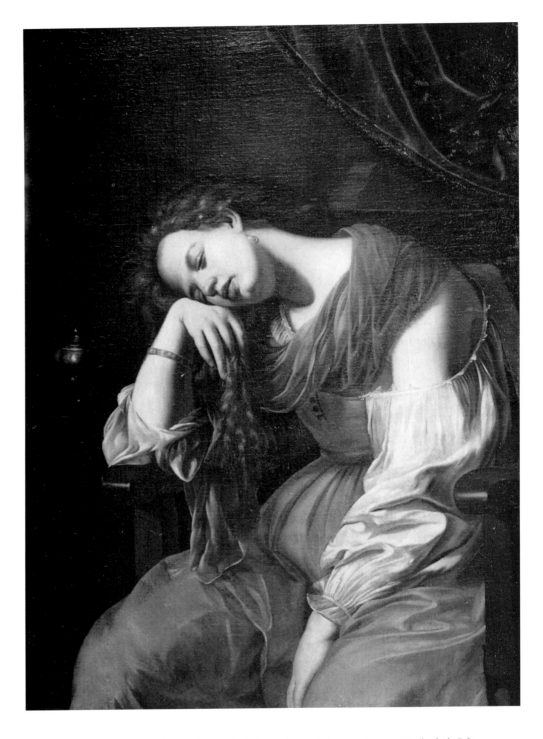

FIGURE 9. Artemisia Gentileschi, *Mary Magdalene as Melancholy,* ca. 1621–22. Cathedral, Sala del Tesoro, Seville, Spain. Detail of central section.

among the extensive art purchases made by the Spanish collector Fernando Afán de Ribera, duke of Alcalá and viceroy of Naples (1629–31), during his stay in Italy in 1625–26.[3] The duke of Alcalá bought several paintings by and after Artemisia on this trip, most likely during his sojourn in Rome from July 1625 to February 1626, and it seems probable that he acquired them from Artemisia herself.[4] Although she took up residence in Venice in 1626–27, the artist and the collector remained in contact, for in 1629, Artemisia went to Naples to work for Empress Maria of Austria, joining Alcalá's own viceregal court. As Brown and Kagan reasonably suggest, it may have been Alcalá who brought Artemisia to Naples.[5]

The painting in the Seville cathedral is unquestionably by Artemisia's hand. It presents distinctive Artemisian motives, such as the brown-gold dress, the curve of drapery suspended in the upper right corner, and the light veil thrown over one shoulder, all of which appear in the Detroit *Judith* (ca. 1623–25). The slight distortion of the foreshortened head can be seen in the *Cleopatra* of about 1621–22 (Fig. 10) and the New York *Esther* of perhaps circa 1630,[6] as well as in the perspectively better adjusted London *Cleopatra* of 1629–30 and the *Self-Portrait as the Allegory of Painting* (see Fig. 42). The figure's swollen lips, down-turned at the corners, and the shape and lighting of the nose recall, in partic-ular, those of the Detroit *Judith*. In other respects, the *Magdalen* is stylistically close to the earlier *Cleopatra* and the Genoese *Lucretia* (Plate 5), which are most reasonably dated 1621–22.[7] Its connections with these works include the strong chiaroscuro combined with sharp clarity of contour, the proportionally large figure-to-format relationship, and the pronounced creases at the underarm.

These relationships suggest a dating for Artemisia's Seville *Magdalen* in the early to mid-1620s (in any case, it must date before the end of 1625, since it was purchased no later than February 1626). I would propose a date of around 1621–22, not only for the connection with the *Cleopatra* and *Lucretia*, but also because the *Magdalen* composition shares with these and other works painted from about 1615 through the early twenties a relative restraint in gesture and movement, a tendency toward compact, closed forms.[8] With the Detroit *Judith* and the *Aurora*, we see a new expansiveness in movement, scale, and setting. A 1621–22 dating for the *Magdalen* would imply that the duke of Alcalá acquired an exist-ing picture in 1625–26. Bissell, however, has dated the two *Magdalen*s to 1625–26 on the presumption that the first version was commissioned by Artemisia's patron, a possibility that must remain open.[9]

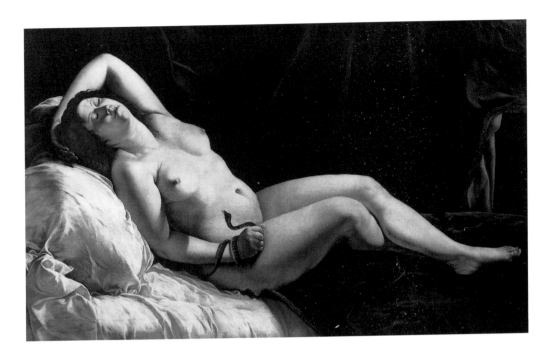

FIGURE 10. Artemisia Gentileschi, *Cleopatra*, ca. 1621–22. Formerly Milan, Amadeo Morandotti.

It is certain that the picture in the Seville cathedral was painted first and that the other version (which I will call the French version) is a replica of its design.[10] The Seville version is softer in its contour lines, more tentative in description, and in most passages appears more directly observed. In the French painting, both the sitter's hair and the shadow on her temple are treated in a slightly more generalized, somewhat stylized, manner (Plates 3, 4). The basic configuration of drapery folds is the same, but every contour is more firmly stated in the French version, sometimes rather mechanically so. A conspicuous difference between the works is the veil that circles the figure's left shoulder, which is much broader in the Spanish picture, completely covering the juncture of arm and breast. Close inspection of the original reveals that the right half of this drapery is an addition to the painting, obvious in its darker color and cruder brushstrokes. In the French version, we see the arm and breast in

specific detail, as if they had been painted from life. Radiography (Fig. 11) has confirmed that under the extra drapery of the Seville picture lies an identically detailed passage, the model for the replica, which was necessarily created before the drapery was added.[11] We can also infer that the replica was made by transferring the main outlines directly from the original, for the contours of the figure are exactly the same size and precisely repeated.[12]

Artemisia's authorship of the French version can be supported in several ways. One is that the replica must have been made directly from the original, and before the drapery over the breast was added to the Seville painting. The additional drapery was most likely a condition of the picture's admission into the cathedral, in accord with the strict decorum enforced by the Spanish Catholic Church. Although the *Magdalen* may not have entered the cathedral until the end of the seventeenth century or later, it would necessarily have remained in Seville in the interval following its arrival in 1626.[13] Yet the replica does not betray the hand of a Sevillian artist.[14] This extrinsic evidence points to a dating before the original composition went to Spain in the mid-1620s — in other words, to Artemisia's own studio.

Intrinsic evidence also points to Artemisia. Most conspicuous are subtle changes in the sitter's physiognomy that result in an entirely different facial type in the second picture: Mary Magdalen here has a slightly rounder face, more pointed nose, more distinctly downturned mouth, and larger eyes. In these deviations from the Seville version, the French saint's face — particularly the enlarged and heavy-lidded eyes, like slit orbs — resembles those of the protagonist of Artemisia's Uffizi *Judith* (see Fig. 8) and *Cleopatra* (see Fig. 10).[15] Such variations are more likely to have been initiated by the author of the original picture than by a copyist. Similarly, the drapery at the upper right is distinctly different in the two versions. The thick and smooth deep burgundy folds of the Seville picture are replaced in the French painting by a thinner and more energetic network of ridges that describe a lighter fabric of salmon and almost greenish hues. As Bissell has noted, such a change is "not the kind of subtle alteration that one would expect in a copyist."[16]

At the same time, X-rays of the two pictures (Figs. 11, 12) reveal significant divergences in the description of form, amounting to two distinct modes of painting.[17] In the Seville version, anatomical forms are built up in sketchy and visible brushstrokes. Lighter passages interact with darker ones in a process of

FIGURE 11. Artemisia Gentileschi, *Mary Magdalene as Melancholy,* ca. 1621–22. Cathedral, Sala del Tesoro, Seville, Spain. X-ray: (a) head, shoulder, and right hand of figure; (b) left hand of figure.

FIGURE 12. Artemisia Gentileschi, *Mary Magdalene as Melancholy*, early 1620s. Private collection. X-ray: (a) head and right hand of figure; (b) left sleeve of figure.

spontaneous mixing and adjustment, to produce the suggestion of structural plasticity in the head and adjacent hand—an effect that is more implicative than descriptive. In the French version, by contrast, brushstrokes are much smaller and tighter. Here volume is achieved by continuous modeling, as in the Renaissance relief mode,[18] which builds steadily from dark at the edges to concentrated light at the near point of rounded volumes. This difference of approach also controls the two ways that the veil over the saint's shoulder is defined. In the Seville

version, lighted edges and folds are evoked only vaguely, by sinuous streaks of varying thickness. In the French painting, a lighted edge, precisely curved and solid, is thrown into relief by the shadow behind it.

To some extent, these differences can be explained by the process of original creation and replication. In Artemisia's Naples *Judith,* a comparable first design for which we also have an X-ray, a similar sketchy and broad-brushed development of the composition is visible.[19] Although fewer *pentimenti* are visible in the Seville picture, its X-rays also disclose ongoing invention, for the earring was added only after the light-shade pattern of the jaw was set.[20] By contrast, when the copy was made, an area of dark was reserved for the earring, now a known part of the picture. It is understandable that an artist who has worked out ideas in the first composition might handle its replication more mechanically. Yet any copyist would have done the same. The question remains, can Artemisia herself have gone about the process of painting two works so differently?

I would answer this question with a cautious yes. On closer inspection of the X-rays, we can see that neither picture is entirely consistent in technique, for each presents a combination of the two modes. In the Seville painting, the dropped hand of the saint (see Fig. 11) is painted far more meticulously than the other hand and head, displaying a relief mode of construction that could easily be mistaken for that of the other picture. Conversely, in the French painting (see Fig. 12), the folds of the white chemise are laid down with slashing, gestural brushstrokes, similar to comparable passages in the other picture. In both paintings, the pleats that descend from the yoke are defined by matchstick-size brushstrokes, parallel though subtly variegated, "buttery," strokes, which are also visible in the Genoese *Lucretia.*[21] In technique the pictures are not incompatible, for each work shows a combination of the two modes, even though one mode dominates in each work. And when the paintings were brought to completion, it is important to note, the differences in technique became far less dramatic.

We can account for Artemisia's combination of modes in the same painting at this time, for on her return to Rome in 1620, following eight years at the Florentine court, she was practiced in both. In her Florentine paintings, Artemisia bent to the prevailing local style, already anachronistic in Rome, which defined forms as inflated, artificially lighted volumes (see Figs. 2, 15). Her second Roman period shows in general a return to the vigorous Caravaggesque tenebrism in which she was early steeped, and to a more fluid and painterly brushstroke. Artemisia did not immediately abandon all remnants of

her saturation in Florentine style, however, for its linear clarity is still visible in, for example, the *Cleopatra,* while other paintings of the 1620s—the Genoese *Lucretia,* the Detroit *Judith*—show a judicious fusion of the two modes. Her alternation between, or combination of, the modes was manifestly less a matter of pure stylistic development than of deliberate choice, perhaps influenced by the tastes of her patrons.

Artemisia's motivation for creating the replica, presumably at the time the duke of Alcalá bought the first version, can easily be surmised. She may have had another prospective buyer, or perhaps she hoped to sell the replica on the strength of the Spanish duke's purchase. In any event, the formal relationship of Artemisia's replica to her Spanish *Magdalen* is approximately the same as that of the Uffizi *Judith* to the Naples version: the composition is essentially the same, though certain details have been changed. Bearing in mind that the Uffizi *Judith* was ordered by Cosimo II, the grand duke of Tuscany, who accepted a composition that replicated an earlier painting by the artist,[22] the analogy suggests that collectors considered Artemisia's second versions of her own works—which stood somewhere between replicas and variations—as desirable as the original versions.

We can reconstruct, if only in a partial and shadowy way, the early history of the picture that found its way to France. This story, which involves another probable Artemisian replica, also indirectly supports Artemisia's authorship of the French *Magdalen.* A recent publication of inventories of art collections in seventeenth-century Naples reveals that a *Magdalen* by Artemisia of 4 × 5 palmi—approximately the same dimensions as our paintings[23]—is mentioned in the inventories of two different Neapolitan collectors. The first was Ettore Capecelatro, marchese di Torella, a lawyer and theorist of feudal law. Capecelatro, who also owned a *Madonna* by Artemisia, acquired his *Magdalen* in the late 1650s (the painting appears in the second inventory of his collection of 1659, but not in the first inventory of 1655). Davide Imperiale, a member of the great Genoese banking family who settled in Naples, also owned a *Magdalen* of 4 × 5 palmi by Artemisia.[24] It is simplest to explain these as one painting, which Imperiale acquired from the Capecelatro estate after the marchese's death in 1659 and still owned at the time of his death in 1672.[25] According to the 1672 inventory, Davide Imperiale owned other works by Artemisia, including two heads, of Christ and the Virgin, and, most intriguing, a *Lucretia* "of the same size" as the *Magdalen.*

Considering that Imperiale's collection had been assembled largely by his Genoese ancestors, it is suggestive that the *Lucretia* by Artemisia in his possession was related to the *Lucretia* that has long been located in Genoa (Plate 5). This relationship is supported by the dimensions and format of the two *Lucretia*s, which were the same, as we can infer from the inventory entry.[26] They cannot have been the same picture, however, for the Genoa *Lucretia* was owned by Pietro Gentile in the early 1620s, and was in 1674 still in Palazzo Gentile, where it was described by Carlo Ratti (as by Orazio). This *Lucretia* later passed to Palazzo Adorno and has remained with the Cattaneo Adorno family until modern times.[27] The *Lucretia* in the collection of the former Genovese Davide Imperiale might therefore be explained as Artemisia's replica of the painting acquired by Pietro Gentile, perhaps painted for Imperiale's father or another member of the family.

Since we know that a *Lucretia* and a *Magdalen* of commensurate size, likely to have been replicas of Artemisia's Gentile *Lucretia* and Alcalá *Magdalen,* both wound up in the hands of Davide Imperiale, we can even surmise that an Imperiale ancestor commissioned them at the same time, soon after the Gentile *Lucretia* came to Genoa. Could Artemisia have visualized the *Lucretia* and *Magdalen* replicas as pendants, a fortuitous linking of two compositions that had separate origins? If reframed to similar proportions, the images would work quite well together, presenting a contrast of active and passive protagonists, with the repeating motif of the chemise slipped over the shoulder to provide continuity. A commission that invited the artist to harmonize the two compositions could also account for the stylistic and physiognomic resemblances of the *Magdalen* and *Lucretia* replicas (to judge the appearance of the latter from the original Genoa painting).[28]

In this scenario, the *Magdalen* replica would have been in the Imperiale collection continuously. Alternatively, the picture could have had an early history entirely different from that of the *Lucretia,* perhaps remaining in the artist's hands until acquired by Ettore Capecelatro in Naples, later to join the *Lucretia* in the collection of Davide Imperiale. The Imperiale *Lucretia* is presently unknown. The Imperiale *Magdalen* is likely to be the picture that went to France, by an undetermined route.[29]

We can thus explain, by a reasonable hypothesis, the existence of and motivation for Artemisia's second version of the *Magdalen* composition. Yet this is

only the beginning of our inquiry. Other questions might be asked. Why, in the second picture, did Artemisia vary her conception of the saint, painting her almost as a different character? That question begs an even larger one: what is the conception of Mary Magdalene presented in the Seville painting? With this securely attributed work as our guide, we now embark on an iconographical adventure, in which expression is a hallmark of identity.

ARTEMISIA AND MARY MAGDALENE

The French and Spanish *Magdalens* do not represent Artemisia's first treatment of this theme. A few years earlier, the artist had produced a painting of the same subject for her Florentine patrons Grand Duke Cosimo II de' Medici and his wife, Maria Maddalena of Austria.[30] The *Penitent Magdalen* in Palazzo Pitti (Fig. 13) was probably ordered to specifications by Maria Maddalena, the deeply religious and ardently penitent grand duchess, who was highly attached to her namesake saint. Maria Maddalena once had herself painted in the guise of the Magdalen, suitably replete with the attributes of penitence and piety (Fig. 14).[31] At the instigation of the grand duchess, the Magdalen's life was celebrated in a decorative cycle in the chapel of the Medici villa at Poggio Imperiale; in a composition performed in the chapel of the Pitti Palace; and in a dialogue performed at the Florentine court, between Mary Magdalene and Martha as exponents of the *vita contemplativa* and *vita attiva*.[32]

Artemisia's first essay on the theme of Mary Magdalene conforms generally to her patron's taste. The saint is presented in a rhetorical pose of spiritual anguish—her eyes turned heavenward, her hand clutching her breast—consistent both with Maria Maddalena's religiosity and with the traditional image of the Magdalen as a "model of zealous devotion," as she was described by Gregory the Great.[33] In her exaggeration of the Magdalen's anxiety, however, Artemisia also signals the spiritual crisis the saint faces in her conversion from sexual sinner to devoted follower of Christ, as she renounces a life of erotic luxury for one of humble service. The inscription on the mirror, OPTIMAM PARTEM ELEGIT, "She chooses the better part," seems to heighten the issue of this choice, though in fact it alludes to another dimension of Mary's identity.

The Magdalen that we know was created out of three different scriptural characters, declared by the sixth century Church to be one and the same.[34] The

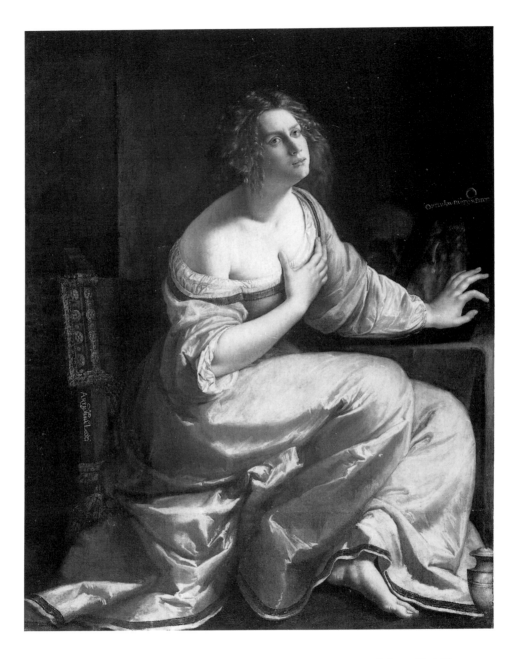

FIGURE 13. Artemisia Gentileschi, *Penitent Magdalen,* ca. 1617–20. Palazzo Pitti, Florence.

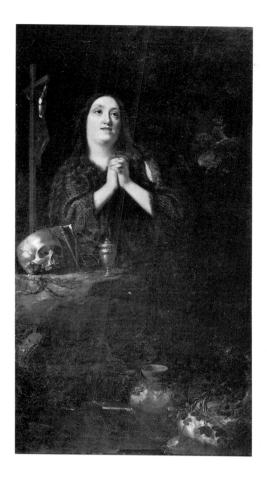

FIGURE 14. Justus Sustermans, *Maria Maddalena of Austria as Mary Magdalene*, 1625–30. Palazzo Pitti, Florence.

first is the Mary Magdalene described in all four Gospels, the beloved disciple of Jesus, witness of the Crucifixion, and the first to see Christ after his Resurrection. In the Middle Ages, Mary Magdalene was merged with Mary of Bethany, sister of Martha and Lazarus. Both these Marys had immaculate reputations; neither is characterized by sexual indiscretion. But they were conflated with a third figure, the repentant sinner described by Luke, who came to Jesus in the Pharisee's house to wash and anoint his feet. Christ forgave this woman her sins, as he forgave the Samaritan woman, whose shadowy identity also accrued

to Luke's repentant whore. Mary Magdalene as sexual sinner came to dominate this tripartite identity.

In the Pitti painting, Artemisia presents the composite Mary Magdalene, former prostitute and sister of Martha. The inscription on the mirror alludes to her superiority over the domestic Martha, who was eager to serve Christ as a guest in her household, for Christ said that Mary chose the "better" path of thoughtful meditation on his words. The polarization of these sisters into types in the early Middle Ages positioned Mary on the meditative and spiritual side of life, Martha on the practical and material side—the inner life versus the outer.[35] Unusual for a female saint, Mary was sanctioned for her mental or, we might even say, intellectual activity, but this slim window of feminist opportunity was in fact rarely opened. Even Artemisia here passes up the chance to give Mary Magdalene her intellectual due, stressing instead the lingering traces of the life of erotic indulgence that the penitent saint is supposed to have put behind her —the fine clothing, the elegant, luxurious coiffure, the ornately gilded chair, the sensuously long, delicate fingers.

As it happens, these features also project the refined taste of the Medici court, an ambience of sophistication and displayed wealth. Writing on this painting some eight years ago, I noted the tension between the saint's restive anxiety and her grand accoutrements and observed that "she seems restlessly trapped in a luxury she lacks the will to renounce."[36] I did not pursue the implications of this remark, however, and I postulated that Artemisia did not at this time identify with the figure of the Magdalen.

I now think otherwise. Both Artemisia and Mary Magdalene were stigmatized as sexually promiscuous—in both cases on trumped-up evidence—and both had reputations as "sinful" women. In 1613, following the highly publicized rape trial, Artemisia had entered an arranged marriage and moved to Florence, no doubt to escape her Roman notoriety.[37] The Pitti *Magdalen,* whose theme was probably assigned to the artist, seems mired in an iconography that stigmatizes female sexuality, for its juxtaposed skull and mirror image of the Magdalen's refined profile emphasize the association with Luxuria and Vanitas, linked types that merge female erotic beauty with transience and mortality.[38] Moreover, *luxuria* could be thought of as not only sexual sin but also the comforts of wealthy patronage. The artist's years in Florence were marked by unusual privilege but also by stressful financial worries; Artemisia was frequently in litigation over debts, incurred mostly by her husband.[39] One can imagine that

she might have identified both with her troubled character's desire to escape the confinement of a luxury she found restrictive and stifling, and, perhaps, with the Magdalen's yearning to move on to a higher spiritual plane.

The inference that Artemisia longed to break out of her gilded box is supported by her departure from the Florentine court not long after painting the Pitti *Magdalen*. She left in 1620, explaining to her patron that she needed to take a short break from her troubles and rejoin her friends in Rome.[40] There Artemisia's style gradually shook off its Florentine late *maniera* affectations and took a different course—as we see in paintings such as the *Jael and Sisera* (see Fig. 37) and *Lucretia*—reacquiring much of the brusque directness and Caravaggesque virility of her first Roman period. Inserting the Seville *Magdalen* into this group of works sharpens one's sense that the artist has redefined both her art and her depicted character.

This saint has distinctly escaped luxury. Her cheeks are no longer rouged; her hair falls in broad locks, not oiled ringlets. Her clothing has been stripped down to a plain chemise and a simple and inelegant dress, the sumptuous gold replaced by a rougher russet. She sits in a plain wooden chair, locked in a pose of closed self-absorption. The chemise slips off her shoulder to reveal, not décolletage, but the wrinkle of a solid natural underarm. Anticipating the modern tendency to interpret any visible portion of a breast as sexually provocative, I would argue that this slipped chemise and partially exposed breast indeed refer to the Magdalen's erotic past, yet not as sinner but as sexually abused woman. She has clearly not arranged herself to titillate; rather, her disheveled appearance is one of those trace elements—a pure Peircian index[41]—that points to what has come before. It is a vestige of her rough sexual handling by men, a signifier of her consequent abject, debased state. Artemisia presented the raped Lucretia as disgracefully abused through the same device (Plate 5). The Pitti *Magdalen*'s chemise falls off the shoulder, too, but since the figure is generally more decorous, it does not function strongly here as a sign of her degradation. The fact that her second *Magdalen* is conspicuously not eroticized—more precisely, she is de-eroticized—tells us what Artemisia was now careful to avoid.

The Magdalen created by Gentileschi represents a deliberate choice from a pool of possible types, within which the most prominent were the openly erotic and the chastely penitent—seeming polarities that were also often combined. In Venice, where Mary Magdalene was in particular favor, she was often

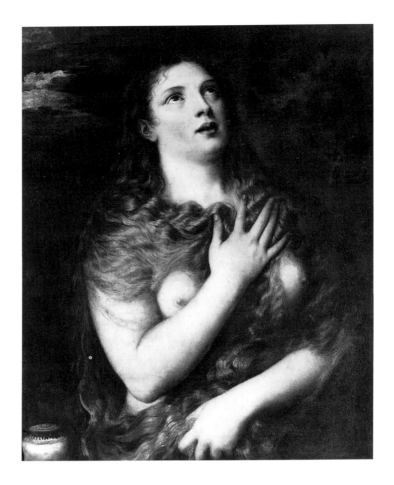

FIGURE 15. Titian, *Penitent Magdalen,* 1530s. Palazzo Pitti, Florence.

imaged as a glamorous prostitute, as in Titian's golden-haired beauty of the 1530s (Fig. 15), the prime example of the Magdalen of sensuous delight, described by Heinrich Wölfflin as "bella peccatrice e non penitente."[42] This interpretive turn was supported by the increasing emphasis upon erotic imagery in sixteenth-century Venetian art, and also by lofty argumentation. Following Neoplatonic theory, the Renaissance Magdalen was frequently described as a goddess of Love and apostrophized as Venus, on the learned but dubious analogy of Venus in her earthly and celestial aspects with the Magdalen's rise from sexual love with men to spiritual love for Christ.[43] By the later sixteenth

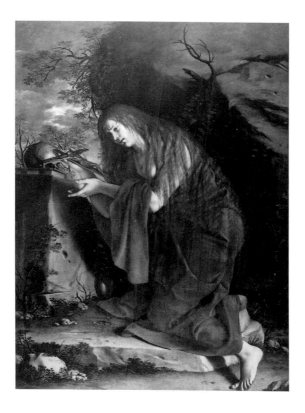

FIGURE 16. Orazio Gentileschi, *Penitent Magdalen,*
1605. Fabbriano, S. Maria Maddalena.

century, Titian's voluptuous and luxurious figure had become the prototype
for countless nude and erotic Magdalens.[44]

Following the Council of Trent, the Church sought to detach the Magdalen
from her widespread association with prostitutes and adultery, redefining her as
a model of penitence and chastity. Theologians especially chastised those artists
who depicted Mary Magdalene as ornamented and decorated, more courtesan
than saint.[45] As a prominent repentant sinner, Mary Magdalene became an im-
portant symbol of the sacrament of penance (not recognized as a sacrament
by Luther and the reformers) and the prime exemplum of conversion to the
Faith, desired for Protestants and other infidels.[46] The saint was now typically
shown as a penitent hermit in her grotto, as in Orazio Gentileschi's *Magdalen* at
Fabbriano, painted in 1605 (Fig. 16). She meditates tearfully on her sins, gazing

FIGURE 17. Attributed to Valerio Marucelli, *Saint Mary Magdalene in the Desert,* 1609. Palazzo Pitti, Florence.

at the crucifix and skull that recall the futility of past vanities, her long hair evoking the haircloth of penance.[47] Yet eroticized images of the Magdalen persisted well into the era of the Counter-Reformation, and there continued to be a market and a taste for them, as an example by one of Artemisia's Florentine colleagues demonstrates (Fig. 17).[48]

THE EXAMPLE OF CARAVAGGIO

In her second depiction of the Magdalen in the Seville painting, Artemisia conspicuously avoided reproducing either her own luxurious saint or the tearful penitent painted by her father. Her radically simplified recasting of the character bespeaks instead the renewed influence of Caravaggio, whose four versions of the Magdalen theme strongly reflect Counter-Reformation ideals. Caravaggio's *Magdalen*s, produced while Artemisia was a young girl during her first years in Rome, undoubtedly made a lasting impression. They could have

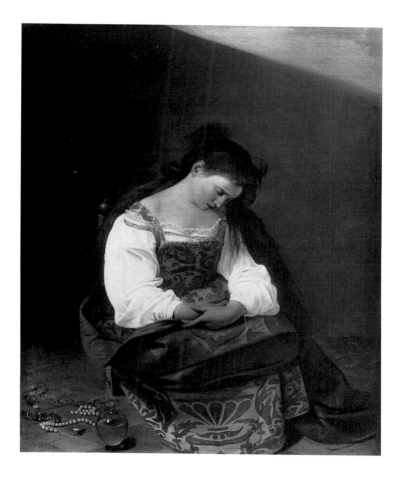

FIGURE 18. Caravaggio, *Repentant Magdalen,* ca. 1596–97. Galleria
Doria-Pamphilj, Rome.

become newly relevant to her life when she returned to Rome in maturity.
Caravaggio's *Magdalen* of about 1596–97 in the Doria-Pamphilj Gallery,
Rome (Fig. 18), presents the repentant saint seated humbly on a low chair, her
eyes cast down—physical expressions of penance, buttressed by its conven-
tional symbol, the ointment jar. There is no sign of the young woman's past
life as a harlot, only her rejection of vanity, hinted in the cast-aside jewelry.
She might be, as Bellori described her, "a girl drying her hair . . . pretending
that she is the Magdalen."[49]

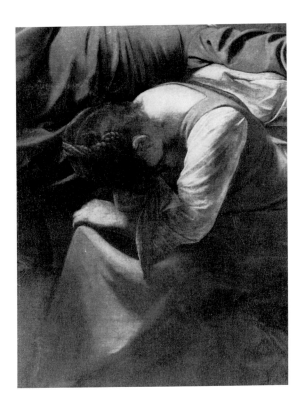

FIGURE 19. Caravaggio, *Death of the Virgin,* 1601–2.
Detail of Magdalen. Musée du Louvre, Paris.

The idea that a young girl might identify with the Magdalen is not far-fetched, for over the centuries Mary Magdalene has been unusually popular among women, perhaps because she seems more human than the impossibly perfect Mary or the preternaturally sinful Eve.[50] Her narrative, fictional though it is, has components that living women can recognize, such as remorse over the consequences of sexual misadventure. The prominent and rare inclusion of the Magdalen in Caravaggio's *Death of the Virgin* of 1601–2 (Fig. 19), as Pamela Askew has shown, was motivated by such real-life occurrences. The painting was commissioned for the Church of S. M. della Scala and its sister institution, the Casa Pia, a social order founded by Carlo Borromeo that sheltered reformed prostitutes *(convertite)* and female refugees from bad marriages *(malmaritate).*[51]

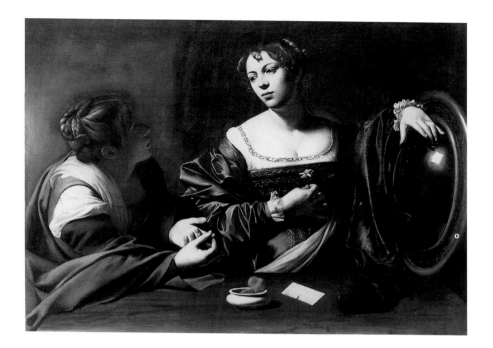

FIGURE 20. Caravaggio, *Conversion of the Magdalen,* ca. 1598. Detroit Institute of
Arts. Gift of the Kresge Foundation and Mrs. Edsel B. Ford.

The Magdalen at the bottom of this painting, the most accessible figure in the
image, was obviously relevant to the lives of the women of the Casa Pia, sym-
bolizing the possibility of redemption and the forgiveness of sexual sins.

Caravaggio's *Magdalens* may have resonated for Artemisia too, because they
consistently offer dignified and serious alternatives to the erotic type. The *Con-
version of the Magdalen* in Detroit, of about 1598 (Fig. 20), presents Mary at
the moment when she renounces past vanities and assumes her new life in
mystic union with Christ. She is seen choosing the "better part," the realm of
ethereal introspection, against Martha's earnest, down-to-earth argumentation.
As Maurizio Calvesi has pointed out, the mirror, with its verbal cognates of
"reflection" and "speculation," is a potent sign of the contemplative life, and
also of divine Wisdom, with which Mary Magdalene was linked in the Early
Christian period.[52] In her Seville *Magdalen,* Artemisia does not dramatize
the mirror's role as a vehicle of introspection—it rests flat on the table, reflect-

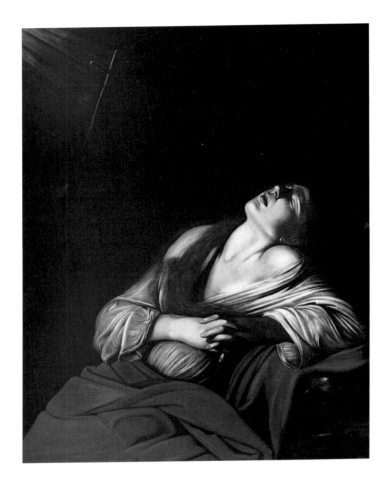

FIGURE 21.　Louis Finson, copy of Caravaggio's lost *Magdalen in Ecstasy* of 1606. Musée des Beaux-Arts, Marseilles.

ing nothing—but she has at least eliminated the allusion to vanity that is hinted in the mirror reflection of her first *Magdalen,* perhaps on the strength of Caravaggio's example.

Caravaggio's fourth image of the Magdalen, painted in 1606 and believed to be lost, is known from copies by a Caravaggio follower, Louis Finson (Fig. 21).[53] The painting showed the saint in the ecstatic trance into which, according to the *Golden Legend,* she regularly fell after her daily elevation into heaven.

Situated in a black void, her head thrown back, her sightless eyes rolled back, the Magdalen is here presented as painfully anguished, recalling, as Howard Hibbard suggested, the "dark night of the soul" of Saint John of the Cross.[54] Tears stream down her cheeks. In this image Caravaggio's interpretation is consistent with the saint's stereotyped feminine identity, for grieving is a woman's job, and weeping was the Magdalen's characteristic emotional state, whether as penitent sinner or as mourner for Christ or the world in general. (The English word "maudlin," meaning "tearfully or weakly emotional," is a corruption of the Magdalen's name.) As an agonistic visionary, Mary Magdalene served as an exemplum for many female mystics—Catherine of Siena, Margery Kempe, and Teresa of Avila, among others—who followed the Magdalen in producing their own copious tears, which in the case of Dorothy of Montau were shed up to ten hours a day.[55] Yet women's tears held little cultural cachet. Michelangelo's famous disparagement of Flemish painting because it appealed to women and caused the devout to weep speaks volumes about artistic and gender hierarchies.[56]

The Magadalen in Gentileschi's painting is close to Caravaggio's prototypes in her solitude, her contemplative self-absorption, and her inner direction. She draws something from each of them—from the Doria and Louvre pictures, the slumped pose; from the Detroit painting, the meditative dignity, the hint of the visionary in the nearly closed eyes. But unlike Caravaggio's Marys, and despite her ointment jar, the Gentileschi Magdalen is not penitent. One sign that Artemisia passed up an opportunity to stress penitence is the particular form of the saint's chair. As Barry Wind has shown, the low seats occupied by Caravaggio's Magdalen in the Doria and Louvre paintings were meant to convey humility, which is one of the conditions of penitence.[57] In contrast, Artemisia's chair is assertive; high-backed and with arms, it is a type associated with persons of stature. Undoubtedly, this deviation from Caravaggio's well-known models was deliberate and carefully calibrated.

Artemisia's Magdalen departs from Caravaggio's Doria example in another important respect, for unlike the young Doria Magdalen with a sparkling tear on her cheek, she does not weep. Her red and swollen eyes imply that she has been grieving, but they now are partly open, with a fixed stare (more pronounced in the French version; see Plates 3, 4). The image of a figure in transition, opening eyes swollen from crying, is a master stroke, and though the

maestra was prepared to depart from Caravaggio for her own purposes, this particular device must have been inspired by the maestro's way of embedding visual traces of previous states. (In the Detroit picture, for example, Mary's dress is elegant and her hair finely coiffed; in combination with her meditative face, these details suggest the inner transformation of a woman who had dressed that morning in finery, under the old set of values.)

Artemisia similarly uses the Peircian indexical sign to include the character's past and future—in this case to suggest that the Magdalen is coming out of her grief, that now she *sees*. It is a tenet of Christian spirituality that contemplation is followed by revelation, the gift of insight and understanding. The principle of "contemplation inspired by grief and its concomitant *revelatio*" was, according to Askew, articulated by Saint Francis of Sales and embodied in the contemplative ideal of the Carmelite order.[58] What, precisely, is revealed to Artemisia's Magdalen is a point to which I will return. But let us first discover how the figure's posture colludes in this expressive formulation, as we examine a set of even more closely related prototypes.

THE EXAMPLE OF MICHELANGELO

We must step back in time, though not in space, to collect the images that directly motivated Artemisia's somewhat curious composition of a Magdalen who rests her head on an awkwardly turned wrist. The picture was designed at the end of Gentileschi's six-year sojourn in Florence, a city in which the artist had every occasion to saturate herself in the example of Michelangelo. At Casa Buonarroti, she had contributed to a decorative cycle created in homage to Florence's favorite artistic son, and the Tuscan city offered numerous examples to extend her knowledge of the exalted master's work and the aura of his growing legend.[59] It therefore comes as no surprise that a Michelangelesque model stands behind Artemisia's *Magdalen*.

The strangely bent wrist supporting an apparently sleeping head comes from a mid-sixteenth-century etching by the French artist Léon Davent (Fig. 22), whose inscription identifies its subject as "the great Florentine sculptor Michelangelo at the age of twenty-three."[60] Michelangelo's pose—head resting on hand, with closed eyes—is intended to establish the artist as a melancholic visionary. Davent followed the example of an early-sixteenth-century

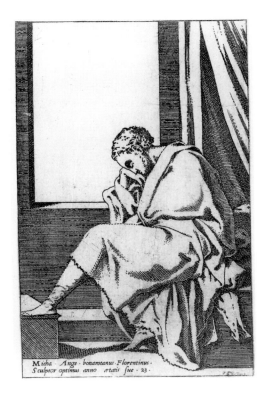

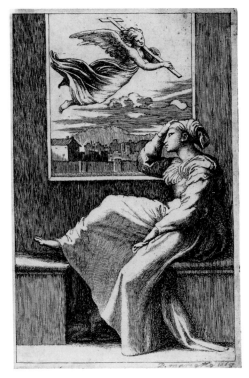

FIGURE 22. Léon Davent, *Michelangelo at the Age of Twenty-three,* etching, mid–sixteenth century. British Museum, London.

FIGURE 23. Marcantonio Raimondi, *Saint Helena,* engraving, early sixteenth century. Metropolitan Museum of Art, New York.

print by Marcantonio Raimondi (Fig. 23), which presents Saint Helena, mother of Constantine, and her visionary dream of an angel carrying the true cross.[61] The use of this pose for a visionary figure was common in the cinquecento, as we see in an engraving of 1561, the *Revelation of Saint John Evangelist* by the French artist Jean Duvet (Fig. 24).[62] But in its earlier history, the "cheek on the hand" conjoined the visionary saint and the melancholic artist; it was a conventional formula for mourning and melancholy in fourteenth-century Provençal poetry, in Petrarch, and in images such as a miniature by Walther von der Vogelweide (Fig. 25), where the melancholic pose is given to a meditative poet.[63]

FIGURE 24. Jean Duvet, *Revelation of Saint John Evangelist,* engraving, 1561. National Gallery of Art, Washington, D.C.

The linking of melancholy with artistic creativity was a major project of the early cinquecento. The large cloak enveloping Michelangelo in Davent's print further identifies him as a "child of Saturn," the melancholic god, who was depicted in antiquity in such a garment.[64] A related print by Marcantonio (Fig. 26) shows the artist Raphael similarly swaddled in a large mantle, his palette and paint pots on one side and on the other, a blank canvas propped on a ledge. Like Michelangelo's open window, the empty canvas expresses the idea of the tabula rasa, the pure potential of the artist's imagination.[65] The pose of the sleeping Michelangelo also invokes the artist's own figure of *Night* in the Medici Chapel (Fig. 27). Noting this echo in Davent's print, David Summers suggested

FIGURE 25. Walther von der Vogelweide, miniature from
the "Grosse Heidelberger Liederhandschrift," early fourteenth
century. Heidelberg, Universitätsbibliothek, Codex Palatinus
germanicus 848, 124r.

that the image was given a feminine gestalt appropriate for the creative artist
as visionary dreamer, who "gives birth to forms" in the dark night that is the
"matrix of inspiration" for the Saturnine temperament.[66]

These concepts were given female form in another famous example,
Albrecht Dürer's *Melencolia I* engraving of 1514 (Fig. 28). It was Dürer's image

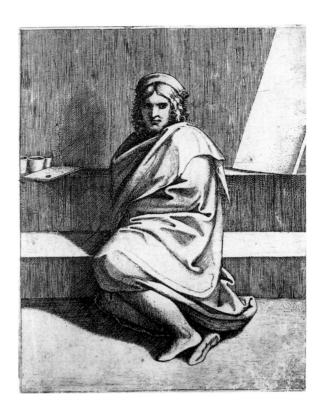

FIGURE 26. Marcantonio Raimondi, *Raphael Sanzio of Urbino*, engraving, sixteenth century. Graphische Sammlung Albertina, Vienna.

of Melancholy, paralyzed and frustrated by her superabundant intellectual labors, that crystallized the Renaissance elevation of the melancholic temperament to the noble status now associated with artistic creativity.[67] Dürer, in turn, had drawn his ideas from an informed understanding of new concepts in Italian art. The philosopher Marsilio Ficino had established creative melancholia as a highly positive and desirable, though volatile, state—one in which the artist was capable of both rare achievement and creative inertia.[68] In the Sistine ceiling, Michelangelo presented himself in the person of the brooding prophet Jeremiah, a self-identification understood immediately by Raphael, whose *School of Athens* includes a visual reference to Michelangelo as creative

FIGURE 27. Michelangelo, *Notte,* 1519–33. Tomb of Giuliano de' Medici, Medici Chapel, Florence.

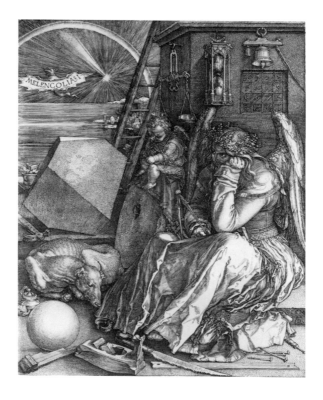

FIGURE 28. Albrecht Dürer, *Melencolia I,* engraving, 1514. National Gallery of Art, Washington, D.C.

FIGURE 29. Paolo Veronese, *Saint Helena*,
1570s. National Gallery, London.

melancholic in the figure of Heraclitus. Such early-sixteenth-century claims
for Saturnine melancholy as a higher (if emotionally plagued) level of creative
activity distinguished the intellectual artist from the mere craftsman, thus
helping contemporaneous artists in their campaign to elevate painting and
sculpture from crafts to liberal arts.[69]

Artemisia's *Magdalen* is an image deeply imbued with these associations,
linked with the melancholic Michelangelo and his *Notte* by the inclined head
resting on a hand crooked at the wrist. Her lower body, the hand dropped
between open legs, is drawn from Marcantonio's *Saint Helena* or perhaps from
a painting based on it by Paolo Veronese, a *Saint Helena* now in the National
Gallery, London (Fig. 29), which replicates the woman at the angle of a win-

dow, her head resting on one hand, the other hand dropped between diagonally arranged legs.[70] Artemisia must therefore have known both prototypes—the Michelangelo image that expresses the theme of noble melancholic artistic creativity and the Marcantonio/Veronese image that gives it feminine form. These connections establish the Magdalen as an alter ego of the artist. She too is a visionary dreamer whose imagination, like that of the great Michelangelo, generates ideas in the dark night that is by tradition feminine. The dark empty space above her head suggestively recalls the tabula rasa of the artist's mind upon which images and visions will be projected.

ARTEMISIA AS THE ALLEGORY OF PAINTING

That Artemisia's *Magdalen* intentionally invokes the idea of the creative artist is confirmed by an image the painter must also have known. A fresco of 1620–23 by Fabrizio Boschi in the former Casino Mediceo in Florence (Fig. 30) presents the allegory of painting, Pittura, as sleeping, to be awakened by the patron Cosimo II de' Medici.[71] This image packages the theme of artistic inspiration in the iconographically conventional form of a female who holds palette and brushes, wears the medallion of imitation, and is shown with her mouth bound, to invoke the simile of painting as silent poetry.[72] Boschi's allegorical figure of painting as a sleeping female who awakens to creative inspiration, visually modeled on Michelangelo's *Notte,* was a highly relevant model for Artemisia's *Magdalen,* providing a link between masculine and feminine figures of artistic creativity. Since Gentileschi and Boschi belonged to the same small circle of artists who worked for the grand duke in Florence, she could have seen this painting at its inception in Florence, and she may have discussed with Boschi its formal origins in the Michelangelesque imagery of melancholy.[73]

At this time, Artemisia did not choose to depict herself directly as Pittura, though she would do so later, in her Kensington Palace *Self-Portrait* (see Fig. 42), which was probably painted in 1630.[74] Yet there is evidence that the young female painter had already been identified with the allegory of painting during her Florentine period. An oval picture that has recently surfaced (Fig. 31) presents a young woman in the act of painting whose features strongly resemble Artemisia's, as seen in the Jérôme David engraving of the later 1620s (Fig. 32). Around her neck is a golden chain suspending an enlarged mask, the mask of

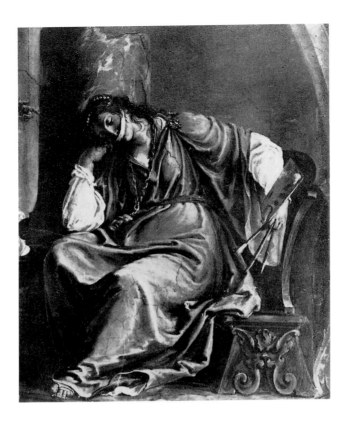

FIGURE 30. Fabrizio Boschi, *The Allegory of Painting Awak-ened by Grand Duke Cosimo II de' Medici,* fresco, 1620–23. Corte d'Appello (formerly Casino Mediceo), Florence.

imitation that is an attribute of the allegory of painting.[75] Although this picture has been ascribed to Artemisia herself, it may instead be a portrait of her by another member of the Casa Buonarroti group.[76] The painting nevertheless offers an early instance of Gentileschi's identification with the art of painting, helping to establish the iconographic framework for her own later *Self-Portrait as the Allegory of Painting,* in which the attributes are more fully deployed.

The David portrait engraving now takes its place within this framework. This image, according to the engraver's inscription, was based upon a self-portrait, but its model is no longer known.[77] The most distinctive feature of the portrait,

faithfully preserved by the engraver, is the artist's flamboyantly unkempt and unruly hair. Hair that is unruly (literally, not subject to rule) effectively represents Artemisia's ferocious independence. It signifies more than that, however, for according to Cesare Ripa, the unruly locks of Pittura symbolize the divine frenzy of the artistic temperament, thus making central to this self-image the concept of artistic inspiration. That concept may also have been evoked in the Florentine portrait, but it is now more conspicuously developed, in a form that parallels the sleeping, hand-to-cheek pose of Melancholy embedded in the *Magdalen*. In both forms, Artemisia claims an exalted identity, placing herself by implication among the creative geniuses of artistic expression.

The references to Pittura's unruly locks were perhaps initially prompted by the natural bushiness of Artemisia's own hair—something unknowable since we have no verifiably accurate images of her.[78] Artemisia's conceptual starting point, however, was probably the image of Pittura on the verso of the portrait medal struck in honor of the artist Lavinia Fontana in 1611, a female figure with wildly flowing locks. This medal, with its profile portrait of Fontana on the obverse, already hints at conflating the identities of female artist and female allegory, as I have previously noted,[79] but we are now in a position to see that Artemisia built frequently and steadily upon that theme, capitalizing upon a visual metaphor uniquely available to a female painter to situate herself firmly in a masculine construct of creative inspiration.

The legend on the oval frame that surrounds the image of Artemisia in David's engraving describes her as a "most famous Roman female painter *[pittrice]*, an academician of the Desiosi." [80] Alexandra Lapierre identified this as the Accademia dei Desiosi, founded in 1625–26 in Rome, noting its members' support of Galileo to explain the otherwise curious inclusion among these men of Gentileschi, who could barely read and write. Lapierre suggests that Galileo may have recommended Artemisia for some sort of honorary membership on the strength of their friendship formed in Florence.[81] Bissell, however, has more convincingly identified the Accademia dei Desiosi as an institution of the same name in Venice, a more shadowy academy, documented only in a citation of 1629, that seems to have identified itself with the fine arts; its members included Gianfrancesco Loredan and Pietro Michiele, two men who are connected with Gentileschi through their literary activities.[82] David's engraving of about 1628 commemorating Artemisia's membership in the Venetian academy could have

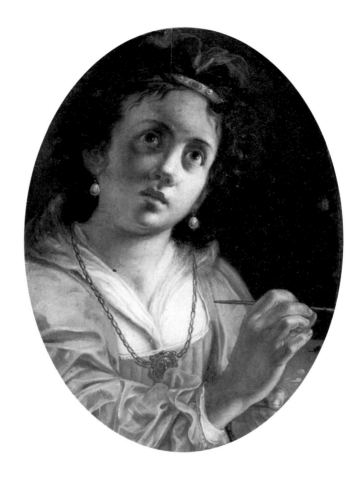

FIGURE 31. Florentine artist (G. B. Guidoni?), *Portrait of Artemisia Gentileschi as the Allegory of Painting*, 1614–20. Private collection.

been based on a self-portrait painted in Venice in 1626–28 or, alternatively, upon one painted in the early to mid-1620s in Rome.

Below the frame in David's engraving, an inscription further defines Artemisia, by way of a quotation from Pliny, as "a marvel in [the art of] painting, more easily envied than imitated."[83] This inscription attests her celebrity in a somewhat darker key. To call Artemisia a "marvel" in painting hints at her exceptionality as a female, a little like applauding the dog who can walk on its hind legs.[84] When applied to Artemisia, the Pliny quotation evokes detractors

FIGURE 32. Jérôme David, *Portrait Engraving of Artemisia Gentileschi*, ca. 1628. British Museum, London.

who resented the exaggerated attention she received as a woman artist and begrudged her a status seemingly acquired with little effort, not to mention her audacious self-identification with the lofty Pittura. It also suggests her unsuitability as an artistic model for other painters. For what male artist could or would want to emulate a woman artist who insinuated herself into her female characters or—if that escaped notice—who presented herself as the allegory of painting?

The quotation suggests that this artist was too idiosyncratic to count as an example. Its application to Artemisia was, in a sinister way, far more apt than the Plinian characterization of a successful male artist, for it defined her simultaneously as famous for being famous and hors de combat. To call Artemisia "a marvel in painting, more easily envied than imitated" was in effect to qualify the image of self-confidence and aesthetic nobility so boldly proclaimed in the lost self-portrait and to establish her separateness from the traditions to which she insistently claimed access.

Nevertheless, Artemisia's self-identification with Pittura survived and apparently even flourished. In the context of the works here discussed, it seems quite likely that the portrait of a woman artist (Fig. 33; formerly Palazzo Corsini, now Palazzo Barberini) represents Artemisia as Pittura. Though probably not a self-portrait,[85] the Corsini/Barberini image undoubtedly draws on an existing identification between the female artist and the allegory that had been fostered, if not constructed, by Artemisia herself. Artemisia certainly produced other images of Pittura with her own features. In 1637 the duke of Alcalá owned two portraits of Artemisia, which were most likely self-portraits. Although the *Self-Portrait as the Allegory of Painting* of 1630, now in England, has been identified with the self-portrait for Cassiano dal Pozzo, it was conceivably instead one of Alcalá's self-portraits, considering the probable origin of the London *Self-Portrait* at the viceregal court in Naples. In addition to the *Self-Portrait,* Charles I owned yet another "Pintura" by Artemisia, one whose inventory name implies a Spanish origin and whose face—we may now claim with confidence—was probably hers.[86]

In the light of this collection of images of Artemisia as Pittura, it seems to me more than possible that Velázquez's *Woman as a Sibyl* in the Prado (Fig. 34), which has been dated to his Italian journey of 1630, represents neither a sibyl nor the Spanish artist's wife, two standing and problematic proposals, but instead Artemisia as Pittura, painted late in 1630 when both artists were working at the Neapolitan court. I have previously argued that Velázquez may have taken Artemisia's *Self-Portrait as the Allegory of Painting* as a point of departure for amplifying in *Las Meninas* the theme of painting as an inherently noble act.[87] The Prado portrait may provide another instance of the two artists' association in Naples. In this relatively sober and restrained image, loose and flowing locks of hair frame the woman's face, as in her self-portrait, while the pearl necklace

FIGURE 33. Unknown artist, *Portrait of Artemisia Gentileschi as Pittura,* ca. 1630? Galleria Nazionale d'Arte Antica, Palazzo Barberini, Rome.

echoes that in the David engraving. The rectangular object she holds is, surely, not a sibyl's tablet, which in this period usually bore cryptic markings, but the tabula rasa, or empty canvas, that forms the back plane of Artemisia's *Self-Portrait* and was, according to the treatise of Vincenzo Carducho, the emblem of the art of painting (Fig. 35).[88]

The Seville *Magdalen,* painted at the beginning of the decade that saw the steady shaping of Artemisia's identification with Pittura, also expresses the painter's self-defined association with artistic creativity. Here Artemisia casts this theme

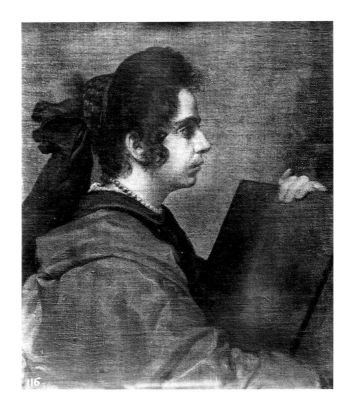

FIGURE 34. Diego Velázquez, *A Woman as a Sibyl (Artemisia Gentileschi as Pittura?)*, 1630–32. Museo del Prado, Madrid.

less personally by embedding creative melancholy in a female biblical figure, Mary Magdalene, whose long flowing locks are her conventional attribute. The *Magdalen* is not overtly a self-portrait, yet the saint's facial features distinctly resemble Artemisia's own, particularly as we see them in the David engraving and the Corsini/Barberini *Pittura* (Figs. 32, 33). This hint of an intimate connection between the Seville *Magdalen* and the artist herself is underlined by the departure of the French *Magdalen* from this physiognomy. Indeed, in changing the facial type, Artemisia suggests that her private identification with her icon of artistic creativity belonged to the moment of the figure's invention.

En la que tabla rasa tanto excede,
que uce todas las cosas en potencia,
solo el pincel con soberana ciencia,
reducir la potencia al acto puede.

FIGURE 35. Vincenzo Carducho, engraved end-piece
to *Diálogos de la Pintura* (Madrid, 1633).

In any event, this identification remains relatively hidden in the Seville *Magdalen*. It surfaces only when we situate the picture among the Pitturas and recognize the coded semiotic reference to the theme of creative melancholy. Although such reconstruction may be essential for modern recognition of the allusion, Artemisia's choice of Mary Magdalene as an alter ego through whom this theme could be expressed was grounded in seventeenth-century thought. The saint had long been associated with contemplation,[89] and she may already have been linked with melancholy as well. Certain contemporary images of the melancholic Magdalen and related figures will further help to situate Artemisia's *Magdalen* in its intellectual context.

THE MAGDALEN AS MELANCHOLY

When the young Guercino (Giovanni Francesco Barbieri) was called to Rome in 1621 to work for the new pope, Gregory XV, the former Cardinal Alessandro Ludovisi, one of his first assignments was to collaborate with Agostino Tassi in painting large decorative cycles in two rooms of the Casino Ludovisi. The frescoes were completed in the fall of 1621. On the ceiling of the room on the lower level, the Sala dell'Aurora, is Guercino's famous *Aurora*. Below, on the wall, two lunettes establish the times of day bridged by the goddess of dawn. In *Notte* (Fig. 36) Guercino depicted the allegorical figure of night in the head-on-hand pose that evokes Ripa's models of Melancholy and Meditation—appropriate to the goddess of sleep and death[90]—in a form that closely resembles Artemisia's Seville *Magdalen*. The relationship is confirmed in Guercino's repetition of Artemisia's configuration of drapery sleeves and the dropping of the hand between the legs.

Guercino would appear to have derived his *Notte* from Artemisia's figure of the Magdalen, and not vice versa, because the Magdalen's bent wrist can only have come from Michelangelo's example, while the position of her hand between her legs is closer to that of Marcantonio/Veronese than is Guercino's. This somewhat surprising direction of influence would, among other things, establish a 1621 date for the *Magdalen*. I would not press the point, since it is possible that Guercino and Gentileschi drew independently upon the same set of sources, but even that would suggest personal contact between the artists.

Other reciprocal echoes in the art of Artemisia and Guercino indicate that the two young painters were aware of each other's work during Guercino's brief Roman sojourn. from 1621 to 1623. For example, the composition of Guercino's *Jael and Sisera,* painted around 1619–20, a lost work recorded in copies (Fig. 37), is more closely related to Artemisia's *Jael and Sisera* of 1620 (Fig. 38) than is either painting to a picture by Lodovico Cigoli of about 1595–96 that has been proposed as Artemisia's model.[91] Guercino's brief uncharacteristic deviation into unglamorous and awkwardly naturalistic Venuses about 1622–25 could have been inspired by Artemisian nudes such as the *Cleopatra* and *Lucretia*.[92] And, as we will see in the next chapter, the two painters may even have collaborated.

FIGURE 36. Guercino, *Notte,* fresco, 1621. Rome, Villa Ludovisi.

Implied in the connection between Guercino's *Notte* and Artemisia's *Magdalen* is the general understanding of iconographic relationships between Melancholy, Night, and the Magdalen. Beyond Artemisia's visual prototype, the relevant iconography is also to be found in the picture usually taken as Guercino's inspiration: Domenico Fetti's allegorical *Melancholia* (or *Meditation*) of about 1618 (Fig. 39), which Guercino would have seen on his trip to Mantua in 1620.[93] Fetti's Melancholy, shown kneeling in a wilderness and contemplating a skull, surrounded by emblems of the liberal arts, implicitly fuses the attributes of Magdalen and Melancholy, suggesting that the types may already have been linked before Artemisia painted her *Magdalen.*[94] Certainly, the penitent Mary Magdalene and the personification of melancholy were iconographically associated by the mid–seventeenth century, as we see in the print *Melancholy, or Meditation* by Giovanni Battista Castiglione of about 1645–46 (Fig. 40), which presents a hybrid of the saint and the personification.[95] In the sparse commentary that exists on this iconographic parallel, however, Melancholy and the Magdalen are assumed to be connected through the shared concept of *vanitas,* not that of visionary inspiration.[96]

FIGURE 37. Photograph of lost copy of Guercino's lost *Jael and Sisera* of ca. 1619–20. Fondazione Giorgio Cini, Venice.

Artemisia's *Magdalen as Melancholy,* as we should now begin to call the painting, may thus have played a pivotal role in establishing a parallel between Mary Magdalene and *creative* melancholy, particularly considering that the logical foundation of this plane of association returns us to the Florentine matrix. For it is in the Medici Chapel that we find paradigmatic expression of the polarity of contemplative versus active that was consistently applied to Mary and Martha. Michelangelo cast the figure of Lorenzo de' Medici, "*il pensieroso,*" as the melancholic and contemplative Saturnine type by using the hand-to-cheek gesture (Fig. 41). Duke Giuliano, by contrast, was shown in a vigorous turning pose, to represent the active life.[97]

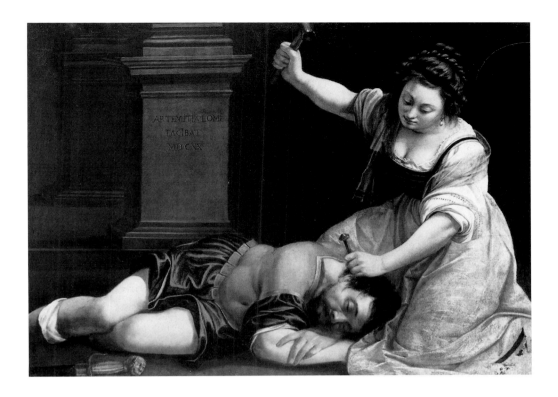

FIGURE 38. Artemisia Gentileschi, *Jael and Sisera*, 1620. Szépmüvészeti Museum, Budapest.

 Like the contemplative Lorenzo, Artemisia's Magdalen is identified by pose
with visionary contemplation and inner mental life, implicitly contrasted
with Martha, who represents the manual and practical. In the ongoing dis-
course of art theory, the sisters replicate the polarity of art's higher and
lower aspects, divinely inspired high art and manual craft. The opposition of
higher and lower entities is, to be sure, ingrained in the mind-set of early
modern Europeans, for we see it in a host of related oppositions, such as that
between theory and practice. Yet I am not aware of a theoretical text that in-
terprets Mary and Martha as models of the intellectual and practical dimen-
sions of art itself. In this respect, Artemisia's *Magdalen* seems to stake out new
territory.

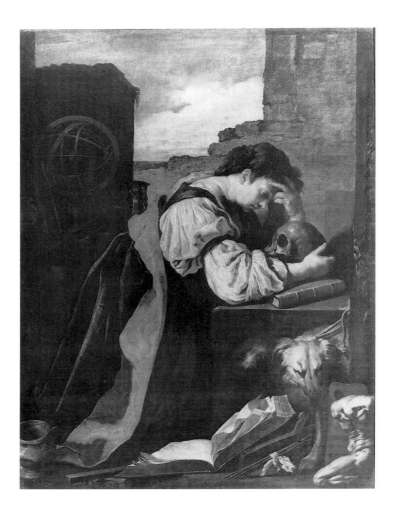

FIGURE 39. Domenico Fetti, *Melancholy,* ca. 1618. Musée
du Louvre, Paris.

Artemisia again took up the theme of art's higher and lower aspects in her
Self-Portrait as the Allegory of Painting (Fig. 42). The artist now openly and boldly
claims the identity of Pittura, investing the allegory with living feminine form.
Resuming a theme initiated in the *Magdalen* nearly a decade earlier, Artemisia
reveals in this *Self-Portrait* a theoretical sophistication and mature commitment

FIGURE 40. Giovanni Battista Castiglione,
Melancholy, or Meditation, etching, ca. 1645–46.
Städelsches Kunstinstitut, Frankfurt am Main.

to both high art and craft, theory and practice. The artist's vigorous engagement
in her work dignifies studio practice, while her thoughtful meditation on the
invisible mirror alludes to art's cerebral aspects. Here gestural expression sets
the two aspects of art in hierarchic relationship: the upstretched hand holding
the brush alludes to the ideal, while the hand on the table, holding the physi-
cal materials of palette and paint, refers to craft.[98] Manifestly both aspects are

FIGURE 41. Michelangelo, *Lorenzo de' Medici, Duke of
Urbino,* 1519–33. Tomb of Lorenzo de' Medici, Medici
Chapel, Florence.

essential to the art of painting, and they are joined in this painting through the
practicing artist, Artemisia herself.

We now see the prehistory of that ripened concept. By contrast with the *Self-
Portrait,* the *Magdalen* implicitly privileges high art, to whose visionary call the
dreaming young artist may be imagined to awaken. In these terms, she sees,
and takes, that "better path" that is the glory of artistic creativity. In the Seville
Magdalen Artemisia began to claim a position for herself within the noble tradi-
tions that had been forged for male artists, and although in the *Self-Portrait as*

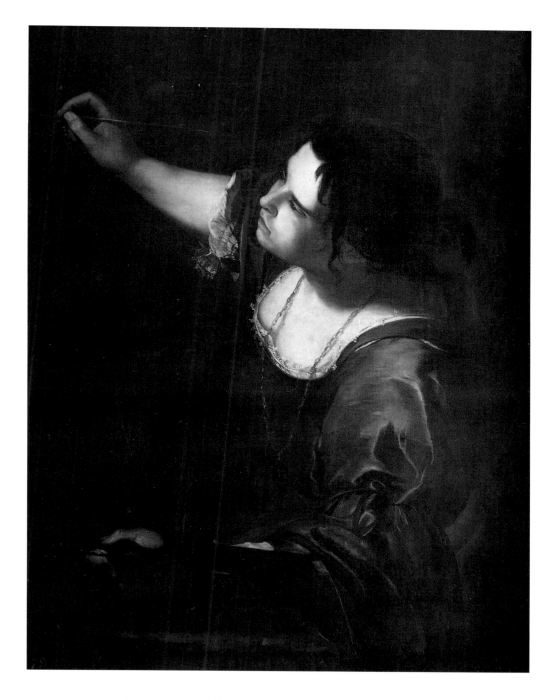

FIGURE 42. Artemisia Gentileschi, *Self-Portrait as the Allegory of Painting,* 1630. Collection Her Majesty the Queen, Kensington Palace, London.

the Allegory of Painting she would abandon the melancholic temperament to claim inspiration from the uninhibited practice of her art, her devotion of more than one type of picture to the concept of artistic inspiration in the 1620s shows that her interest was abiding.

We might speculate that Artemisia's patron, the duke of Alcalá, shared her interest in the theme of artistic creativity. He unquestionably fostered her creative life by offering patronage and protection and by including among his Gentileschi purchases the *Magdalen* and two self-portraits, images that held personal meaning for the artist. But we have no idea what interested the duke about these paintings; if he was like other (male) patrons, he probably merely enjoyed them as examples of feminine beauty. In other instances, as we will see in the next chapter, the divergence of gender perspectives could present more acute problems. Yet a conflict of divergent gender positions is subtly apparent in the *Magdalen* around the charged theme of melancholy in its male and female aspects. Though different in iconography, both the *Magadalen* and the later *Allegory of Painting* functioned as responses to gendered dichotomies in the social world, presenting bold resolutions in feminist terms.

THE REAPPROPRIATION OF GENDERED MELANCHOLY

Despite Artemisia's subtextual allusions to Melancholy and artistic creativity in this painting, she has cast the figure as primarily Mary Magdalene, whose receptive, visionary state is perfectly legitimate to her Christian identity. This may have been a wise decision. The melancholic model is not easily transferable from male to female, although it was easily adapted in the other direction. Julianna Schiesari has written insightfully of the "privileged lack" of the male melancholic, in which masculine subjectivity "invests its eros by appropriating the putative lack of some other, in particular, by appropriating the feminine."[99] An example is at hand in the Michelangelo print, and in the many instances in Michelangelo's art and poetry in which the artist identified with night and femininity.[100] When the male melancholic appropriates the feminine, loss is tragic, despair is heroic, and emptiness is pregnant with creative possibility. Cast as a female, the melancholic risks appearing merely pathetic.

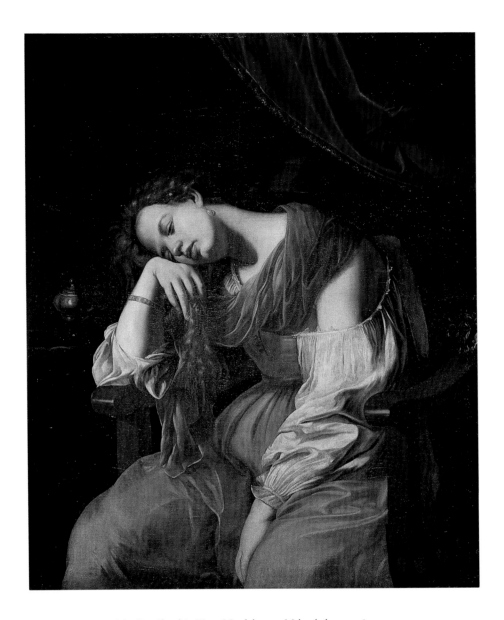

PLATE I. Artemisia Gentileschi, *Mary Magdalene as Melancholy*, ca. 1621–22.
Cathedral, Sala del Tesoro, Seville, Spain.

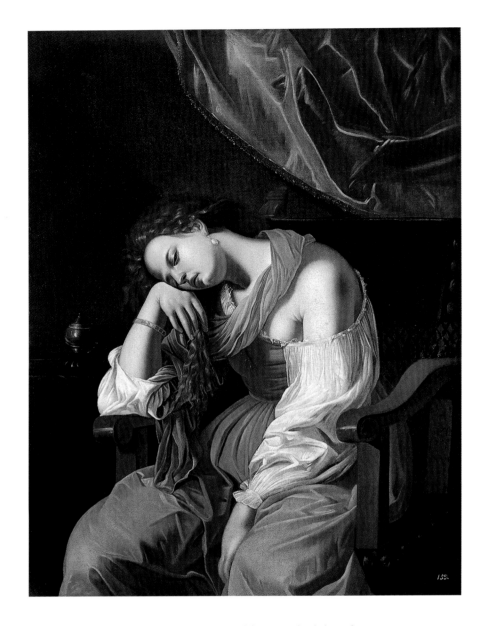

PLATE 2. Artemisia Gentileschi, *Mary Magdalene as Melancholy,* early 1620s.
Private collection.

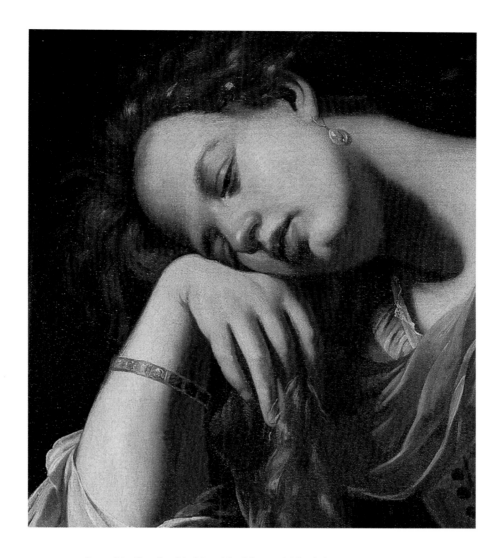

PLATE 3. Artemisia Gentileschi, *Mary Magdalene as Melancholy,* ca. 1621–22. Cathedral, Sala del Tesoro, Seville, Spain. Detail of head.

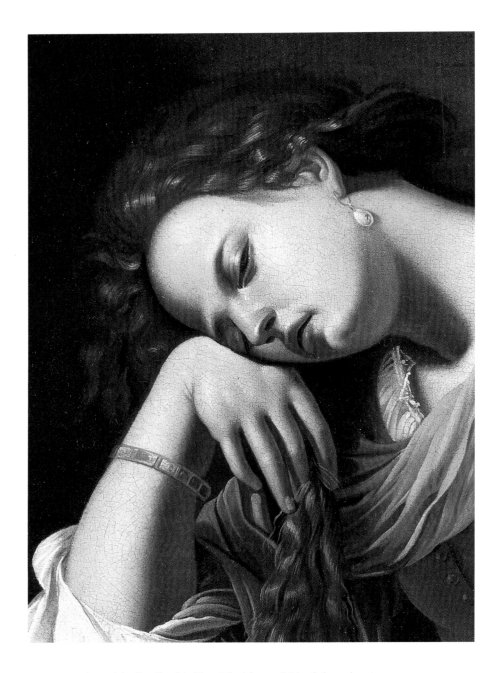

PLATE 4. Artemisia Gentileschi, *Mary Magdalene as Melancholy*, early 1620s. Private collection. Detail of head.

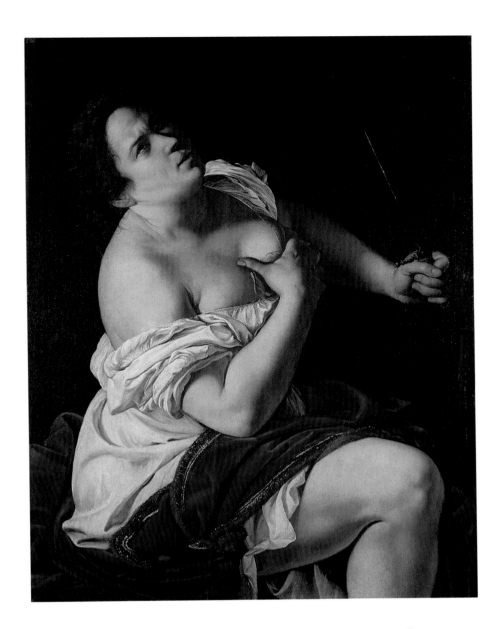

PLATE 5. Artemisia Gentileschi, *Lucretia,* ca. 1621. Collection Piero Pagano, Genoa.

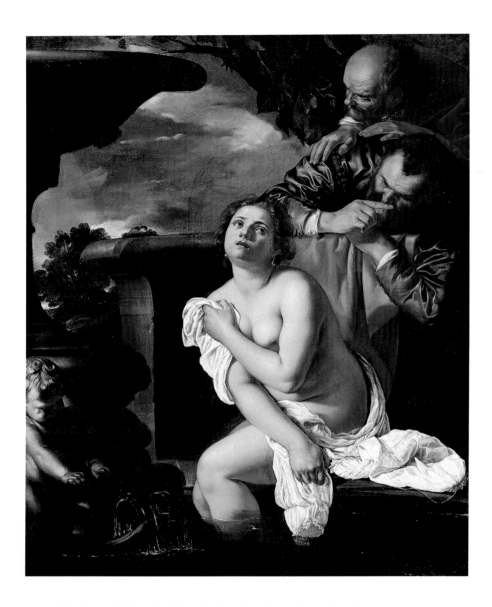

PLATE 6. Artemisia Gentileschi, with alterations by another artist, *Susanna and the Elders,* signed and dated 1622. The Burghley House Collection, Stamford (Lincolnshire), England.

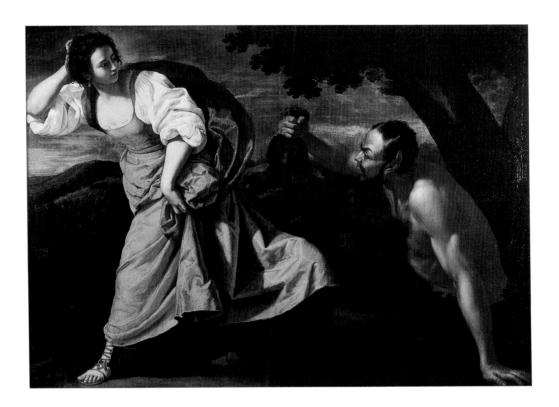

PLATE 7. Artemisia Gentileschi, *Corisca and the Satyr,* early 1640s. Private collection.

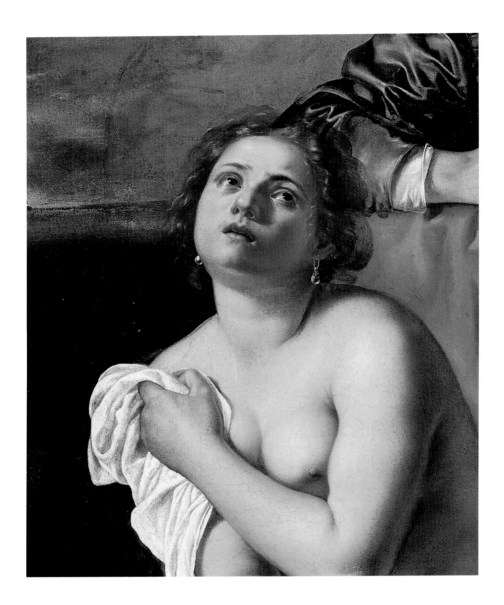

PLATE 8. Artemisia Gentileschi, with alterations by another artist, *Susanna and the Elders*, signed and dated 1622. The Burghley House Collection, Stamford (Lincolnshire), England. Detail.

At first sight, Artemisia's *Magdalen as Melancholy* seems to follow the Caravaggian model of the sorrowful, abject figure, slumped in grief and penitence, her pose signaling loss and despair, the whole body a cipher of perpetual negativity. Her identity is fortified, however, by the formal associations with creative melancholy, which allude subtextually to the grand tradition of artistic inspiration, thereby converting this feminized negative into a subliminally bi-gendered positive. What might be considered a remote iconographic allusion to traditionally masculine artistic creativity is made clear in formal language. Artemisia virilizes the image of the female saint by revising the passivity of the pose taken from her sources, cropping the legs before they can open too wide (and hint at expectant sexuality), and changing the posture from reclining to upright. The verticality of Mary's body, as well as the vitality of the drapery folds over her legs, implies potential action, energy in reserve, while the upper body is fully submissive to the spirit.

Artemisia's desire to give the contemplative Magdalen an active dimension echoes the effort of another creative woman of the period to reconstitute Mary Magdalen as a psychically whole figure. Saint Teresa of Avila, who modeled her own conversion on that of the Magdalen and sustained a lifelong identification with the saint, has recently been shown to have intentionally integrated the identities of Martha and Mary of Bethany to combine the strengths of each.[101] By joining two virtuous female identities that tradition had artificially split, Teresa resolved a false opposition, connecting Mary's privileged communion with God and Martha's good works in the world—in effect reviving the Magdalen's earliest identity as activist apostle. (The stance was also practical theologically, for by thus recasting her Magdalenean role model, Teresa could defend both her own highly activist apostolic mission and her legendary ecstasies and visions.)[102]

Teresa was beatified by the Church in 1614 and canonized as a saint in 1622. News of the Spanish mystic's life and the ideas she championed may well have reached Artemisia's ears as events current in Rome during those years. I do not argue that Artemisia's *Magdalen* was directly influenced by the example of Teresa of Avila, however—only that those two vigorous feminists shared an interest in expanding the psychic profile of the Magdalen to make her a more suitable model for women, even though the terms in which each balanced the active and contemplative necessarily differed.

By enlarging the identity of the feminine contemplative Magdalen to include the idea of masculine melancholy, Artemisia might be said to justify her own artistic ambition by claiming identity on masculinist terms. But there is another way to look at her appropriation of the discourse of creative melancholy. For in this slyly sophisticated image, she corrects the anomalous gender of the image of the melancholic Michelangelo to present the recipient of divine inspiration as *appropriately* female. As in the Kensington Palace *Self-Portrait,* Artemisia shows this Other as a Self who can claim femininity in her own right and on her own terms, resisting the system that consigns women to alterity by the rules of allegory. In both pictures, Artemisia reclaims agency for a woman subject and woman artist and in so doing subverts the masculine deployment of feminine identities, turning each discourse on its head.

In her *Self-Portrait as the Allegory of Painting* Artemisia simultaneously trumped several masculinist traditions: the noble self-portrait, the allegorizing of art as female, and the brooding melancholic temperament. By freely recombining familiar iconography and by inverting models of aesthetic posturing (such as the very discourse of creative melancholy examined here), she produced a synthesized image of active, unobstructed artistic creativity. We can now see that her achievement in the *Self-Portrait* was a second act. In the Seville *Magdalen as Melancholy,* Artemisia classically undermines the distinction made, first by Ficino and later by Freud, between mourning as feminine and melancholy as masculine[103]—a suspect distinction from a feminist perspective—by fusing the categories. For the Magdalen's grief is shown not to differ formally, and therefore not to differ in nature, from creative artistic melancholy. In this quietly radical image, the artist ennobles female grief, culturally debased as insignificant, by suggesting that lurking in this, and perhaps every, contemplative Magdalen is a divinely inspired artist—a prospect that carries bold implications, considering that her identity is subtly entwined with that of her maker, Artemisia Gentileschi.

The attribution of the Seville *Magdalen* to Artemisia rests on a certain amount of documentary evidence as well as on formal analogies with her oeuvre. These connections are greatly strengthened by the picture's expressive correspondence to known interests of the artist. It sings a theme that recurs later in a different form. The painting is therefore exemplary of the most satisfying

kind of attribution problem, whose resolution leads us to a changed under-
standing of Artemisia's art, as broader in expressive range yet more consistent
in the voicing of important themes than we had thought. Not all attribution
problems are so happily resolved. The next chapter examines the case of the
Burghley *Susanna,* which presents more complex problems, challenging our
ability to locate the artist's identity within the painting—either as maker or as
subject.

TWO

THE BURGHLEY HOUSE SUSANNA

A PROBLEM PICTURE

The painting *Susanna and the Elders* at Burghley House (Fig. 43; Plate 6) has held a continuous but somewhat shaky position in the Gentileschi oeuvre. Its modern attribution to Artemisia, dating from as recently as 1968, has been questioned by some scholars and only weakly supported by others.[1] My own deattribution of the Burghley House *Susanna* in 1982 was linked to its conspicuous expressive departure from Artemisia's treatment of the same theme in her first documented picture. I argued that Artemisia's *Susanna and the Elders* in Pommersfelden (Fig. 44), executed in 1610, reflects a rare visual expression of female victimization, metaphoric testimony to the artist's own resistance to the sexual harassment she endured from a community of Roman males in the year preceding her rape by Agostino Tassi.[2] In her interpretation of Susanna's parallel harassment by the Elders, Artemisia presented the female subject as an anguished victim, an unusual treatment of the theme that differs significantly from the prevailing type of the period, here represented by the ur-version, Annibale Carracci's engraving of about 1590 (Fig. 45), which showcases masculinist values, presenting Susanna as an eroticized beauty suggestively receptive to her molesters.[3]

The problem with the Burghley *Susanna,* as I then saw it, was that—despite certain Artemisian features, which I will shortly describe—the picture is closer to the masculinist type than to Artemisia's feminist revision of that type. In the Pommersfelden version, Artemisia presents Susanna in awkward discomfort, twisting on a hard bench to fend off the oppressive Elders who attempt to seduce her. Selective naturalistic features, such as the wrinkled brow, strained

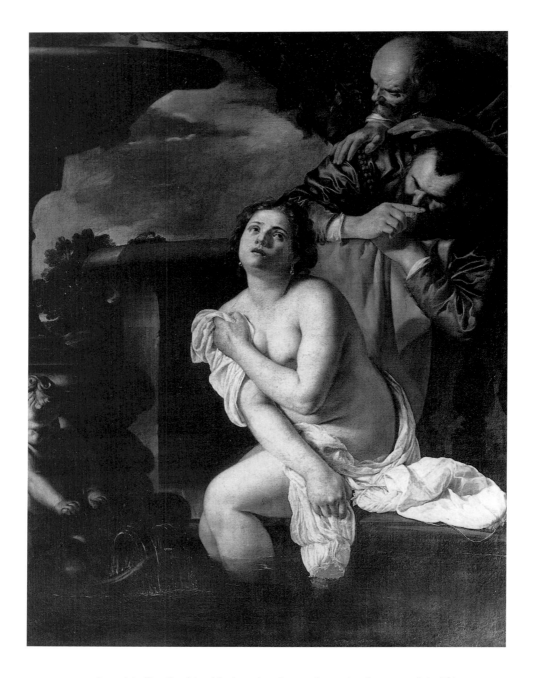

FIGURE 43. Artemisia Gentileschi, with alterations by another artist, *Susanna and the Elders*, signed and dated 1622. The Burghley House Collection, Stamford (Lincolnshire), England.

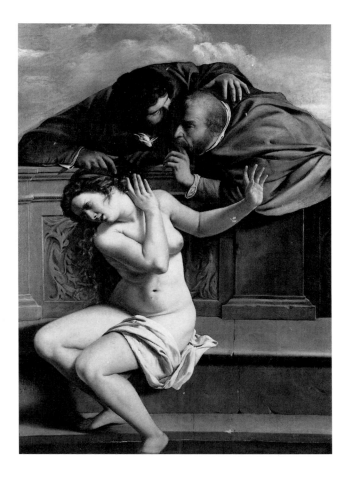

FIGURE 44. Artemisia Gentileschi, *Susanna and the Elders,*
signed and dated 1610. Schloss Weissenstein, Pommersfelden.

flesh, and taut muscles, heighten our sense of the victim's distress and vulnera-
bility. In the Burghley House painting, Susanna is a more normatively classi-
cized figure, a variant of the Hellenistic Crouching Venus quoted by Annibale.
She does not resist but engages her assailants, her uplifted eyes expressing only
mild anxiety, and even this seems merely a baroque rhetorical convention. The
biblical Susanna, paragon of virtuous resistance, is shown in the Burghley pic-
ture—just as she was by Annibale Carracci, Rubens, and a host of other artists
—as a visually available beauty, seated in a lush garden with a spurting fountain.

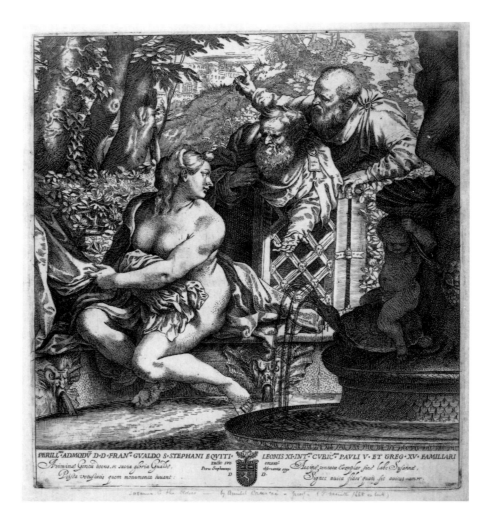

FIGURE 45. Annibale Carracci, *Susanna and the Elders*, etching and engraving, ca. 1590.
National Gallery of Art, Washington, D.C.

When first writing on the Susanna subject, I was puzzled by this insistent trans-
formation of the biblical theme that so flagrantly defied its traditional moral
meaning. At that time, it was enough to blame universal patriarchal masculin-
ism. Only recently have I realized that pictorial Susannas of this type were as-
similated, like filings to a magnet, to an enduring literary topos. To situate the

Burghley *Susanna*, it is essential to establish that topos and to consider some of its ramifications.

SUSANNA IN THE GARDEN OF LOVE

The sensuous garden with its bubbling fountain that became a staple setting for Susanna paintings is none other than the allegorical Garden of Love, described by writers from Claudian to Petrarch, Boccaccio, and beyond. In Boccaccio's *Decameron,* the garden is a happy refuge, a *locus amoenus,* while in Petrarch's *Trionfo d'Amore* it is a site of danger. The Fountain of Love is the end point of the amorous chase, where a lady waits in a pleasant grove, to snare her lover with a net and her piercing gaze.[4] In the Petrarchan model (as in its modern formulation), the lady is pursued by the male quester until she catches him. The Garden of Love, with paired-off lovers seated near the magic fountain that keeps young men ensnared, appears frequently in Early Renaissance art, as in a *desco da parto* by Mariotto di Nardo of around 1420 (Fig. 46). In the same period, the Garden of Love setting had already been appropriated for the theme of Susanna and the Elders, as we see in a salver of around 1447 by the Master of the Bargello Tondo (Fig. 47), which presents the stoning of the Elders in the foreground, the virtuous Susanna and the adjudicating Daniel at the garden's entrance, and the groves and fountain in the distance.[5]

The enchanting powers of the Petrarchan beloved, fortified by her site, had nothing directly to do with the Susanna story. But in its broader dimensions, the topos held sinister relevance. The more dangerous face of Petrarch's idealized *donna* is realized in Dante's Cruel Lady, the *donna crudele* of the *Rime petrose,* whose cold indifference elicits the poet's intense desire and aggressive sexual fantasies. The *donna crudele,* negative shadow of the pure and angelic Beatrice, is the counterpart to the Siren of the *Purgatorio,* who is none other than Homer's Circe, archetype of the treacherous temptress.[6]

The literary conceit of the beautiful woman who entraps her lover with her fatal penetrating glance is widespread in literature, from Petrarchan poetry to Shakespeare.[7] Pietro Bembo rehearses the topos in *Gli Asolani,* describing young men snared by lambent eyes in pleasant gardens, stepping into traps, and pretending to be caught. According to Bembo, the ancients cast their women as nymphs who "with the barbs of penetrating glances slew the hearts of savage

FIGURE 46. Mariotto di Nardo, *Garden of Love, desco da parto* (childbirth tray), ca. 1420.
Private collection.

men."[8] In the later sixteenth and seventeenth centuries, the literary temptress
in the garden became a more overtly sinister figure. She appears in Ariosto's
Orlando Furioso as the enchantress Alcina, who ensnares Ruggiero with her
veil of deception in an alluring garden that is co-extensive with both female
nature and unnatural, artful corruption.[9] The theme is sustained in Tasso's
Gerusalemme liberata in the figure of Armida, whose garden, with its luxuriant
foliage, fountains, and bathing nymphs, symbolizes the deceptive dangers of
sensual attraction.[10]

FIGURE 47. Master of the Bargello Tondo, *Susanna and the Elders,* salver, ca. 1447. Serristori Collection, Florence.

The *donna crudele* topos was even applied to a character depicted by Artemisia Gentileschi in the 1640s: the nymph Corisca in Battista Guarini's *Il Pastor Fido* (1602). This treacherous sorceress, *perfida maga,* as her creator called her, tricks the Satyr with her beautiful hair, a feature of stereotypical female allure. When he catches her, the hair turns out to be a wig, left hanging empty in the woeful Satyr's hand. Corisca was categorized by the writer Marco Boschini as one of the archetypally evil enchantresses and witches, along with Circe and Medea.[11] Yet from Corisca's point of view, Boschini's description of her as a dangerous

sorceress quite distorts her identity. As one can see in Artemisia's version of this rarely illustrated theme (Plate 7), Corisca did not desire the Satyr but tried to escape him, only making him more lustful. In this, she is closer to Dante's Cruel Lady, whose maddening inaccessibility provokes desire, a crime for which she is conflated with the Siren, as Corisca is conflated with Circe.

The two types were intertwined because they were considered alternative provocations to masculine desire. The allegedly seductive woman has two weapons, her "aggressive eye," as this fatal gaze has been called, and her cruel indifference, which is also a classic come-on. Indeed in *stil nuovo* poetry, and even in the poems of Michelangelo,[12] the *donna bella e crudele* who spurns the poet's love is conceptually inseparable from the archetypal seductress. It is the same for Susanna, paragon of chastity, object of the Elders' lust. As with Dante and Corisca, masculine desire becomes *her* fault. And so the invocation of the *donna crudele* topos in Renaissance and baroque paintings—the paradoxical figure of the inaccessible beauty who enchants and entraps—subtly laid the ground for shifting responsibility for the adulterous overture to Susanna herself.[13]

SUSANNA AS SOCIAL SCAPEGOAT

The irony is that these cultural myths contradicted social reality. Sandra Cavallo and Simona Cerutti have shown that in courtship skirmishes, it was far more frequently the male who practiced entrapment, duplicity, and betrayal, and the female who was victimized.[14] Both before and after the Council of Trent, the mere promise of marriage could entitle a man to sexual intercourse as the first step toward lifelong commitment, but the woman's honor depended upon what happened next. The man held the power to "make her an honorable woman," and he also held the power to deceive her simply by claiming he had never promised to marry her. As Cavallo and Cerutti demonstrate, such deceptions were so commonplace as to be named: *dare la burla, gettare la burla* (to play or throw the trick). The man, whose own honor was not at stake, maintained his power by ridiculing the woman who had believed him in the first place.

There are few if any cases of women performing such tricks. Only the woman was so vulnerable, for honor meant different things for the two sexes. A man's honor was defined by his bonds with other men; loss of honor came from not adequately defending the sexual purity of his women or from unseemly

conduct toward his brothers. A woman's honor was defined by her bond with one man, to whose decent behavior she was hostage. As Julian Pitt-Rivers has observed, in Mediterranean culture the honor, *onore,* that enhances a man's masculinity is for a woman at best a negative virtue, the preservation of chastity and the avoidance of shame, *vergogna.*[15]

Yet chastity and rape are interlocked concepts, for chastity, as Stephanie Jed has shown, is "a cultural construct which invites sexual violence."[16] In this respect, Susanna is related to Lucretia, for in each case the woman's celebrated chastity provokes its testing. Lucretia and Susanna, both paragons of virtue, are objects of masculine desire to possess what is socially off limits. In each case, the attempted seduction puts a male bond at risk. This is the primary theme of the story of Lucretia, whose kinsmen vindicate her honor by declaring war on the kinsmen of her seducer. In the story of Susanna, threatened patriarchal bonding is a suppressed theme. Although we are not asked to dwell on it, Joachim, the unsuspecting husband, has been unscrupulously betrayed by the Elders, his colleagues. This element of the story is whitewashed, just as the Elders intended when they invented the story of Susanna's imaginary young lover, to force her sexual favors and take the heat off themselves.

Nevertheless, the subcurrent of male betrayal in this story would remain potentially troublesome, certainly to every husband of a beautiful woman whose friends visited his home. Thus from a masculinist perspective there was great advantage in hinting at Susanna's complicity. Presenting Susanna as seductive makes her responsible for the Elders' action, which was the legal and social crime of cuckolding her husband.[17] The appearance of her inviting their attentions wipes out this issue. And it keeps all three men, the Elders and Joachim, on the same side—as joint venturers in the tricky business of balancing their sexual appetites with their desire to maintain patriarchal control of their women.[18]

An exception to the norms of its genre, Artemisia's Pommersfelden *Susanna* presents the image of a victimized woman, oppressed rather than intrigued by her would-be seducers, her fragile honor under immediate threat. It offers a perspective on sex crime distinctly at odds with literary convention but perhaps more accurately reflective of social practice, unmasking in its very difference the raw reality of male manipulation of female chastity. The *Susanna* in the Burghley House Collection offers a fundamentally different, and more

normative, conception of the theme. The Fountain of Love is back—along with the garden setting, putti, and spurting dolphins—to establish the *locus amoenus* where amorous entrapment may occur. Susanna covers her pudenda with both arms, in a conventional expression of modest refusal. But like the enchantresses at the fountain of the Garden of Love, she turns her head toward the intruders, her melting gaze fixed upon them, her eyes saying yes to contradict the no of her body language.[19]

THE PICTURE: TECHNICAL ANALYSIS AND DOCUMENTATION

On the basis of such iconological evidence, these radically different interpretations of the Susanna theme would seem unlikely to have been painted by the same artist. When the Burghley picture was cleaned in preparation for the 1995 traveling exhibition of paintings from Burghley House, however, a signature was discovered on the wall, just above Susanna's knee, which reads: ARTEMITIA GENTILESCHI LOMI / FACIEBAT. A.D. M DC XXII.[20] Normally, the discovery of a signed painting by Artemisia Gentileschi would be cause for celebration, as a confirmed addition to her small oeuvre. But in this case the discovery of the signature and the cleaning have further problematized an already problematic picture, and the specificity of the date 1622 only points up more difficulties.

For one thing, with rare exceptions, no landscape backgrounds appear in Artemisia's paintings before the 1630s.[21] When Artemisia began to include landscape backgrounds in the mid-1630s, she hired another artist, Domenico Gargiolo, to paint them. The background in the Burghley House painting, with its diagonally structured pattern of gray and white clouds against a deep blue sky, recalls the style of Guercino, as Ann Sutherland Harris has rightly pointed out.[22] Yet it is highly improbable that Artemisia should respond temporarily to Guercino's influence, venturing to paint her first landscape background, doing it rather skillfully, and then, as far as we know, never deigning to paint another landscape herself, from now on assigning both landscape and architectural backgrounds in her pictures to other artists. The sharply defined, glistening tree and the tiny figures at its base do not even resemble Artemisia's later subcontracted landscape elements. The fountain, with the pair of putti riding water-spurting dolphins, resembles nothing else painted by Gentileschi, either in type or in its mellifluous and broad-brushed style. No counterpart can be found in her art

for the definition of an entire figure, the second putto, as a dark shape silhouetted against a lighter ground.

Certain features of the painting, however, do invite connection with Artemisia's oeuvre. The figure of Susanna is comparable to that of the Genoese Lucretia (Plate 5) as a seated female nude who, in addition to her similar pose, offers an analogous rendering of certain anatomical features, such as the swelling curve of the thigh and the angle under the knee. Susanna's hair, unrestrained and bushy, is comparable to that not only of Lucretia, but also of many other Gentileschi females, as in the Spada *Lute Player* or the Pitti *Magdalen*.[23] In a more general sense, the naturalistic representation of the Elders as rather coarse-skinned men, with sharply highlighted noses and wrinkled brows, can be related to the Elders of the Pommersfelden *Susanna* and to Artemisia's *Gonfaloniere* now in Bologna, a work firmly dated to the same year, 1622. As the Pommersfelden *Susanna* and other works demonstrate, Artemisia typically rendered males and females somewhat differently, employing for males a rough, ruddy naturalism, thickly brushed; females are lighter in skin tone, defined in a more sharply articulated and less gestural style.

Yet there are significant distinctions of style between the Burghley *Susanna* and comparable Artemisian works of the period. The white draperies surrounding Susanna seem flat, inert, and tightly delineated when compared with the dramatic and vigorous light-shadow patterns of the Uffizi *Judith* and the Detroit *Judith*.[24] Purple is juxtaposed with gold in both the Burghley picture and the Detroit *Judith*, yet when the two works are set side by side, the folds of the Elder's purple sleeves appear overdefined and shiny in comparison with those of the Detroit Abra's more loosely and lightly described garment. The face of the Burghley Susanna, in an odd divergence from the figure's own draperies, displays a more painterly hand. Though plump and fleshy, the head (Plate 8) lacks density; contours are not outlined. Slabs of pink paint float above an eyelid and at the corner of the mouth; white and pink highlights sit on the surface of the forehead. The whites of the eyes, moist and gleaming patches of paint, overflow their boundaries. By contrast, in both the Florentine *Magdalen* and the Genoese *Lucretia* (see Fig. 13 and Plate 5), the contours of the heroine's eyes, lids, and irises are defined by continuous lines; they shine with moisture, yet they display a firm structure of form drawing. This technique combines the relief and total-visual-effect modes discussed in the preceding chapter. Even when tenebrism dominates, it sits on a residual base of the Florentine relief mode.

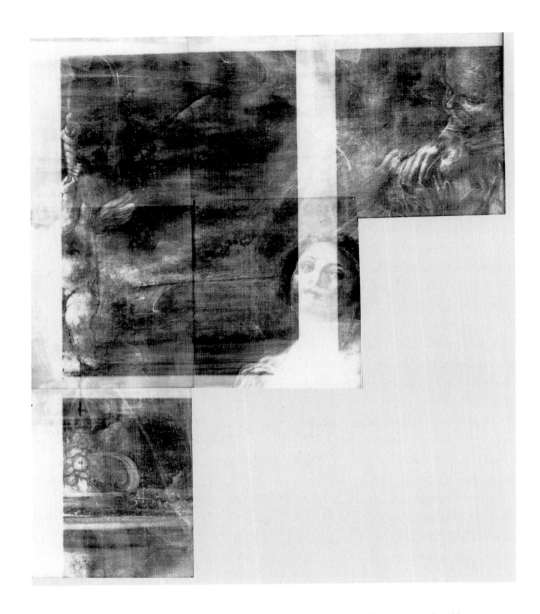

FIGURE 48. Artemisia Gentileschi, with alterations by another artist, *Susanna and the Elders,*
signed and dated 1622. The Burghley House Collection, Stamford (Lincolnshire), England.
X-ray of upper and left parts of painting.

The upturned eyes of the Burghley *Susanna* invite comparison with those of the *Lucretia,* where the heroine's upward gaze, the brow furrowed in anxiety and the lips pursed, is meant to convey the extremity of her circumstances as she struggles to decide whether to kill herself. Susanna's situation is less extreme—she is threatened with rape, whereas Lucretia has already experienced it—but each faces terminal shame should she manage to survive, and so we might call these situations comparably stressful. Yet the expressions differ. The Burghley *Susanna* has a smooth and untroubled face; her upward gaze seems rhetorical. It is the lack of inner motivation in this figure that differentiates it from comparable ones in Artemisia's contemporary oeuvre.

The absence of a sense of inner genesis and organic coherence in this passage applies to the painting as a whole. Even to the naked eye, the Burghley *Susanna* displays peculiarities, ranging from still-visible *pentimenti* to apparent overpaintings, which point to a construction in several stages. When the Burghley exhibit began its American tour and it became possible to examine the newly cleaned painting closely, differences in style between the figures and the landscape and garden elements were so obvious as to suggest to me that the left third of the painting might be by another hand. Subsequent technical examination has supported these suspicions.[25]

Infrared reflectography and radiography (Figs. 48, 49) show that the left side of the picture, and other areas, have been completely repainted. Susanna was originally positioned before a balustrade, not a stone wall. The balusters are visible in infrared (see Fig. 49), to the right of Susanna's body.[26] The fountain that we see in the painting today was preceded by at least one different fountain, and perhaps two. What may be one of these is still visible in ghostly form in the sky just under the basin of the present fountain.[27] The first fully developed form of the fountain was located in the foreground, roughly where it is now, but with a design distinctly different from that of the final version (see Fig. 48). Lower and slightly smaller than the present fountain, this structure consisted of a pedestal adorned at its base with piles of fruit, crowned by a winged putto who spurted water upward through a cornucopia held to his mouth. The water fell into a basin, located at the level of the present putti, which also received water shot from spouts at the base of the pedestal.

A figure facing right (one of the Elders, unquestionably) was earlier located directly above Susanna; his shadowy bald pate and right arm are visible in the

FIGURE 49. Artemisia Gentileschi, with alterations by another artist, *Susanna and the Elders,* signed and dated 1622. The Burghley House Collection, Stamford (Lincolnshire), England. Infrared reflectogram of figures and balustrade.

X-ray, and the contour of his arm can be seen by the naked eye (Figs. 50, 51; Plate 6).[28] Above him, a tree branch extended toward the upper left from what became a squarish leaf when the branch was eliminated and replaced by sky. The figure of Susanna was originally intended to be located a bit higher and to the right (see the dotted lines in Fig. 50), although this initial outline may have been abandoned early.[29] Drapery once covered more of her body than at present, for a triangular piece of cloth over her right shoulder can be seen in infrared; there may have been more drapery covering her chest and framing her left shoulder.[30]

The face of Susanna, according to both conservators who examined the picture, betrays no overpainting under X-ray and infrared analysis. In comparing the X-ray image (see Fig. 51) with the painted face (Plate 8), however, one sees subtle differences. In the X-ray, the eyes, less animated, seem to look more out-

FIGURE 50. Artemisia Gentileschi, with alterations by another artist, *Susanna and the Elders,* signed and dated 1622. The Burghley House Collection, Stamford (Lincolnshire), England. Partial reconstruction of the first version of the painting.

ward than upward toward the Elders, producing a trance-like expression like that of Artemisia's Spada *Lute Player.*[31] Thus the face may have been touched up lightly in the final stage, to create an expression more responsive to the Elders and to eliminate the appearance, inappropriate to Susanna's conventional casting, of a heroine who seemed disengaged, dissociated from the action.

This evidence permits us to reconstruct at least two compositions and two distinct versions of the narrative. The first composition embraced certain early

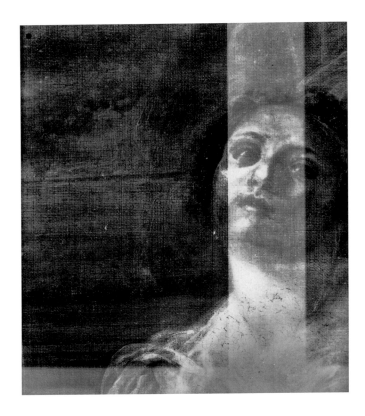

FIGURE 51. Artemisia Gentileschi, with alterations by another artist, *Susanna and the Elders,* signed and dated 1622. The Burghley House Collection, Stamford (Lincolnshire), England. X-ray of Susanna's face and shoulder.

design changes, such as the shifting of Susanna's body and the elimination of the fountain in the middle distance, but it must have resulted in a fully developed picture. We know this because the contour of the back of the Elder first located above Susanna extends below the present wall and comes down to meet the cornice of the balustrade, and because there is evidence of a sky painted in coordination with the balustrade and the Elder in the first position.[32] Available X-ray evidence does not permit us to read the position of the second Elder in the first composition.[33] A clue to the possible earlier arrangement of both Elders, however, may be seen in Artemisia's late *Susanna* at Brno (Fig. 52).[34] This painting offers a reprise of the artist's earlier *Susanna*s: the female figure echoes that of the

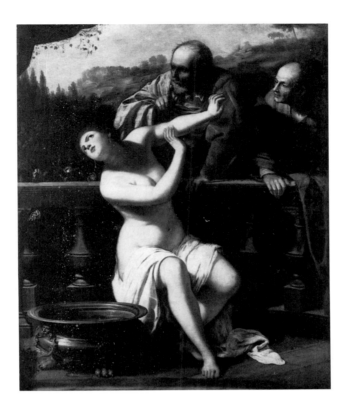

FIGURE 52. Artemisia Gentileschi, *Susanna and the Elders,* 1649. Moravská Galerie, Brno, Czech Republic.

Pommersfelden *Susanna,* and the balustrade repeats that of the first Burghley composition. Because the contour of the Elder on the left in the Brno picture is almost identical to that which remains from the first composition, one might infer that both Elders originally looked somewhat as they do in the Brno painting (though they were placed closer together) and coordinated similarly with the original cornice of the balustrade. Since the original balustrade was positioned lower than the new wall, the original Elder on the right cannot have leaned forward with his elbow overhanging the wall in the first composition, as he does in the second.

The balustrade probably continued behind Susanna, on the left side of the picture; horizontal banding visible in X-ray appears to represent its cornice.[35]

(The location of the putto fountain militates against the possibility that the present wall was created in the first composition, since its left edge would have awkwardly abutted the putto had the two elements been contemporaneous.) The extended tree branch visible in X-ray also belongs to the first composition, eliminated to make room for the basin of the present fountain. We may therefore infer fairly precisely, except for the position of the Elders, the completed form of the first version of the painting (see Fig. 50). This inference is consonant with the conservators' opinion that X-ray images (these include the first fountain, head of Susanna, and head of the bald Elder) exhibit a consistency of technique and medium compatible with the given date.[36]

The Burghley painting was then reworked to produce a new composition with a prominent patch of landscape and a new fountain in place of the first one (Plate 6). The sky was repainted, so that it now overlaps the former tree branch, and the tree and earth passages were adjusted tonally with the fountain and wall. The present fountain and left side of the wall are conceptually of a piece, since their contours are composed of curves and straight edges that echo each other closely, while the flat lighted edge of the wall was adjusted as a shape to fit the silhouette of the putto in shadow. Consistent lighting also falls on the rim of the fountain basin and on the curved edges of wall molding. It must have been at this stage that the head of Susanna received its painterly adjustments, for its contours were enlarged in thin paint over the purple sleeve of the right Elder, a form that belongs to the second composition.[37]

The visible signature and date, ARTEMITIA GENTILESCHI LOMI / FACIEBAT. A.D. M DC XXII, belong to the second composition, added after the painting was reworked, because they are attached to the wall that replaced the balustrade.[38] This signature, located near Susanna's knee, has certain surprising features. It reads somewhat darker in ultraviolet than might be anticipated; because pigments lighten in ultraviolet over time, the darker reading could point to a substantially later date.[39] More telling is the unusual form of this signature, which casts doubt upon its authenticity. No other painting signed by Artemisia includes both the names Gentileschi and Lomi, and no known work painted after Artemisia left Florence in 1620 includes the name Lomi.[40]

At the time when the Burghley *Susanna* was cleaned and the signature on the wall exposed, however, traces of a second inscription—more accurately, a first inscription—were discovered to lie under the present paint surface, just below the heads of the two fountain putti, detectable only by the texture of its

lettering. Understandably, the authors of the exhibition catalogue did not publish this fragmentary evidence since without knowledge of the earlier composition they would not have recognized its potential significance.[41] Coordination with the X-rays shows that the inscription was located on the rim of the basin of the original fountain. This rim is still visible on the present surface as a lighter horizontal band (Plate 6 and Fig. 48).

The legible fragments of the uppercase letters—an initial AR, followed after an interval by an S—are few, yet enough to establish as a virtual certainty that the original fountain bore the inscription "Artemisia Gentileschi." From the known height of the letters and the intervals between them, we can see that following the initial *AR,* the *S* would correspond exactly to the *S* in Gentileschi.[42] The word "Gentileschi" would have ended approximately where the silhouette of the putto now on the right intersects the former rim. (Both elements are visible in the X-ray.) Assuming that the inscription conformed to the curving surface of the fountain rim, as was common in Artemisia's signatures,[43] we can infer that there would have been just enough space on the right for the name Artemisia Gentileschi to have been followed by 1622 (minus the A.D.) or (less likely) by Lomi, but not both. Since the rim curves away and into shadow at that point, however, "Artemisia Gentileschi" may have been the full inscription.

The evidence of the original signature confirms that the first composition was a painting carried to completion and signed by Artemisia. It may or may not have been dated, but on stylistic grounds 1622 would not be an inappropriate date. It is the visible second signature that now requires explanation: if the style of the repainted passages points to another artist, why was Artemisia's signature painstakingly reinscribed, in a slightly altered form, on the composite work? I shall return to this question after considering that of provenance, which is also complicated by the insistent inscription of Artemisia's identity upon the surface of this painting.

Despite the visible signature, the Burghley *Susanna*'s connection with Artemisia Gentileschi cannot be confirmed through its alleged provenance. The painting was first recorded in an eighteenth-century list, handwritten by the ninth earl of Exeter, Brownlow Cecil, where it is described as a work by Artemisia Gentileschi that had come from the Barberini Palace in Rome.[44] The Gentileschi attribution, however, was evidently forgotten by 1815, when the painting was catalogued as a work by Caravaggio.[45] Only in 1968 did Mina Gregori propose reattributing this picture to Artemisia on stylistic grounds.[46]

The signature was presumably no longer visible, and Gregori was apparently unaware that the picture had been connected with Artemisia in early Burghley House inventories.

A Barberini provenance would make sense, for Artemisia counted Cardinals Francesco and Antonio Barberini among her patrons, and we learn from her letters that she painted several works for the brothers, one of which, a *"donna con amore,"* is listed in the Barberini inventories.[47] Yet the Cardinals Barberini are unlikely to have directly commissioned the Burghley *Susanna,* because the date inscribed on the painting would place its execution several years before they began to collect and patronize art.[48] If Francesco or Antonio purchased the picture, it would have been in the mid-1620s or later.

None of the nine *Susanna*s documented in seventeenth-century Barberini inventories, however, can be correlated with the Burghley House painting. All but one of them were either listed as by another artist, or smaller than the Burghley *Susanna,* or both.[49] We might tentatively identify the Burghley House *Susanna* with the single example that would fit, an unattributed *Susanna* purchased (at uncertain date) by Antonio Barberini and listed in his inventory of 1644.[50] But why would a painting signed by the artist enter the Barberini inventory anonymously? In the absence of any *Susanna* ascribed to Artemisia Gentileschi in the Barberini collections, the Burghley House painting's signature presents a problem. Since the signature on this relatively recent picture cannot have been invisible to its new owner, we must conclude either that it was not yet present when the painting entered the collection or that the Burghley House painting did not come from the Barberini collection at all.[51]

More promising evidence comes from another Roman collection built in the 1620s, that of the Ludovisi, who were the Barberini's greatest rivals. The first inventory of the collection of Cardinal Ludovico Ludovisi, nephew of Pope Gregory XV, drawn up in November 1623, shortly after his uncle's death, contains an entry for a *Susanna and the Elders* by "artimitia" eight palmi in height.[52] It has been suggested that this work may have been Artemisia's Pommersfelden *Susanna,* yet the Burghley *Susanna* seems a more likely candidate, first, because it was a more recently painted picture and, second, because the measurements correspond more closely to those of the latter picture, if, as seems likely, the "eight palmi" of the Ludovisi inventory included the frame.[53] If the Burghley *Susanna* was the picture by Artemisia that Cardinal Ludovisi acquired, it would logically have been one of the three hundred paintings the cardinal procured

in Rome during his uncle's short pontificate, between February 1621 and July 1623, and assembled at the Vigna di Porta Pinciana.

Artemisia's *Susanna* did not remain in the Ludovisi collection, however, for it does not appear in the inventory of 1633, created after the death of the cardinal on 18 November 1632.[54] In the interval, Cardinal Ludovisi had disposed of quite a number of the works in his collection, while acquiring others; although the two inventories contain almost the same number of objects, their differences show, in Wood's description, "steady traffic of works in and out of the Vigna after 1623."[55] If the Burghley *Susanna* is identical with the picture cited in the Ludovisi inventory—and this is not a certainty—then the alterations would have been made to the painting either before the cardinal acquired it or after he disposed of it.

To approach this issue from the perspective of the earls of Burghley House, if the Barberini provenance is to be questioned, then the theory of a direct Italian origin for the picture is also unstable. At least to be considered is the possibility that the Burghley picture is identical with the *Susanna* by Artemisia Gentileschi that was owned by Charles I. This painting was listed in the Van der Doort inventory of 1639, which recorded works purchased by the English king in Italy in the 1630s and included at least two other works by Artemisia, a *Tarquin and Lucretia* and a half-length *Fame*. The *Susanna* acquired by King Charles may well have been the deaccessioned Ludovisi picture.[56] In any event, the king's *Susanna* by Artemisia was probably among the works sold in 1651 following his execution and so could have remained in England. This leaves open the possibility that the Burghley House *Susanna* is the painting formerly owned by Charles I, acquired by the ninth earl not in Italy but in his own country.

COLLABORATION OR UNAUTHORIZED ALTERATION?

The technical and documentary evidence would accommodate two plausible explanations for the alteration of the Burghley House *Susanna*. One is that, having finished the first version of the picture, Artemisia collaborated with another artist to change the composition. The second is that the picture was repainted by another artist without her participation, and marketed as a work by Gentileschi. Each alternative can be supported from intrinsic and extrinsic evidence, and I will explore them both, beginning with a few

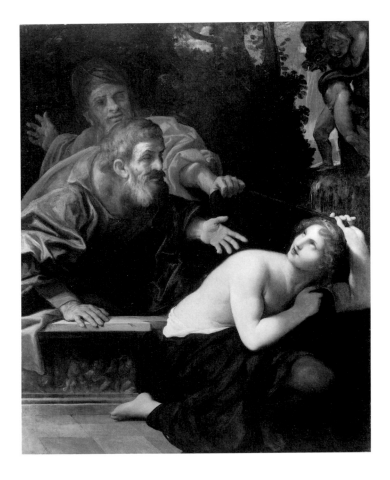

FIGURE 53. Ludovico Carracci, *Susanna and the Elders,* 1616. National Gallery, London.

interpretive postulates that arise from the technical analysis and apply to both explanations.

In key respects, the earlier version of this painting (see Fig. 50) would have been closer to Artemisia in expression than the present version. When one Elder was positioned directly above Susanna, the composition would more nearly have resembled the oppressive vertical piling-on of Elders that we see in the Pommersfelden version and would have shared its awkward dramatic tension. In the first version, the prominent fountain, with its thrusting, energetic putto,

competes with Susanna for the viewer's eye. The effect of its reduction to a deeply shadowed *repoussoir* was to focus the spotlight on Susanna's body and to minimize compositional tension. This, in combination with the removal of some of the drapery on the body, resulted in a more conventional image in which the sensuous beauty of the heroine was more pronounced.

The curious structure of the first fountain is reminiscent of Artemisia's gender wit. Certain of its motifs are common to fountains in Susanna images of the Carracci circle, for a putto holding a water-spouting object can be seen in a painting by Ludovico Carracci (Fig. 53),[57] and fruit and flower elements are faintly visible in Annibale Carracci's print (see Fig. 45). Yet Artemisia's fountain offers a biting exaggeration of the satyr heads on Annibale's fountain basin, whose lecherous associations playfully support the Elders' venture. She too emphasizes the erotic theme, by giving her putto wings. But she brings this little eros into an aggressive juxtaposition with the fruit below, to establish a polarity freighted with gender associations, an erotic psychomachia in which the phallic putto-plus-cornucopia (representing the desiring Elders' braggadocio) triumphs over its object, the fruit and flowers at the base (Susanna's sexuality).[58]

Artemisia's upward-spurting fountain mimics the ejaculatory gusto of the suitors' urgency, while the unusual (and most unfountainlike) symbolic fruit—a squat and static trophy—mocks the entire phallic scenario. The displacement of the Elders' desire to the fountain, and thus to doubly fictional art, has the interesting effect of liberating the more ontologically real Susanna, reminding us that she will eventually escape their overtures. Ultimately, the inspiration for this triumphant little icon of masculine lust may have been the satyr fountain in Titian's Prado *Venus and Organist* (Fig. 54). Here too we see a symbol of male sexuality in statuary form, lifting with both hands a water-spurting urn (which Artemisia made a cornucopia), poised above the body of Venus that is the object of the organist's desire.[59]

By stating the theme of conquest in ludicrous terms, Artemisia seems to ridicule the stereotypical features of Susanna's seduction as depicted by male artists. There are parallel instances in which women writers of the period played with masculine literary forms in a spirit of scornful parody. Laura Bacio Terracina wrote a commentary on all the first cantos of *Orlando Furioso,* in which Ariosto's lines are used, resituated, for opposite and openly feminist meaning.[60] Isabella Andreini based her pastoral play, *Mirtilla,* on Tasso's *Aminta,* inverting the roles so that the nymph, instead of being victimized, takes revenge on her would-be

FIGURE 54. Titian, *Venus and Organist,* ca. 1550, detail of satyr fountain. Museo del Prado, Madrid.

seducer, the satyr. Artemisia Gentileschi, who could have known Andreini's play, also dramatized a nymph's revenge upon a satyr in her painting *Corisca and the Satyr,* as we saw earlier.[61] The painter Sofonisba Anguissola also exaggeratedly mimicked masculine art forms in a clearly ironic spirit in such works as her *Bernardino Campi Painting Sofonisba Anguissola* and the hyperpatriarchal *Family Group* (both late 1550s).[62] There is, in short, plenty of evidence from overt feminist expression in Renaissance culture to support the possibility that Artemisia composed the Burghley *Susanna* in a parodic voice.

If the first fountain subtly satirized a formal type that it superficially seemed to perpetuate, such mockery would be consistent with other double-edged forms of female expression found in an age whose sense of irony and double meaning was sharply honed. Even men knew that women practiced a form

Dear valued customer,

Thanks for your purchase.

Delivering satisfaction to customer is our goal. If you have any issue regarding your purchase, please contact us asap. We will work with you and try our best to solve any problem.

If you're happy with your experience, please leave us "positive feedback".

We appreciate your business and support.

B.regards,

Book Edge, Inc.

of doublespeak with men, as we see exemplified in Castiglione's *Book of the Courtier.* Emilia Pia's highly ambiguous response to the Magnifico's defense of women—"Now we [women] can't at all understand your way of defending us"—suggests (if we read it as deferential) that women are not intellectually sharp enough to follow sophisticated arguments, or (if we see it as derisive) that men's arguments on behalf of women are absurd, beside the point.[63] Artemisia herself occasionally adopted this ironic stance, seemingly obsequious but in fact mocking high-flown conventions, in her letters to male patrons. For example, she writes to the duke of Modena, who had thanked her for sending paintings: "Your Most Serene Highness calls a gift of generosity what is actually a tribute of my vassalage; you consider a gesture of affection and an act of courtesy what is due Your Grandeur as a sign of obedience."[64] The wit of the bemused ironist who wrote this passage, confident that her patron would miss her irony, echoes that of the playfully overstated putto and fruit of the first fountain.

With the replacement of the putto fountain by one that is grander, more decorous, less graphically allusive, the gender humor was decisively eliminated. The alterations of the figure of Susanna—her head enlarged, her upward gaze heightened, and her protective drapery reduced to reveal more flesh—subtly changed her expressive cast. She came to appear more alluring and desirable, less vulnerable and threatened. The relocation of the Elder to the upper right corner supported this expressive change, rendering the whole seduction a genteel affair in a noble setting. This Elder's gaze is now linked with Susanna's through a strong diagonal axis, amplified in the solidly baroque zigzag that extends through her body to the bottom of the image. The figures are compositionally locked in a counterpoint of yes, and no, and yes again, suggesting the conventional ritual of courtship, with its entreaty and resistance, seduction and conquest. The visual dialogue created by this repositioning gives the imminent event an air of inevitability and rightness.

Let us first imagine that Artemisia herself instigated the changes. She might have wanted to include more landscape elements—a distinct possibility, considering the rising popularity of landscape in Rome in the 1620s[65]—but found herself unable (or unwilling) to paint them. Perhaps she invited a collaborator to help her reconceive the composition, modernize it with an ampler natural setting. Considering that this landscape background has reminded more than one observer of the style of Guercino, one wonders why Artemisia's collaborator could not have been Guercino himself. These two artists of about the

same age were both in Rome in 1622, still establishing their reputations, though Guercino had taken a clear lead, with the prestigious backing of the duke of Mantua and Cardinal Alessandro Ludovisi, now Pope Gregory XV. A context for their association is given in the acquisition of an Artemisia *Susanna* (putatively, the Burghley picture) by the pope's nephew, Cardinal Ludovico Ludovisi. Personal contact between the painters is also strongly implied in Guercino's immediate familiarity with Artemisia's *Magdalen,* which, as we have seen, may have been the model for his figure of *Notte* at the Casino Ludovisi, as well as in the close resemblance of the two artists' compositions of *Jael and Sisera.*

Their artistic collaboration would not have been unusual in the period. In 1621 Guercino joined with Agostino Tassi to paint frescoes, first at the Palazzo Lancellotti and again in the Casino Ludovisi where, according to their recognized strengths, Tassi executed the fictive architecture and Guercino the figure and landscape elements.[66] Although Agostino Tassi was also a recognized landscape specialist, Artemisia was unlikely to enlist his collaboration, for obvious reasons. Yet one could imagine her, in a spirit of competition, inviting the artist currently working with her presumed enemy to collaborate with her. Artemisia herself collaborated in the 1630s and 1640s with Viviano Codazzi, an architecture specialist, and Domenico Gargioli, a landscape specialist.[67] It is, indeed, suggestive that Artemisia's reliance on collaborators in architecture and landscape, Tassi's two specialities, might, on a psychological level, have been a form of distancing herself from the man who had raped and dishonored her.[68]

Guercino would have been a good choice, given his strong demonstration of poetic and skillfully painted landscape backgrounds. His *Et in Arcadio Ego* of about 1618 and *Elijah Fed by Ravens* of 1620 (Fig. 55) present landscape features comparable to those of the repainted Burghley *Susanna,* such as the feathery gestures that describe leafy branches and the zigzag patterns of gray, blue, and white in the clouds and sky. Guercino's mastery of baroque diagonality, seen in such works as *Saints Francis and Benedict* (Louvre, 1620), seems to inform the compositional structure of the revised Burghley *Susanna,* while the glistening, wet look of his viscous brushwork finds a counterpart in the painting of the revised wall and fountain.

The figures themselves suggest a composite of the two artists' styles. The physiognomy and positioning of the Elders, with their wrinkled brows and foreshortened heads, find counterparts in Guercinian male figures of the period,

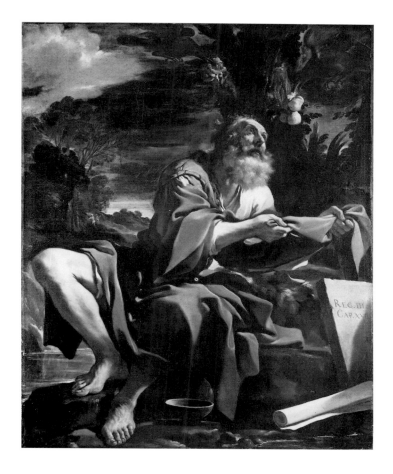

FIGURE 55. Guercino, *Elijah Fed by Ravens*, 1620. Collection Sir Denis
Mahon, on loan to the National Gallery, London.

such as the *Elijah* (see Fig. 55) or *King David with Violin* (Rouen, ca. 1620). But
the pawlike hands of the bald Elder look more like Artemisia than Guercino,
comparable to those of her Gonfaloniere or the king in *Esther before Ahasuerus*.
The possibility that the Elder in his changed position may have been painted
by Artemisia (with the corollary that she also repositioned the second Elder in
conjunction with the creation of the wall) would support the argument for a
collaborative process, for it would indicate that she still participated in the
work's creation after it was reconceptualized.

Whereas Susanna's anatomy and pose are comparable to those of other

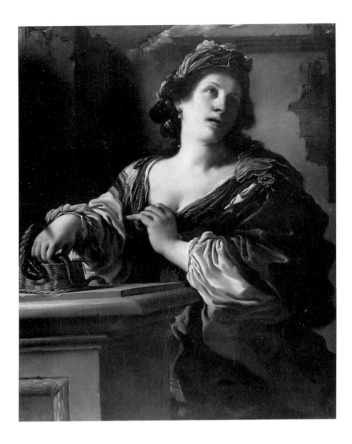

FIGURE 56. Guercino, *Cleopatra*, ca. 1621. The Norton Simon
Foundation, Pasadena, California.

figures by Artemisia, her face looks a great deal like Guercino's work—his
Cleopatra of about 1621, for example, who even wears an Artemisian ear-
ring (Fig. 56).[69] At the same time, Susanna's face is less idealized than that of
Guercino's *Cleopatra,* the fleshy lips and bushy hair a bit more Artemisian. It
could be a face painted by either, adjusted in the direction of the other's style.
These relationships suggest a process in which Guercino might have replaced
the left side with the new fountain, wall, and landscape; Artemisia located the
Elders in their new position; and both artists adjusted these figures and that of
Susanna to blend stylistically with the Guercinian left side of the picture. The
scenario of collaboration in the Burghley *Susanna* is supported by the hint

of Artemisia's style in certain portions produced in the reworking and also by the high quality of the resulting picture, credibly a joint effort of the young Artemisia and Guercino. It remains unclear, however, why Guercino would have been willing to collaborate in a work for which he took no credit. And it is difficult to believe that a picture resulting from Artemisia's collaboration with Guercino would not have been documented in some way.

Even so, one could understand Artemisia's orchestration of the Guercinian changes, as well as her departure from the expressive intensity of her first *Susanna,* by considering her unusual relationship to the art market. The Pommersfelden and Burghley *Susannas* were probably both painted on speculation, but under different circumstances. Young or unrecognized artists in early-seventeenth-century Rome typically created pictures on speculation.[70] Artemisia had no known patron for her earliest works, yet unlike many other young artists who, lacking patrons, were obliged to rely on dealers, she had an artist father who vigorously promoted her.[71] As something of a prodigy, and with Orazio to back her, the seventeen-year-old Artemisia is likely to have painted the Pommersfelden *Susanna* largely to show off her talent. (The stamp of her personal viewpoint on the subject may, as I have consistently argued, have been unconscious.)

In the normal course of things, the Burghley House *Susanna,* produced a decade after the artist had begun to attain recognition, would have been painted for a specific patron. Francis Haskell has defined the pattern of patronage for young artists who came to Rome in the early seventeenth century.[72] First, the artist would receive support from a benefactor, perhaps a cardinal who had been papal legate in the artist's native city. (The example of Cardinal Alessandro Ludovisi's support of Guercino comes to mind.) This benefactor would find the young artist living quarters and get him commissions for church altar paintings or decorations for the family palace, where the artist would then be installed. The artist would meet other patrons among the cardinal's friends, for whom he would first work exclusively, building a reputation that eventually would give him a position from which to accept commissions from a wider range of sources.

Artemisia's experience did not fit this pattern. Nor, of course, did that of many a young male artist who lacked access to high circles. Artemisia, however, was no stranger to powerful patronage; in Florence, she had enjoyed the protection of Cosimo II de' Medici (whose death in 1621 terminated a favored

situation), and she received additional support from Michelangelo Buonarrotti the Younger.[73] Returning to Rome, she sold paintings to Cardinals Barbarini and Ludovisi, yet was supported by neither. No church commissions are recorded and, until the duke of Alcalá became her patron in 1625, the only known buyers of her work were Cardinal Ludovisi, her father's Genoese patron Pietro Gentile, and the patron of the Bolognese *Gonfaloniere*.[74]

Unquestionably, Artemisia's gender was a factor. As a self-sufficient woman in Rome with one or two children,[75] she would not have fit the mold of the independent artist living in the court or palace circle. Her letters convey a continuing need to find patrons. Even in the 1630s she seems to have made a practice of sending unsolicited works to wealthy men, for example, Francesco I d'Este, duke of Modena, and Ferdinando II de' Medici in Florence, in the hope that they would buy them.[76] Indeed, near the end of her life she could still complain to Don Antonio Ruffo, her Sicilian patron, that "a woman's name raises doubts until her work is seen."[77] Her comment reveals the circumstances women artists faced in a period when they were still rare: the presumption that they could not be good by objective standards, and the consequent valuation of their works less as works of art than as examples of their exceptional existence.

Considering Artemisia's pressing need to find buyers for her paintings, the adjustments to the Burghley *Susanna* that she hypothetically subcontracted could be understood as her effort to reach a market. The prevailing Susanna picture, with squirting fountains and a lusciously displayed nude, was still going down quite well, as is demonstrated in Ludovico Carracci's *Susanna* of 1616 (see Fig. 53), a late work by the artist that perpetuates the type of his cousin's print.[78] To make a salable *Susanna,* Artemisia might have created a broadly traditional type of composition, despite its unconventional and parodic deviations. Then, perhaps fearing (or finding) that her first version was still too unorthodox to be marketed successfully, she might have enlisted a collaborator to create an attractive landscape and a more conventional, visually subordinated fountain, and perhaps to aid her in making Susanna a bit more alluring. The participation of Guercino or a Guercinesque artist in making these adjustments would be especially understandable if the prospective buyer of the painting had been Guercino's own patron Cardinal Ludovico Ludovisi. Had this been the case, we would see here Artemisia's effort to meet the expectations of the marketplace—including a willingness to glamorize a female character to suit masculinist taste. It would not have been the first time she did so, for the Florentine

Magdalen and the Casa Buonarroti *Allegory of Inclination* were also painted largely in conformity to such tastes.

Yet when one takes all the available evidence into account, the collaboration theory becomes the less credible alternative. Under laboratory analysis the Burghley *Susanna* reveals an internal reversal of values, the replacement of a composition that sustained the Pommersfelden *Susanna*'s feminist spirit (albeit in different terms) with a more conventional gender stereotype. Artemisia would have had to change her original conception and radically revise a finished painting, after she had signed and dated it.

Moreover, if the signature is not authentic—and it is unlikely to be so— Artemisia literally did not "sign off" on this revised painting, as she had on the first version. The visible signature might conceivably have been added much later by someone wishing to restore an authorship that had been erased in the repainting. But with the first signature no longer visible, the signer would have needed to know both the picture's origin and Artemisia's two surnames. The simpler explanation is that the second inscription was affixed by the artist who repainted the left side of the picture, its double surname constructed from knowledge of the "Lomi" that Artemisia had used as recently as the *Jael* of 1620, conjoined with Gentileschi, her more familiar name in Rome.[79]

Third, the examples of the contemporaneous *Lucretia* and *Cleopatra* show us that such an authorial cover-up for marketing purposes was unnecessary, since Artemisia was clearly able to have it both ways. In its demythologizing of the reclining female nude, the *Cleopatra* (see Fig. 10) subverts the very genre it belongs to, yet it was probably acquired as a desirable example of the genre that gave it protective cover. The *Lucretia* (Plate 5), similarly, could have been marketed on the strength of a lot of female flesh, including an exposed breast, despite that breast's clear allusion to lactation rather than erotic pleasure. What we might call the alternative values of these works may simply have been invisible to Artemisia's male contemporaries.[80] It is harder to make that case for the parricidal *Judiths*, but perhaps the recognition of a known and familiar theme could be reassuring, no matter what an artist's rendition actually looked like.

The evidence of these paintings shows that Artemisia could produce pictures that expressed two sets of values simultaneously. Their generic themes and visible body parts satisfied a contemporary male audience while their subtle realignment of expressive elements spoke in code to a different audience, albeit one that may have existed only dimly in Artemisia's mind and experience.[81]

Such coding depends for its effectiveness upon masculinist deafness to the feminist voice. Since Artemisia evidently could produce man-killing heroines for buyers who saw them as glamorous images, it is implausible that she would have collaborated to modify the Burghley *Susanna* dramatically, in an effort to meet market demands.

The interpretive changes made to the *Susanna* point instead to a hidden social issue: the problematically sexualized identity that had attached to Artemisia herself for a decade. This issue was manifestly present, though as yet unproblematized, in the contemporary reception of Artemisia's pictures, particularly her *Susanna*s, that is reflected in certain contemporary texts. These texts reveal a dynamic that goes beyond men's ignorance of Artemisia's subversive feminism to their manipulation of her eroticized identity as a form of control. And they provide a rationale for the alteration of the Burghley *Susanna* and its marketing as a Gentileschi. The alterations are likely to have been motivated less by the opinion that the original version was offensive than by the belief that it could be improved, along lines that would better represent the "Artemisia" whom the art world welcomed.

ARTEMISIA AND SUSANNA, PUBLIC AND AUDIENCE

In 1619 the Neapolitan poet Giovanni Battista Marino published his *Galeria,* a collection of poems about art, based on paintings and sculptures he had seen in various art collections and on similar imaginary works. Two of the ekphrastic poems of the *Galeria* celebrate imagined depictions of Susanna. Marino's imagery draws on Susannas of the type in Annibale's print, and as George Hersey has recently pointed out, it partakes of the same masculinist perspective.[82] Hersey argues convincingly that Marino may allude subtly to Artemisia's paintings. In the closing lines of the poem, Susanna exclaims: "Before I allow you to injure and disgrace me, I will turn this pure fountain, silvery and crystalline, into a fountain of blood." The unexpected invocation of the imagery of blood, the threatened suicide by stabbing, indeed brings to mind Artemisia's paintings of the suicidal Lucretia and the sword-wielding Judiths.[83] Such associations are almost necessary, since the biblical Susanna did not threaten suicide.

Hersey proposes that observers who knew both Marino's poem and Artemisia's paintings are likely to have let the one feed into the other, to gain pleasure

from the extended associations now produced. In a Judith poem, Marino's description of Holofernes' blood that "washed his obscene bed," "soaked and stained also by his infamous love," evokes Artemisia's painted Uffizi *Judith* (see Fig. 8). (It also evokes the imagery of blood and violence that figures in her description of her rape in the trial testimony.) Artemisia's history was known to patrons such as Cosimo II de' Medici, who commissioned the Uffizi replica of the Naples *Judith*. Hersey argues provocatively that the grand duke desired not just a gory Judith, but one painted by Artemisia, the famous rape victim. For the male viewer, it was the painter more than the painting that titillated. And the story of her rape would only have added spice.

As one attempts to understand Artemisia's position in the social world, it is useful to employ a distinction Bernadine Barnes has made between *public* and *audience*.[84] Especially because of the rape trial, but even before it, there was a public that knew Artemisia more as a woman than as an artist, a public consisting of every male past puberty in the artists' quarter of Rome, a world of would-be suitors and gossips who taunted her, competed for her attention, told stories about her, and in so doing invented a persona, that "Artemisia" who was said to be a loose woman, a sexual libertine.[85] Artemisia's public included an audience that actually saw her pictures, but even her audience was made up primarily of men, who were surely influenced by public talk. In such a climate, Artemisia's paintings—the *Susanna*s and *Judith*s, the *Lucretia* and *Cleopatra*—partook of a discourse that was only partly about art, voiced by an interpretive community interested in Artemisia primarily as a sexual creature who had been rendered desirable by the publicity of the rape trial and whose art was seen through the filter of her provocative beauty.

Anonymous verses published in Venice in 1627, dedicated to three paintings by Artemisia, describe a Susanna standing between her would-be suitors, naked and beautiful; she wishes to lift her eyes to heaven, but dares not.[86] The latter part of the description may have been drawn from the Pommersfelden picture (see Fig. 44), the only version of the theme by Artemisia that presents the critical and unusual detail of a Susanna who does not lift her eyes to heaven.[87] In the poet's explanation of that feature, however, we can measure the difference between the female artist and her male audience. "Modest and ashamed," he says, *"modesta e vergognosa,"* she dares not. This is an amazing misreading of a picture that so clearly signals Susanna's distress and distaste. And why should Susanna be ashamed, when she is the one who is wronged? The poet can interpret the

unusual expression of the Pommersfelden *Susanna* only from within familiar conventions: if the elders are inflamed with passion for this naked and beautiful woman, it is her fault, and if she is not even able to look up, she must be consumed with shame.[88]

The concept of shame, though officially irrelevant to the subject of Susanna, is nevertheless its shadow counterpart, for it evokes the trope of her sexual guilt as seductress. In this poem it also subtly reminds the reader of the painter's own reputation, as both rape victim and alleged sexual profligate. By the early 1620s Artemisia herself was vulnerable in a larger way than she had been a decade earlier. In the period of the first *Susanna,* she was a girl who, like many others, had experienced sexual harassment and rape. By the time the second *Susanna* was painted, she was Artemisia the woman artist, very much in the public eye, with a social identity that had been constructed out of the notoriety of her experience, which persistently conflated the personal and professional. In the masculinist reading of Artemisia's pictures, her sexually compromised female subjects always risked being interpreted as titillating autobiography. "The knowledgeable viewer," says Hersey, "would see, behind the gawkiest Susanna and most massive Judith, their famously beautiful creator." Such an autobiographical reading would explain why Artemisia's pictures were purchased and admired by patrons who were seemingly undisturbed by their subversive content.

Yet hers was a position of potential advantage. Hersey suggests that Artemisia's own enterprise may have been, accordingly, "to play the beautiful defamed rape victim by painting unsettling protest pictures about rape"—to profit from her own victimization, that is, by feeding a market hungry for sexy pictures that were always really about "Gentil'esca," "tender allure," as she was described in the mock-epitaphs published after her death.[89] One could conclude, as Hersey does, that Artemisia willingly joined in the marketing of Artemisia, from which it might follow that she was prepared both to capitalize on her strengths—an insider's skill in painting the female body and her reputation as a sexually responsive woman whose heroines resembled herself—and to supplement her weaknesses by inviting collaborators to paint landscape and eventually architecture. Such an interpretation would give us an Artemisia willing to concede to both commercial opportunity and social expectation.

There are reasons, however, to question the argument that Artemisia was in effect selling herself. Given her precarious position in the social world, she cannot have welcomed the conflation of her identity with eroticized heroines. She

would have needed to present herself professionally as a respectable woman, and toward this end she had every reason to avoid depicting seductive or acquiescent heroines. Like Susanna, Artemisia had been victimized twice, first by sexual intimidation and then by slanderous publicity. Under such circumstances, it would have been suicidal for her to hint at Susanna's complicity with her seducers. As a work of the seductive type, going on the market bearing Artemisia's prominent signature, the Burghley *Susanna* would inevitably have been taken as a counterpart of the artist, representing her in quite defamatory terms, in effect violating her again by offering pictorial testimony about Susanna's sexuality—and by extension, Artemisia's—that countered the artist's own testimony: that of her first *Susanna,* and that of her trial deposition.[90] From this perspective, it is implausible that Artemisia Gentileschi would have collaborated in the alteration of the Burghley painting that changed it from a commentary on the Elders' sexual aggression (read that of men in general) into a conventional image of the theme, business as usual between the sexes.

Precisely because the picture was most likely marketed on business-as-usual terms to prospective patrons who would relish a seductive Susanna painted by the beautiful rape victim, an alternative hypothesis of its creation can be developed. Since the alteration of the Burghley picture by another artist is more likely to have occurred at some interval after it left Artemisia's control than soon after she completed and signed the work, it follows that, if the painting is identical with the Artemisia *Susanna* owned by Ludovico Ludovisi, it was probably altered after its deaccession by the cardinal (that is, after 1623) and not before he acquired it (that is, 1621–23). Artemisia's painting—whether as the deaccessioned Ludovisi picture or as an unsold different work—may have come into the hands of a dealer after she herself left Rome in 1626–27. Let us say the dealer had much of the work repainted—to alter the landscape and fountain, reposition the Elders, and touch up Susanna's figure—by an artist who then prominently placed her name on the surface of the picture. The addition of the signature would have been essential to the gambit, for it provided the necessary proof of Artemisia's authorship of a picture not purchased from the artist. To describe the mechanism at work, one might reverse Artemisia's comment quoted earlier: "a woman's *painting* raises doubts until her *name* is seen."[91]

The alteration of the Burghley *Susanna* must have been motivated by the desire to make the artist as well as the picture more attractive. It is not accidental that the person who transformed Artemisia's original Susanna into a more

glamorous and conventional heroine in a more bland and supportive setting also insistently identified the picture with Artemisia through the new inscription. Here is Susanna resocialized as agreeable, again seen through the Elders' eyes, and Artemisia herself is presented as the agent of the transformation—metaphorically, a self-transformation. The very desire to associate Artemisia with this painting (a desire interestingly echoed by Burghley House, which is remarkably proud of its Gentileschi and has been unusually resistant to its deattribution[92]) reveals its own psychic foundations. Taken as a sign of the artist herself, the Burghley *Susanna* represents a particular "Artemisia"—the sexualized, perpetually vulnerable, visually available beauty whom one dreams of possessing.

We must recognize this topos of the beautiful Artemisia for the red herring that it is. To insist that images of women by women artists are self-representations, emblems of beauty above all, no matter what the depicted women are actually doing, is an act of resistance, a subconscious attempt to deny the threatening nature of what these women *are* doing. Artemisia's patrons and buyers saw in her paintings what they wished to see. Yet the subversive content of those pictures must have been noticed by her male contemporaries, if only subliminally, for they made discernible efforts to neutralize its effect by the tactic of distraction. To rave about the beauty of the artist who painted the Uffizi *Judith,* to savor the picture as an in-joke about rape fantasies, is fundamentally an effort to control the power of a very dangerous image.

There *was* an autobiographical component in Artemisia's art, one that she herself pressed, but it represented a perspective very different from the one her contemporaries liked to read in her works. The most overtly autobiographical paintings—the *Judith*s, the Seville *Magdalen,* and the Kensington Palace *Self-Portrait* in particular, all works from her early period—feature women who are either getting the best of men or insisting upon a woman's place in the discourse of art. It is not credible that such intensely feminist images as the Detroit *Judith* or the *Self-Portrait* could have been painted by an artist whose real agenda was to market herself as a rape victim. That is a masculinist view of what she was doing, and it denies the authenticity of Artemisia's art and the reality of her protest. In a culture that has naturalized acts of sexual violence against women, nowhere more noticeably than in literature and art, very few visual artists—none before Artemisia—have expressed a woman's sense of alienation and powerlessness in a world of gender inequity and sexual violence. Much of Artemisia's

art is grounded in the specific circumstances of her own life. But she was hardly the only woman to be victimized by sexual violence.[93] Nor was she the only woman who struggled to become an artist in a gender-biased society. At its best, Artemisia's art speaks for many women, and its anti-patriarchal expression stands as a powerful cultural statement on their behalf.

Read against the background of the public shaping of Artemisia's image in the decade following the rape trial, the creation and alteration of the Burghley *Susanna* reflects a social struggle over the very identity of the painter. (In quite a literal sense, it was also the surface upon which that struggle was played out.) Yet we cannot fail to notice that before the picture's original expression was in effect censored, it had already been marked by a degree of self-restraint. For after we have read away the subtle compromising modifications of the protagonist's image, what remains is a figure posed as the Venus Anadyomene, a time-worn erotic signifier. The Susanna of Artemisia's original design—surely as much the artist's alter ego as her youthful Pommersfelden version—no longer vigorously repels her assailants but seems intimidated by them.

Invoking the autobiographical subtext, we might say that the threat to Susanna is no longer directly and simply sexual; it is now a more diffuse but larger social threat involving both sexuality and reputation, whose dangers cannot be avoided by simple protest. For Artemisia there was a great deal more at stake in 1622 than in 1610. No longer unknown and untarnished by scandal, she had a position to protect, which required diplomacy and caution. Accordingly, Susanna's movements are more ambiguous; frozen in the archetypal pose of feminine modesty, she neither responds nor resists. Instead, she appears numb and detached, and her feelings about the narrative in which she finds herself are displaced to the putto fountain, which functions as a mirror of her psyche.[94] Within the narrative Artemisia's subversive critique of masculinism is expressed in this sculptural ensemble, just as in life she channeled it through her art. We might deduce from the visual model that the artist herself sustained a balancing act: a socially poised woman yields to convention in certain respects while producing, in an artistic fiction, an aggressive challenge to patriarchal convention. Which was compensation for the other is anybody's guess.

CONCLUSION

The Shaping of a Complex Identity

AS WORKS OF THE SAME PHASE of Artemisia's life, the Seville *Magdalen* and the Burghley *Susanna* stand at a crossroads, pointing to the two contradictory directions she would later take in her art. The *Magdalen* is highly creative in its imaginative combination of sources, in respects that reveal her awareness of the gender shading of artistic conventions. It is also progressive, for it advances the artist's lifelong project to be taken seriously as an artist despite being female, and it is assisted by that apparent liability. The *Susanna*, by contrast, even in its first (Artemisia's) formulation, is expressively regressive. The allusion to the Venus Anadyomene in the heroine's pose may have been given an intentional parodic twist by the winged eros who surmounts the fountain, but at best this would have been secondary to the central figure's basically conservative gestalt. Even before its alteration, the *Susanna* showed Artemisia conceding slightly to the tastes of the masculine art world.

One must grant that the very theme of Susanna and the Elders presented restrictive terms for character development. Unlike Lucretia, whose dilemma on the point of suicide at least offered expansive dramatic potential, Susanna cannot be shown agonizing over a decision. Nor can she, in the spirit of Jael or Judith, kick the Elders in the groin and chase them out of the garden. Having explored the delicious opportunities for enlarged female agency offered by these other characters, Artemisia is not likely to have been content to restate her visual assertion of 1610 that the strongest thing Susanna can do is protest and resist oppression. Having gained a more established social position of her own (though she was still vulnerable to defamatory critique), she might have considered that both she and Susanna could be better served by dignified, impervious neutrality than the outrage of victimhood. Consequently, it is credible

that Artemisia conceived the first version of the Burghley *Susanna* composition from a post-victim position and that she displaced her feminism from the heroine to the subtly satirical fountain.

It is in this sense that Artemisia may be said to have *dis*identified with Susanna in this painting,[1] vacating a character with whom she now had a problematic relationship. Faced with a professional need to paint pictures that would sell, she either accepted a commission for this subject or chose it as one that would find a market, and she must therefore have been prepared to risk its reception on autobiographical terms. Within those constraints, Artemisia distanced herself from the heroine, by rendering her as passive and unresponsive as possible in the first draft—which I would argue was her last contact with the painting.

In the *Magdalen,* by contrast, Artemisia seized the opportunity to develop the autobiographical dimension, asserting proudly but very subtly her identification with the contemplative saint. In this case, she did not risk her identity through unwarranted identification with a sexualized woman, for the Magdalen's face and hair are not Artemisia's in either of the two versions, and neither figure is a self-portrait. They represent, rather, a conception of the Magdalen as reconstructed and elevated by Artemisia, who drew from her example inspiration highly relevant to her own life, of a visionary creativity that replaced a prior association with debased sexuality. In the *Susanna,* Artemisia works to ward off a publicly imposed identity with the character, while in the *Magdalen* she reveals the character to us in a new light, by way of a privately held identification.

Assuming Artemisia's authorship both of the first version of the Burghley *Susanna* and the two *Magdalen*s, how are we to account for such different works bearing the same date?[2] This question invites another: what is the chronological sequence of Artemisia's works of the 1620s? At present we cannot answer, not only because there are few dated works or names of patrons, but also because we lack a clear understanding of Artemisia's internal development. Bissell calls the 1620s an interval between Artemisia's early Caravaggism and the classicism of her first Neapolitan period, an interval when the artist displayed an increasing willingness to eroticize and beautify her female figures in accordance with both her patrons' desires and changing canons of aesthetic beauty. In my view, this interpretation both oversimplifies the trajectory traced by the known works and leaves out Artemisia's own motivations and her response to a range of factors beyond her patrons' wishes.[3]

Proceeding from this book's discussion of the *Magdalen* and Burghley *Susanna*, I would construct a different picture of the 1620s. The two paintings under discussion here are framed by the Uffizi *Judith* (1620), *Jael and Sisera* (1620), *Lucretia* (ca. 1621), *Cleopatra* (ca. 1621–22), and Detroit *Judith* (ca. 1625). From both a formal and an expressive point of view, the *Magdalen* takes its place logically in this sequence as contemporary with the *Lucretia* and *Cleopatra*. The Burghley *Susanna* exhibits fewer relationships to works of the period, probably largely on account of its repainting. Without the Burghley *Susanna*, the work of the 1620s would have a more coherent cast and a clearer development. We would see a decisive reorientation on Artemisia's return to Rome in the formal direction of Caravaggism and a rough expressive vitality (*Jael*, the Seville *Magdalen*, *Lucretia*, *Cleopatra*) that steadily grew into the more mature and seasoned Detroit *Judith* and the *Allegory of Painting*.

Though seemingly an interruption, however, the Burghley picture in fact resumed a type of passive feminine beauty represented earlier in the Florentine *Inclination* and Pitti *Magdalen*. Although alien revisions may have exaggerated key features, the Burghley *Susanna* showcases the beauty of an inactive protagonist, and in this respect the picture may be said to have initiated the artist's willing concession to conventional expectations, on what would prove to be an oscillating basis. The graceful feminine beauty of the *Inclination*, Florentine *Magdalen*, and Burghley *Susanna* anticipates that of Artemisia's female characters in works that begin to appear around 1630 and continue into the 1640s: the Princeton *Sleeping Venus*, the London *Cleopatra*, the Columbus *Bathsheba*, and the late *Bathsheba*s and *Susanna*s. By the 1640s this type alternated with strong or active female characters like the Corisca, and may have outnumbered them.

The pattern of oscillation points to Artemisia's self-contradictory management of autobiographical presence in her art. We see in the *Judith*s, especially, an insistent desire to create characters who were the artist's alter egos, through whom she formed identity or led a vicarious life. That desire is also evident in the sequence of works in which she expressed the theme of creative inspiration through a female figure. This series was launched by the Florentine portrait of Artemisia as Pittura, an identity construct that she herself took up in the Seville *Magdalen*, the self-portrait upon which the David engraving was based, the *Self-Portrait as the Allegory of Painting*, and perhaps in other lost self-portraits. The *Magdalen* thus contributes to the recognizable core of the artist's positive self-definition through metaphoric identification with her characters.

Although the *Magdalen* and *Susanna* point in different directions, their near-simultaneity, as well as the very oscillation of the Gentileschi oeuvre, is perhaps understandable because they were ultimately motivated by the same thing: Artemisia's determination to succeed as an artist. She affirmed her identification with elevated art through the metaphoric presentation of herself as Pittura. And she also did so by succeeding in her profession, even at the risk of providing her buyers with art that sustained the link between herself and feminine beauty. The Burghley *Susanna* shows her at the point of taking that step. The *Magdalen* reveals the ambition that drove her to it.

The Burghley *Susanna,* as here anatomized, may show the effect upon Artemisia of pressures to conform to market values, but it also raises the specter of a market prepared to capitalize on Artemisia's name without her consent or cooperation. At the least, it reveals the shaping of her artistic identity in a direction warped by gender norms that were continually monitored by masculinist constructions of femininity. The *Susanna* forecasts what would happen in the later years, for through her choices and repetitions of theme, however differently motivated, Artemisia created a demand that she later supplied. As time went on, she seems increasingly to have played into gender expectations.[4] The later *Susanna*s and *Bathsheba*s fed a market for attractive female nudes; at least twice Artemisia produced a pairing of these two figures that (considering their iconographic disparity) must have been intended as samples of beautiful women.[5]

This concession on her part should not be surprising, for identity is shaped both from within and without. As an internal process, identity formation is already complex, for as Diana Fuss has pointed out, identification (as, for example, with one's own created characters) both brings identity into being and calls it into question: "The astonishing capacity of identifications to reverse and disguise themselves, to multiply and contravene one another, to disappear and reappear years later renders identity profoundly unstable and perpetually open to radical change."[6] Such a dynamic is echoed in Artemisia's changing relationship with her characters, her identification and disidentification with them over time. That changing relationship was also affected by Artemisia's interaction with her public, however, and in this respect her public identity cannot be separated from her private identifications, for it is through their reciprocal interchange that her identity was formed and re-formed.

Reception theory has helped us to recognize the process by which the

contemporary and later spectators who make up the artist's public partici-
pate over time, through their variable responses to the work, in the changing
construction of its meaning.[7] Yet while ongoing viewer reception can effect
changes in the hermeneutic status of a work of art, the process also works in
reverse, for art holds a lasting power over its reception. As Michael Ann Holly
has posited, works of art may through their visual rhetoric "semiologically leg-
islate" what is said about them.[8] If we take these opposite processes as an in-
teractive dynamic — a kind of dance between artist and audience, of encoded
meanings on the one hand and expectations and responses on the other — we
can perhaps understand how it was that Artemisia frightened her public into
trying to contain her, then wound up giving them what they wanted after all.

To begin with, the early Gentileschian images of female characters embody
discursive features of a fuller narrative — the biblical Susanna is not merely a de-
sirable pretty girl (to which she had been reduced by most artists), but a victim
of impending sexual assault. Mary Magdalene is not the oxymoronic penitent-
yet-still-sexy saint so facilely produced by many artists, but a visionary who
had sublimated an earlier identity as sexually exploited woman. An argumenta-
tive Lucretia calls into question the justice (to her) of her self-mandated suicide.
In each of these figures as depicted by Artemisia, a troublesome dark dimension
of the character's literary identity, successfully expunged in normative imag-
ery, remained as a distinctive trace element. Even when — or perhaps especially
when — not recognized consciously, this reminder of a problematic sexual-
ity in the narrative provoked reaction on the part of the gender that was be-
ing subtextually accused. Responding defensively to an unvoiced accusation,
Artemisia's male audience said, in effect, isn't she beautiful when she's angry?
Or they deflected the criticism, as Marino did when he projected onto an
"ashamed" Susanna the guilt of the Elders that Artemisia had implied.

The escalating terms of this now-polarized discourse set an agenda for both
artist and public. Artemisia, who had been publicly sexualized by the rape trial
and was now celebrated as a famous and beautiful artist, began to develop an art
that responded to allegations about her, that played both *against* and *to* expecta-
tions — against because to, and vice versa. She would continue to produce trans-
gressive images such as the *Corisca,* or the now lost *Hercules and Omphale,* painted
in 1627–28 for Philip IV's Alcázar Palace in Madrid. The latter work hung for
a time with its intended pendant, *Ulysses Discovers Achilles* by Van Dyck and
Rubens, but was later removed because of its offensively unheroic image of a

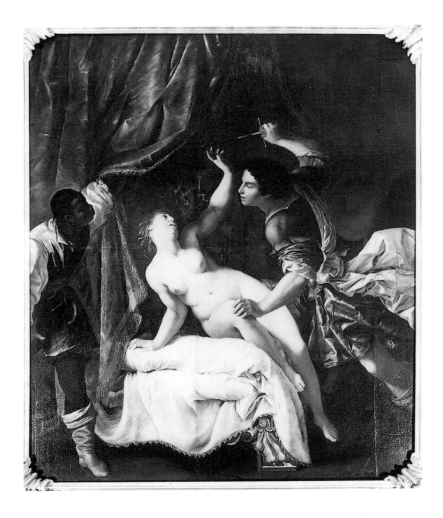

FIGURE 57. Artemisia Gentileschi. *Tarquin and Lucretia,* late 1640s. Stiftung
Preussische Schlösser und Gärten Berlin-Brandenburg, Potsdam, Neues Palais.

Hercules "reduced to spinning thread meekly among women."[9] Yet as if in
overcompensating reaction to her own feminism, Artemisia produced, perhaps
in greater numbers, pictures of the type for which she was praised and rewarded
—for Dottore Luigi Romeo, a *Bathsheba* and *Susanna;* for Don Antonio Ruffo,
a *Diana, Andromeda,* and *Potiphar's Wife.* The two sides are now in unspoken
rapport, for Artemisia's patrons demanded what she needed to give them—im-
ages of beautiful nude women that would effectively suppress the troublesome,

dark Artemisia who was never openly acknowledged to exist. A silent compact to deny the hidden, unavowed feminism in Artemisia's art was made and sustained by artist and public alike.

Nevertheless, the feminist Artemisia could not entirely be suppressed. She may have been kept alive by the artist's resistance to the public identity that had been projected onto her, or by the need to meet demands she helped to create but did not respect. However it is to be explained, the oscillation in Artemisia's art between transgression and conformity never ceased. The decorous but vacant beauties of the early 1640s were followed (if we can believe the attributions) by grotesquely inflated heroines, whose almost comic exaggerations of femininity suggest that their creator not only had ceased to identify with her female characters but may also have mocked privately the shallow expectations of the patrons and flatterers of that now very public "Artemisia" who was partly of their own making. One could understand the Potsdam *Lucretia* (Fig. 57) as a bombastic parody of femininity. We will never know whether it amused or depressed its maker to see that the more she exaggerated her heroine's now very faux-feminine beauty, the more desirable her pictures became.

Over time, the production of art seems to have become for Artemisia more a business than a channel of personal expression. She did not necessarily become less a feminist—we know from her letters that she bristled to the end over gender inequity—but her feminism may eventually no longer have shaped her art.[10] Yet we cannot allow her later practices to overshadow the ambitious originality of her earlier work, or to conceal her consistent choice of themes that supported her own artistic identity formation. If the Burghley *Susanna* in its original state represents the beginning of the artist's concession to market demands, the Seville *Magdalen* attests the continuing reality of her private agenda, which was to paint female characters who were as complex, multi-dimensional, and serious as male characters, and as fully human as the artist herself.

In the spring of 1998, while I was writing this study, a new film on Artemisia opened in American theaters. Centered on the rape and its sexual aftermath, *Artemisia,* by the French filmmaker Agnès Merlet, presents the relationship between Gentileschi and Agostino Tassi as a love story, with Artemisia cast as a romantic heroine and Tassi as a near-blameless romantic hero. Before I was able to see this film that so outrageously distorted history, I read some prere-

lease publicity. As explained by the filmmaker, the film focuses on Artemisia's double initiation at Tassi's hands, into the art of painting and the art of love, presenting transformative sexual initiation as the force that unleashed Artemisia's artistic creativity. Merlet stated that in creating the film, she avoided overhistoricizing it, taking care "not to ground the film in the great currents of thought of that time" in order to preserve her own creative freedom.[11] In so doing, she gave us, not a new concept at all, but a very old cliché.

The film turned out as promised, saturated in the gender stereotypes that the artist seems doomed never to escape. Tassi could not help himself, Merlet has the film say, because Artemisia was sexually provocative. Here was a pure reapplication of the Susanna-as-seductive-woman topos to the painter's own life. In the film, the creation of the Uffizi *Judith* is staged as Artemisia's seduction of Tassi, her model for Holofernes; the painting matters only as a sign of their love affair. Here was a perfect example, in a long line of examples reaching back to the seventeenth century, of resistance to the *Judith*'s subversive content. Through the film's mendacious handling of Artemisia's biography, the artist appeared to have been raped again—as critics were quick to observe[12]—just like Susanna herself, victimized once by rape and again by false publicity.

In the end the film was roundly criticized, at least in America, by an audience familiar with the general outlines of the history of the rape trial.[13] Many of its critics were further outraged that Artemisia, a "feminist icon" (as even the newspapers were now calling her), should have been compromised by an unconscionable resexualization that bepoke complete disdain for her real story. These reactions to the film generated more publicity, and counterreactions from both the filmmaker Merlet and Miramax Zoë, the film's distributor. Merlet insisted that hers was a "feminist film"; Miramax stuck to its initial claim that the film presented a "true story."[14]

Now that the storm of publicity has subsided, what is most astonishing is that the whole affair has perpetuated the dynamic I have described. Why, journalists asked, did Merlet play so fast and loose with the truth? One answer might be that the filmmaker pandered to the desires of a masculinist market, as Artemisia herself had had to do. But this only reminds us that our culture is still controlled by masculinist values. In a modern context that remains essentially unchanged, Artemisia's art (to which the filmmaker admits a powerful yet unexplained attraction) might be said to call perpetually for its own recasting. As the embodiment of a fundamental cultural critique, it is an art that demands either accep-

tance on its own inflammatory terms or neutralizing displacement by the sexualization of the artist. Like so many before her, Merlet chose the latter option.

It is now Artemisia's turn to respond, and in her absence, this part is taken up by her modern feminist defenders, who escalate the parry-and-thrust, criticizing the film's misrepresentation of the reality of the rape and insisting, once again, that Artemisia was sexually innocent. But why is she on trial here? Like Artemisia herself, we defenders are obliged to dwell, not on the art but on the rape, even in our resistance to its distortion of her identity. We too are forced to react in the terms set (in reaction) by the fashioners of Artemisia's identity, to respond both against and to the film's allegations, ever and always mired in a discourse about sexuality and feminism that holds these terms in a perpetual false opposition.

As I have outlined the cause-and-effect sequence, it might seem that the construction of this opposition is ultimately to be traced to Artemisia herself. We must remember, however, that she did not invent gender stereotypes, and she is not responsible for the patriarchal power system. Like all socially sensitive artists, Artemisia made pictures that encapsulated realities of her own culture. If her art makes us think and talk about sexual violence, stereotypical femininity, the beauty myth, and, most of all, about feminism, it must be conceded that she has given the early twenty-first century a semiological blueprint for a discussion that is, unfortunately, still relevant and meaningful.

In the wake of the unusual publicity generated by this film, as well as the forthcoming exhibition, there will be a growing market for "new" paintings by Artemisia Gentileschi, ripe to be fed by anything that can be credibly passed off as a work of the artist. For this reason, I hold up a large red flag, urging closer scrutiny of images that "look like her," particularly when they represent beautiful women. Moreover, as the case of the Burghley *Susanna* shows, Artemisia's signature had a particular value that may have encouraged its false attachment to works not by her hand. For this reason, no attribution should be accepted solely on the strength of a signature, especially if it is dubious on other grounds.

R. Ward Bissell's catalogue raisonné now serves as the critical tool for reframing the process of establishing Artemisia's definitive oeuvre. The essays in this book are conceived as a complement to his study, as a diagnostic demonstration by example of the conceptual standards and problematic considerations that must be taken into account for each future attribution.

NOTES

PREFACE

1. See, for example, Laurie Schneider Adams, *Art and Psychoanalysis* (New York: HarperCollins, 1993), 303–11; and Mieke Bal, "Seeing Signs: The Use of Semiotics for the Understanding of Visual Art," in *The Subjects of Art History: Historical Objects in Contemporary Perspective,* ed. Mark A. Cheetham, Michael Ann Holly, and Keith Moxey (Cambridge: Cambridge University Press, 1998), 74–93.

2. For example, Bal, as in note 1 and in other writings; Nanette Salomon, "The Art Historical Canon: Sins of Omission," in *(En)gendering Knowledge: Feminists in Academe,* ed. Joan Hartmann and Ellen Messer-Davidow (Knoxville: University of Tennessee Press, 1991), 222–36; and Griselda Pollock, *Differencing the Canon: Feminist Desire and the Writing of Art's Histories* (London: Routledge, 1999), chaps. 5 and 6, which expand upon her review of my Gentileschi book (*Art Bulletin* 72 [1990]: 499–505).

3. See Norma Broude and Mary D. Garrard, eds., *The Expanding Discourse: Feminism and Art History* (New York: HarperCollins, 1992), 4.

INTRODUCTION

1. Roberto Longhi, "Gentileschi padre e figlia," *L'Arte* 19 (1916): 245–314; R. Ward Bissell, "Artemisia Gentileschi—A New Documented Chronology," *Art Bulletin* 50 (1968): 153–68. Mina Gregori, Erich Schleier, and Nicola Spinosa are among those who have contributed to Gentileschi connoisseurship in occasional articles and catalogue entries. Mary D. Garrard, *Artemisia Gentileschi: The Female Hero in Italian Baroque Art* (Princeton, N.J.: Princeton University Press, 1989); Roberto Contini and Gianni Papi, *Artemisia,* exh. cat., Florence, Casa Buonarroti, 18 June–4 November 1991 (Rome: Leonardo–De Luca Editori, 1991).

2. R. Ward Bissell, *Artemisia Gentileschi and the Authority of Art: Critical Reading and Catalogue Raisonné* (University Park: Pennsylvania State University Press, 1999). The Artemisia and Orazio Gentileschi exhibition, organized by Judith W. Mann, opens in Rome in the fall of 2001 and travels to the Saint Louis Art Museum and the Metropolitan Museum of Art, New York, in 2002.

3. Mary D. Garrard, "Artemisia and Susanna," in *Questioning the Litany: Feminism and Art History,* ed. Norma Broude and Mary D. Garrard (New York: Harper and Row, 1982), 146–71. Although Ward Bissell (1999, 2–10) has reaffirmed the attribution of the *Susanna* to Artemisia, his arguments point more logically to Orazio as the author. Bissell doubts that the picture's expression indicates a female hand, suggesting that it might "document Orazio's sensitivity to what Artemisia had been through"; he finds bias in my alleged presupposition "that a man would have been incapable of empathizing with Susanna's dilemma." Space does not permit me to engage Bissell's position on the *Susanna,* except to point out that my argument is misrepresented. I did not say that a man would have been incapable of identifying with the heroine's plight but only that, given a choice between these two candidates for authorship, I think Artemisia more likely to have painted it, considering our knowledge of the oeuvre of both artists and the general predisposition of each sex to empathize with its own.

4. I am thinking particularly of the work of John Shearman and Konrad Oberhuber.

5. My term is "gender identification," as opposed to (biological) gender identity, because certain male artists (for example, Gerrit van Honthorst) portray women with greater sensitivity and less reliance upon stereotype than certain females (for example, Elisabetta Sirani).

6. Erwin Panofsky, "The History of Art as a Humanistic Discipline," in *Meaning in the Visual Arts* (Garden City, N.Y.: Doubleday, 1955), 22.

7. Filippo Baldinucci, *Notizie de' professori del disegno da Cimabue in qua,* in *Opere di Filippo Baldinucci* (Milan: Società tipografica de' Classici italiani, 1802–12), 11:11–13. Baldinucci tells the story that a certain artist, G. F. Romanelli, depicted Artemisia in the act of painting a still life (see Garrard, 1989, 83–84). On Artemisia and still life, see Contini and Papi, 1991, 54–58; and Bissell (1999, 105–8), who sensibly debunks the accuracy of Baldinucci's vignette and argues that the writers (Alessandro da Morrona and Baccio Dal Borgo) who perpetuated the legend of Artemisia as a still-life painter may have confused her with her contemporary Giovanna Garzoni. Bissell also acknowledges (44–45) that Artemisia's reputation as a portrait artist, though based on known examples, was probably exaggerated by Baldinucci and Morrona.

8. John T. Spike, "Florence, Casa Buonarroti, Artemisia Gentileschi," *Burlington Magazine* 133 (1991): 732. For X-rays of the Naples *Judith* (and ascription of its originality to Artemisia), see Garrard, 1989, 307 ff. and Figs. 18 and 274. I am happy to see that Bissell (1999, cat. 4), has also rejected this rather absurd argument.

9. Two publications by Fredrika H. Jacobs take up these issues in some depth: "Woman's Capacity to Create: The Unusual Case of Sofonisba Anguissola," *Renaissance Quarterly* 47 (1994): 74–101, and *Defining the Renaissance Virtuosa* (Cambridge: Cambridge University Press, 1997), chap. 3.

10. Spike, 1991. For a selection of earlier writers who have ascribed the design of the

Susanna to Orazio, see Garrard, 1989, 184. My own position is that Orazio may have helped in the execution but not the design of this early essay by his pupil.

11. Garrard, 1989, appendix A, no. 25.

12. Annibale Caro, for example, wrote to the father of Sofonisba Anguissola that he delighted in owning female self-portraits, such as those by his daughter, which he could exhibit as "two marvels, one the work itself, the other its painter."For other examples and discussion, see Mary D. Garrard, "Here's Looking at Me: Sofonisba Anguissola and the Problem of the Woman Artist," *Renaissance Quarterly* 47 (1994): 556–622.

13. Garrard, 1989, appendix A, no. 16. Self-portraits by Artemisia were also owned by Fernando Afám de Ribera, duke of Alcalá (see Chapter 1 and, on the self-portraits, Chapter 1, note 4); King Charles I (as *The Allegory of Painting*); and Don Antonio Ruffo (perhaps unfinished; mentioned in a letter [Garrard, 1989, no. 17]).

14. See Garrard, 1989, 63–64, 172–74. The Venetian poems are discussed below. Bissell (1999, 39) suggests that Dumonstier's mention of "les mains de l'Aurore" refers to Homer's "rosy-fingered Dawn," which may be so, but if the Frenchman was acquainted with Artemisia's *Aurora* (dated by Bissell 1625–27), the allusion was surely meant to include it.

15. See Garrard, 1989, 173–74; and Garrard, 1994. The physical beauty of certain male artists was also celebrated—Leonardo da Vinci comes to mind—but that was not virtually all that was said about them, as it tended to be for the women.

16. Elizabeth Cropper, "The Beauty of Woman: Problems in the Rhetoric of Renaissance Portraiture," in *Rewriting the Renaissance: The Discourses of Sexual Difference in Early Modern Europe,* ed. Margaret W. Ferguson, Maureen Quilligan, and Nancy J. Vickers (Chicago: University of Chicago Press, 1986), 175–90; and Garrard, 1994.

17. One might say that the choice of the painting is understandable since it is in Casa Buonarroti, but the keynote image the exhibition's organizers were justified in selecting was exploited by the commercial enterprises accompanying the exhibit.

18. See, for example, James M. Saslow, " 'Disagreeably Hidden': Construction and Constriction of the Lesbian Body in Rosa Bonheur's *Horse Fair,*" in *The Expanding Discourse: Feminism and Art History,* ed. Norma Broude and Mary D. Garrard (New York: HarperCollins, 1992), 187–205. Bonheur herself must have felt the need to personalize Edward-Louis Dubufe's vapid portrait, for as Norma Broude informed me, she replaced a table in his painting with a bull, a signature feature that helped offset an image of conventional femininity.

19. To choose only examples from the Contini and Papi catalogue (without implying that the authors are uniquely prone to this bias), see the *Apollo and Marsyas* (cat. 25), an attribution that has been roundly challenged; the *Madonna with Cherries* (cat. 14); the *Female Martyr* (cat. 16); and the portrait of a child (cat. 23; presented as a work possibly by Artemisia).

20. I thank Judith Mann for the information that the Escorial *Madonna* bears the signature "Artemitia Gentileschi" (which was not legible to my eye in the museum). See Bissell (1999, cat. 51) for the picture's provenance and the literature. Evelina Borea ("Caravaggio e la Spagna: Osservazioni su una mostra a Siviglia," *Bollettino d'arte* 59 [1974]: 46–47) was alone among scholars in explicitly questioning

the *Madonna*'s attribution to Artemisia, arguing that it was painted by Angelo Caroselli, the "showy signature" added "to increase its value." Bissell considers it a late work by Artemisia, identical with both a small Madonna promised to her Sicilian patron, Don Antonio Ruffo, in August 1650 and a small picture on copper mentioned in a letter of January 1651. This documentation, as well as the repetition of certain Artemisian motifs in the mother's pose, also noted by Bissell, would not preclude the possibility that the Escorial painting is a weak replica of a lost original by Artemisia.

21. Bissell, 1999, cat. X-6. Here Bissell, usually very careful in framing stylistic arguments, fails to support the attribution to Orazio in these terms, giving insufficient weight to the dates of the works he compares, the *Cleopatra* of ca. 1621 and works by Artemisia from the late 1620s.

22. See Bissell, 1999, cats. 1 and X-19, for his own and prior opinion on the two paintings and his useful outline of scholarly positions. The alternative candidate for both pictures has most frequently been Giovanni Francesco Guerrieri. Bissell notes that the strongest arguments for Artemisia as author of the Pitti painting have come from Borea and Roberto Contini and of the Spada painting, from Giovanni Papi and from me. Contini and Papi are unusual in ascribing both pictures to Artemisia. It should be noted that originality was not the issue for Bissell, who sees the Spada picture's stronger design as a conservative feature and the Pitti's weaker design as a sign of Artemisia's "willingness to experiment."

23. The inventory descriptions read as follows: "Una Madonna d'Artemisia Gentilesca con un putto in braccio" and "Una Santa Cecilia della medisima sone il leuto simile grandezza." In 1637 Biffi's collection was pawned *(dato in pegno)* to the Veralli family; a Veralli heir, Maria, married Orazio Spada on 6 January 1636. In the absence of further documents, Papi concludes that Biffi was unable to redeem his pictures and that they went through Maria into the Spada collection. I am grateful to Gianni Papi for sharing this information prior to its appearance in his review of Bissell's book of 1999 (*Burlington Magazine* 142 [2000]: 450–53).

24. See Bissell, 1999, cat. X-28, for the literature. Alternatives to the Artemisia attribution that have been proposed for the Spada *Lute Player* include Orazio Gentileschi, Giovanni Baglione, Angelo Caroselli, and Anteveduto Grammatica.

25. Especially the 1610 *Susanna,* the Pitti *Magdalen,* and the *Allegory of Inclination.* See Garrard, 1989, 23–25, 230.

26. Valeria Finucci, *The Lady Vanishes: Subjectivity and Representation in Castiglione and Ariosto* (Stanford, Calif.: Stanford University Press, 1992), 6.

27. Contini and Papi (1991) exemplify this approach, especially in their two biographical essays, but they are hardly unique. Bissell (1999) has discussed expressive elements of Artemisia's art, yet his narrative account of the motivations for her stylistic variations and development remains driven primarily by the desires of her patrons.

28. See, for example, Contini and Papi's description (1991, 110) of my *"filofemminista"* perspective on the 1610 *Susanna* as sometimes distracted from the "main argument" by a factional battle on behalf of women's equality. For Richard E. Spear (*The "Divine" Guido: Religion, Sex, Money and Art in the World of Guido Reni* (New Haven, Conn.: Yale University Press, 1997), 345 n. 53), my readings of Artemisia "tend to press biography and a feminist agenda onto images that rarely support [my] interpretations."

29. I cite only a sampling of modern texts on the Renaissance gender discourse: Ian Maclean, *The Renaissance Notion of Woman* (Cambridge: Cambridge University Press, 1980); Patricia Labalme, "Venetian Women on Women: Three Early Modern Feminists," *Archivio veneto* 152 (1981): 81–109; Beverly Allen, Muriel Kittel, and Keala Jewell, eds., *The Defiant Muse: Italian Feminist Poems from the Middle Ages to the Present* (New York: Feminist Press, 1986); Constance Jordan, *Renaissance Feminism: Literary Texts and Political Models* (Ithaca, N.Y.: Cornell University Press, 1990); Pamela Benson, *The Invention of the Renaissance Woman: The Challenge of Female Independence in the Literature and Thought of Italy and England* (University Park: Pennsylvania State University Press, 1992); James Grantham Turner, ed., *Sexuality and Gender in Early Modern Europe: Institutions, Texts, Images* (Cambridge: Cambridge University Press, 1993). For an overview of the gender battles waged in treatises of the sixteenth and seventeenth centuries, see Garrard, 1989, chap. 2.

30. See Steven Shapin, *The Scientific Revolution* (Chicago: University of Chicago Press, 1996), intro., esp. 4–8. Shapin summarizes succinctly: "In the seventeenth century the word 'science' (from the Latin *scientia,* meaning knowledge or wisdom) tended to designate any body of properly constituted knowledge . . . while inquiries into what sorts of things existed in nature and into the causal structure of the natural world were referred to, respectively, as 'natural history' and 'natural philosophy.' . . . The term 'scientist' was invented only in the nineteenth century and was not in routine use until the early twentieth."

31. Bissell, 1999, 117–19.

32. Artemisia Gentileschi, letters to Don Antonio Ruffo, Garrard, 1989, appendix A, nos. 24 and 21. For Bissell (1999, 117–18), these exclamations are defensive reactions to male attitudes and therefore (bewilderingly) do not represent feminist expression, which apparently requires uncomplicated and socially rootless self-assertion.

33. Bissell, 1999, 133.

34. See, for example, the reviews of my book by Richard E. Spear, *Times Literary Supplement* (2–8 June 1989): 603–4; and by Kristen Lippincott, *Renaissance Studies* 4 (1990): 444–48. In an article Judith W. Mann challenges autobiographical explanations of Artemisia's art, which she explicitly identifies with feminist interpretations, as somehow echoing "past restrictive readings of women's art as a reflection of inferior intellectual capabilities." I fail to follow her reasoning in this, but her desire to save Artemisia from "femininity" (projecting it instead onto Caravaggio) depends upon a dangerously narrow equation of intellectual strength with copying elevated models and avoiding allusion to personal experience ("Caravaggio and Artemisia: Testing the Limits of Caravaggism," *Studies in Iconography* 18 [1997]: 161–85). Griselda Pollock, in her review of my Gentileschi book (*Art Bulletin* 72 [1990]: 499–505), also objected to my connecting Artemisia's biography with the expression of her art. Her perspective was that of a feminist who feared that I had ahistorically essentialized gender difference. Desiring to rescue Artemisia's art from being merely "the expression of an individual creator," Pollock wanted to subsume the artist in a psychoanalytic theory that, despite her claims for its greater historicism, assumes that "sexual difference must be perpetually produced." Thus she would flatten a historically unique figuration of sexual difference into a psychological universal. Pollock accurately observed that my book does

not analyze Artemisia's negotiation of specific socio-economic conditions; this book now moves in that direction to the extent that evidence permits. Pollock's view, however, that the real challenge is to interpret iconographic changes in female imagery as symptoms of "deeper transformations . . . [in] that emergent capitalist world of 16th- and 17th-century Italy" reflects an agenda that is simply different from mine, one that is destined from the start to screen out the sound of the individual voice, which in Artemisia's case, ironically, is the voice of feminism. In a later essay on Artemisia (in *Differencing the Canon*), Pollock modified her position. See the Preface to this book for discussion.

35. "Ogni dipintore dipigne sè," ascribed to Cosimo de' Medici, was recorded by Angelo Poliziano. See Rudolf Wittkower and Margot Wittkower, *Born under Saturn: The Character and Conduct of Artists: A Documented History from Antiquity to the French Revolution* (New York: Norton, 1963), 94; and Martin Kemp, " '*Ogni dipintore dipinge sè': A Neoplatonic Echo in Leonardo's Art Theory*," in *Cultural Aspects of the Italian Renaissance: Essays in Honour of Paul Oskar Kristeller,* ed. Cecil H. Clough (New York: Zambelli, 1976), 311–23.

36. See especially Christopher Fulton, "The Boy Stripped Bare by His Elders: Art and Adolescence in Renaissance Florence," *Art Journal* 56 (1997): 31–40.

37. Vasari first pointed out Michelangelo's inclusion of his own face as Nicodemus in the Florentine *Deposition.* On Michelangelo's possible affiliation with the Nicodesmi, a Catholic reform group deemed heretical by the Counter-Reformation Church, see Valerie Shrimplin-Evangelidis, "Michelangelo and Nicodemism: The Florentine *Pietà*," *Art Bulletin* 71 (1989): 57–67.

38. *The Age of Caravaggio and the Carracci: Emilian Painting of the Sixteenth and Seventeenth Centuries,* exh. cat. (Washington, D.C.: National Gallery of Art; New York: Metropolitan Museum of Art; and Milan: Electra Editrice, 1985), 338–41, summarizes interpretations of Caravaggio's fusion of his face with Goliath's.

39. Charles Seymour, Jr., *Michelangelo's David: A Search for Identity* (Pittsburgh: University of Pittsburgh Press, 1967).

40. See *Age of Caravaggio,* 338.

41. Cf. Finucci, 1992, 4.

42. On these works, and on visual references to the goddess Artemis (related to the painter by name) in the Uffizi and Detroit *Judith*s, see Garrard, 1989, chap. 5. Laurie Schneider Adams, *Art and Psychoanalysis* (New York: HarperCollins, 1993), 303–11, offers an extended psychological interpretation of Artemisia's *Judith*s.

43. For evidence of Artemisia's frustration, see her letters, nos. 16, 24, and 25 in Garrard, 1989.

44. Bissell (1999, 125 ff.) assesses the importance of the rape for the interpretation of Artemisia's art, examining the claims of both feminist and psychoanalytic writers on the subject. He usefully distinguishes examples of feminist analysis that he seems to consider credible from some fairly preposterous Freudian interpretations. Although such an implicit distinction between approaches does not categorically elevate feminist over psychoanalytic readings, I for one welcome it. In this book, my speculations along certain psychological lines are grounded in broad and generally accepted principles rather than specific psychoanalytic theories. The distinction between "psychoanalytic,"

which is an organized disciplinary perspective, and "psychological," which merely designates a general category of human identity, is important to maintain.

45. For the concepts "absent presence" and "present absence," see Mariann Sanders Regan, *Love Words: The Self and the Text in Medieval and Renaissance Poetry* (Ithaca, N.Y.: Cornell University Press, 1982), chap. 1. Regan uses the terms in a more strictly psychological sense than I do.

46. On Renaissance identity construction as not autonomous but subject to a variety of ideological and power demands, cf. Stephen Greenblatt, *Renaissance Self-Fashioning: From More to Shakespeare* (Chicago: University of Chicago Press, 1980), 162 and passim.

CHAPTER 1

1. The exhibition, "Paint and Passion: Artemisia Gentileschi, Orazio Gentileschi and Agostino Tassi," was held at Richard L. Feigen and Company, 29 April–13 June 1998. The inclusion of the *Magdalen* in that exhibition was a fortuitous coincidence from my point of view, for I began this study in the fall of 1997, focusing on a work I then believed obscure, which has now been seen by a large audience.

2. The new *Magdalen,* oil on canvas, measuring 135.5 × 100 cm, has recently gone to a corporate owner. I first encountered the painting in 1994, then still in the possession of a family in Lyon, France. The owners, who requested anonymity, said that they believed that the picture had come from a Spanish collection but could provide no further information about its provenance. As I discuss below, there is reason to doubt the claim of Spanish provenance for the French *Magdalen,* which may result from knowledge of its connection with the original in Spain.

3. Jonathan Brown and Richard L. Kagan, "The Duke of Alcalá: His Collection and Its Evolution," *Art Bulletin* 69 (1987): 231–55. The Seville *Magdalen* is painted in oil on panel, and measures 115.2 × 92 cm. (Its earlier-published dimensions of 122 × 64 cm are inaccurate.) The description of Artemisia's Magdalen comes from the inventory of Alcalá's house in Seville (Casa de Pilatos), which lists works of art in his palace at the time of his death in 1637. The *Magdalen* in the Seville cathedral has been published by Enrique Valdivieso (*Catálogo de las pinturas de la catedral de Sevilla* [Seville: Enrique Valdivieso Autor y Editor, 1978], 131), who noted its general correspondence to Artemisia's style while suggesting that it might be a copy of an unknown Gentileschi original.

4. The following works by or after Gentileschi are named in the inventory: (1) a copy after Artemisia of "the Savior blessing some young boys with his right hand" (the inventory states that the original had been given to the Cartuja de Santa María de las Cuevas); (2 and 3) two portraits of Artemisia ("Retratto de Artemissa gentilesca pintora Romana" and "un rretratto de Artemissa gentilesca"), presumed by Brown and Kagan to have been self-portraits since no artist's name is given; (4) a *Saint John Baptist* by Artemisia; and (5) a half-length figure of David holding a harp, by Artemisia (listed only in an inventory of 1711). Brown and Kagan note that the listing of works by and

after Artemisia Gentileschi without crate numbers in the inventories indicates that they were purchased in Rome rather than later in Naples.

5. Brown and Kagan, 240. Artemisia arrived in Naples in late 1629, a few months after Alcalá; see Bissell, 1999, 56–57, and the recent biography by Alexandra Lapierre (*Artemisia: Un duel pour l'immortalité* [Paris: Robert Laffont, 1998], 473–75). Lapierre has found documentation establishing that by 1627 Artemisia had left Rome (she was no longer listed as a resident of Via del Corso). In the winter of 1626–27, she was already in Venice, her presence confirmed in letters published in 1627 by a certain Antonio Colluraffi, who recommended her to an artistic disciple as a talented artist established in Venice. She is documented in Venice in 1628 (see Bissell, 57 and L-40).

6. Bissell's arguments (1999, 70–72 and cat. 28) for dating the *Esther* to Artemisia's first Neapolitan period (he puts it at 1630–35) have obliged me to advance my previous dating of the work from 1622–23 to ca. 1630. As Bissell points out, Ahasuerus's Caravaggesque costume could be explained as an ornamental Caravaggism inserted to suit *retardataire* Neapolitan taste. A dating at the end of the 1620s would account for the influence of Veronese's *Esther* as a consequence of her Venetian sojourn, now datable approximately 1627–29 (see note 5). Artemisia's *Esther,* moreover, is logically contemporary with the *Cleopatra* formerly in London (Bissell, cat. 22), both for the steep facial foreshortening and the diminutive maidservants.

7. To be considered is Bissell's new dating of the *Lucretia* to ca. 1611 and his attribution of the *Cleopatra* to Orazio Gentileschi (1999, cats. 3 and X-6). Against his own earlier theory, Bissell now argues that both pictures arrived in Genoa long before Orazio (and putatatively, Artemisia) went there in 1621. I am not persuaded by his redating of the *Lucretia,* which is grounded largely in his stylistic connection of this work with the 1610 *Susanna.* In addition to significant formal differences between these works, particularly in color and lighting, the *Lucretia* is more like Artemisia's works of the late teens and early twenties: in chiaroscuro and facial features it is related to the 1620 Uffizi *Judith;* and in the figure's pose, to the Pitti *Magdalen* of 1617–20. Bissell is right that the *Lucretia* and Pitti *Magdalen* "are not of the same lineage," but their difference can be accounted for by the Florentine stylistic interlude, which ended on Artemisia's return to Rome, as the Bologna *Gonfaloniere* of 1622 and the Detroit *Judith* (dated by Bissell 1623–25 and by me and others ca. 1625) demonstrate. It is also not logical to preclude the *Lucretia* from an early 1620s dating simply because its orientation differs from that of the Princeton *Venus and Cupid,* the *Cleopatra* formerly in London, and the newly discovered *Magdalen* in Naples, all reclining figures, dated by Bissell in the later 1620s. The *Lucretia* shares a vertical format with the Detroit *Judith* and, more important, with the Seville and French *Magdalens,* which Bissell dates ca. 1625–26. His arguments for redating the Genoese *Cleopatra* to 1611–12 are even less convincing, following from his recognition of its stylistic relationship to the *Lucretia* (despite their different authorship, in his view!), and its stylistic divergence from the three reclining figures cited above. Apart from the weakness of at least one of these attributions, the *Cleopatra*'s stylistic divergence from them is understandable, since it would be separated from them by a gap of four to eight years, even by Bissell's dating.

8. The Uffizi *Judith* and the Budapest *Jael and Sisera* are exceptions in that their com-

positions derive from other works—the Uffizi *Judith* repeats the design of the Naples *Judith* of ca. 1612; I discuss the *Jael* later in this chapter.

9. Bissell, 1999, cats. 16 and 17. We lack a clear chronological sequence for Artemisia's works of the 1620s because, apart from the dated *Jael* of 1620 and *Gonfaloniere* of 1622, there are no certain reference points or names of patrons other than Pietro Gentile and the duke of Alcalá. Other points in favor of the *Magdalen*'s early 1620s dating is its compositional relationship to Florentine models and its possible use as a model by Guercino in a work of 1621 (both discussed later in this chapter).

10. Before seeing the Seville picture, I had believed that the French version was Artemisia's original painting, from which the second version was made (indirectly, a testament to the quality of the French painting, which I first saw before its conservation). Bissell's premature publication of my opinion (1999, cat. 17), given to him in an informal telephone conversation, represents that stage of my thinking. I should also mention that Ann Sutherland Harris observed to me when the French painting was on display in New York that it looked to her like a copy, not an original.

11. Three other passages in the Seville picture are also restorations, perhaps from the time that drapery was added over the breast. First, in the lower right corner of the painting, the chair studs are visibly repainted, so that they now appear as virtually blank ovals rather than the light-reflecting convex forms visible in the French version. Second, the curtain at upper right has been reworked in places, which are now less subtly articulated than in its French counterpart, the lighted ridges more generalized and the overall color more opaque, less coloristically diverse. Surface abrasions are still visible on the right edge of this curtain, extending up to the corner and down to the chair arm. Third, the yellowish curved rectangular shape to the right of and behind the figure's back may also be a later addition; in the French picture we see only the dark, carefully articulated chair back and pendant tassels. The yellowish rectangle makes no formal or descriptive sense and was conceivably a restorer's effort to alter the chair back.

12. The French version measures 135.5 × 100 cm, the Spanish, 115.2 × 92. Drawing upon the fuller image presented in the French version, we can infer that the Spanish version was cut approximately fifteen centimeters on the top, about three centimeters on the bottom, and about eight centimeters on the right. If these portions are added back, the picture's measurements would become virtually identical with those of the French version. Overlapping projections of slides of the two paintings reveals that their major contours are identically positioned.

13. The *Magdalen* was still in the duke's estate at his death in 1637. (I am grateful to Jonathan Brown for a copy of the inventory of the Genoa estate sale of 1637, as well as for guidance on Spanish collections and inventories.) After the death of Alcalá's daughter, Maria, in 1638, the remainder of the estate passed to his nephew, Juan Francisco Tomás, a "succession accompanied by numerous lawsuits," during which much of the collection was either dispersed or sold (Brown and Kagan, 236 n. 53). Artemisia's *Magdalen* had certainly left the ducal collections by the eighteenth century, since it was not mentioned in the inventories of 1711 and 1753. A recently published document names a " 'Magdalena' de Artemisia Gentileschi" that in 1680 was in the collection of Don Agustín Carrosio of Seville, a knight of the Order of Santiago. (Juan

Miguel Serrera Contreras, "Nobleza y coleccionismo en la Sevilla del siglo de oro," in Contreras, *Nobleza, coleccionismo y mecenazgo* [Seville: Real Maestranza de Caballeria, 1998], 55.) If this work is identical with the painting now in the cathedral, it must have entered the church after 1680.

14. For this point, I rely upon Enrique Valdivieso's expert knowledge of Sevillian art of the seventeenth century.

15. The figure's round, full chin, downturned mouth, and enlarged eyes connect her as well with a *Saint Catherine of Alexandria* ascribed to Artemisia that was sold at auction (Sotheby's, New York, 24 April 1995); see Bissell, 1999, fig. 233.

16. Bissell, 1999, cat. 17. Bissell also observes that the recent, "rather too earnest," restoration of the French *Magdalen* has "enhanced the impression of slickness." That was my own first impression when I saw the painting after its conservation. Preconservation photographs confirm softer transitions, with flesh and drapery passages that were warmer and less opaque. I am informed by the conservator Sarah Fisher, however, that the picture's present oversharp, flattened, and bright appearance may result from a zealous stripping of the varnish to which modern eyes are accustomed.

17. For assistance in reading the X-rays, and for helpful confirmation of my own interpretations, I am much indebted to a discussion with Sarah Fisher, senior conservator at the National Gallery of Art, Washington, and her colleague Michael Swicklik.

18. Here I allude to the terminology of Arthur Pope, who contrasted the "relief mode" in Italian Renaissance painting (and its counterpart, "form drawing") with the "total visual effect" created by international baroque and later artists (*The Language of Drawing and Painting* [Cambridge, Mass.: Harvard University Press, 1949]). Alois Riegl makes essentially the same distinction, using the terms "haptic" (tactile) and "optic" (*Late Roman Art Industry,* trans. Rold Winkes (Rome: G. Bretschneider, 1985).

19. See Garrard, 1989, fig. 274. I am unaware of any comparable X-ray of the Uffizi *Judith,* which might be telling.

20. The National Gallery conservators noted the addition of the earring and also considered the bracelet a late addition to the Seville picture. In contrast, the drapery over the shoulder was clearly planned for, since an area of dark was reserved for it.

21. The term "buttery" comes from Sarah Fisher, who felt these passages were analogous.

22. See Bissell, 1999, cat. 12, for the dating and history of the Uffizi *Judith.* He argues that this work was painted entirely in Rome, where, he assumes, Artemisia would have had access to her *Judith* now in Naples. The patronage and early whereabouts of the Naples *Judith* are unknown; it is possible that Artemisia never sold it, in which case she might have had the picture with her in Florence.

23. Dimensions of 4×5 (Neapolitan) palmi are equivalent to 105.6×132 cm. The French *Magdalen* measures 100×135.5 cm. (The Roman palmo is 22.34 cm, the Neapolitan, 26.4 cm.)

24. Gérard Labrot, with Antonio Delfino, *Collections of Paintings in Naples, 1600–1780,* ed. Carol Togneri Dowd and Anna Cera Sones, Provenance Index of the Getty Art History Information Program, Documents for the History of Collecting, Italian Inventories I (Munich: K. G. Saur, 1992), cats. 16, 19, 21. Capecelatro presumably purchased his *Magdalen* in Naples, perhaps through previous contact with the recently

deceased artist, whom he could have known through Domenico Gargiuolo (Micco Spadaro, pseud.), who painted landscape backgrounds in Artemisia's Neapolitan pictures. Spadaro's own works figure prominently among Capecelatro's later acquisitions; he was hired by Capecelatro's sons to evaluate the estate after their father's death.

25. Bissell (1999, cats. L-80 and L-81) believes them different paintings, considering their identical dimensions "insufficient evidence to link the two works." An alternative explanation, that Artemisia made a replica of Capecelatro's *Magdalen* for Davide Imperiale (another way of accounting for two *Magdalen*s of the same dimensions in the Neapolitan inventories), is unlikely, however, for it would presuppose her creating a third version of an original over thirty years old. The two *Magdalen*s of the Neapolitan inventories were probably not new compositions because their reported dimensions are at variance with those of the generally larger works from Artemisia's later Neapolitan period.

26. The *Lucretia* is described in the Imperiale inventory as "the same size" as the *Magdalen* (i.e., 4 × 5 palmi), and the Genoa *Lucretia* is comparable in size to the existing *Magdalen*s. The Genoa *Lucretia* was at one time reduced on four sides to the figure only, truncated at midcalf. A later artist augmented the picture to its present format, which measures 137 × 130 cm. We can therefore deduce from the French *Magdalen*'s dimensions that in its original design the Genoa *Lucretia* was about 30 cm narrower than at present and about 2 cm taller. This inference would support Bissell's argument (1999, cat. 3) that the Genoese *Lucretia*'s original format was essentially the same as the present (extended) format.

27. Carlo Giuseppe Ratti, *Instruzione di quanto può vedersi di più bello in Genova in Pittura, Scultura, ed Architettura ecc.*, 2d ed. (Genoa: I. Gravier, 1780), 1:119–20 and 122. See Garrard, 1989, 54–56; and Bissell, 1999, cat. 3.

28. Formal and technical similiarities between the French *Magdalen* and the Genoa *Lucretia* include the delicate parallel pleats falling from the yoke of the chemise.

29. There is reason to suspect that these paintings may have returned to Genoa, into the same circle of collectors. Davide Imperiale died childless; his estate was inherited by his sister Maria Caterina Imperiale, marchesa di Petra, who married a Grimaldi. The Grimaldi and Cattaneo families had intermarried earlier in the century (see Arthur K. Wheelock, Jr., Susan J. Barnes, Julius S. Held, et al., *Anthony van Dyck,* exh. cat. [Washington, D.C.: National Gallery of Art, 1990], cat. 36).

30. On the Pitti *Magdalen,* see Garrard, 1989, 45–48; and Contini and Papi, 1991, cat. 12. Bissell (1999, 26–31 and cat. 10) gives other literature and discusses the possibility that strips added on the left and bottom of the painting, along with the inscription and signature, might be interventions by another hand (though the strip at the left may substitute for damaged original canvas).

 Bissell has attributed two new Penitent Magdalen pictures to Artemisia, one a half-length figure in a private collection in Los Angeles (cat. 9) and the other a reclining figure in a landscape in a private collection in Naples (cat. 2). Although I have seen neither picture in the original, the attributions are not convincing to me, but in any case they came to my attention too late to be included in this discussion.

31. On Justus Sustermans's portrait of Maria Maddalena as the Magdalen, previously thought to be Vittoria della Rovere, see Susan Haskins, *Mary Magdalen: Myth and*

Metaphor (New York: Harcourt Brace, 1993), 298–99; Marilena Mosco, ed., *La Maddalena tra Sacro e Profano* (Milan: Arnoldo Mondadori Editore, 1986), 236; and Marco Chiarini and Claudio Pizzorusso, eds., *Sustermans: Sessant'anni alla corte dei Medici* (Florence: Centro Di, 1983), cat. 14.

32. Garrard, 1989, 46; Chiarini and Pizzorusso, cat. 14.

33. Haskins, 114.

34. A lucid account of this complex story is given by Haskins, chap. 1. Other useful general sources on Magdalenean iconography include Victor Saxer, *Le culte de Marie Madeleine en Occident: Des origines à la fin du Moyen Âge* (Auxerre: Publications de la Société des fouilles archéologiques et des monuments historiques de l'Yonne, 1959); Marjorie M. Malvern, *Venus in Sackcloth: The Magdalen's Origins and Metamorphoses* (Carbondale: Southern Illinois University Press, 1975); Eve Duperray, ed., *Marie Madeleine dans la mystique, les arts et les lettres,* Actes du colloque international, Avignon, 20–22 July 1988 (Paris: Beauchesne Éditeur, 1989).

35. Luke 10: 38–42, John 11:1. See also Haskins, 20–22; 109, 182, who traces Mary of Bethany as a symbol of the contemplative life to Origen.

36. Garrard, 1989, 47.

37. On these developments and Artemisia's subsequent reputation, see Garrard, 1989, 20 ff. and 137–38.

38. See Guy de Tervarent, *Attributs et symboles dans l'art profane, 1450–1600* (Geneva: Librairie E. Droz, 1958); see also Heinrich Schwarz, "The Mirror in Art," *Art Quarterly* 15 (1952): 97–118; Ellen Kosmer, "The 'Noyous Humoure of Lecherie,'" *Art Bulletin* 57 (1975): 1–8; and François Rigolot, "Magdalen's Skull: Allegory and Iconography in *Heptameron* 32," *Renaissance Quarterly* 47 (1994): 57–73. John T. Spike (1991) has proposed that Artemisia's Pitti *Magdalen* may originally have been intended as a Vanitas. Although I am not convinced of this reading, the very possibility of confusing a Magdalen with a Vanitas demonstrates their iconographic relationship.

39. Elizabeth Cropper, "New Documents for Artemisia Gentileschi's Life in Florence," *Burlington Magazine* 135 (1993): 760–61.

40. Letter to Duke Cosimo II de' Medici, 10 February 1619; see Garrard, 1989, 377.

41. On the index in the semiotic philosophy of Charles Saunders Peirce, see Margaret Iversen, "Saussure v. Peirce: Model for a Semiotics of Visual Art," in *The New Art History,* ed. A. L. Rees and Frances Borzello (Atlantic Highlands, N.J.: Humanities Press International, 1988), 82–94, esp. 89.

42. Wölfflin's remark is cited by Mosco, 192.

43. Castiglione's characterization of the Magdalen (*The Book of the Courtier,* ed. and trans. Charles S. Singleton [New York: Doubleday, 1959], bk. 4, p. 358) is cited by Haskins, 239, who discusses this and other equations of the Magdalen and Venus in the broader context of Neoplatonist doctrines of love and beauty.

44. On the Venetian *Magdalen*s, see Haskins, 276 ff.; and on Titian's *Magdalen,* Haskins, 239–45; and Mosco, 192–95. In counterpoint, Veronica Franco and other female writers offered a proto-feminist perspective on the iconic Venus and her intersection with Venetian prostitutes; see Margaret F. Rosenthal, "Venetian Women Writers and Their Discontents," in Turner, 1993, 107–32.

45. Molanus inveighed against indecently dressed Magdalens, while Cardinal Paleotti

attacked artists who painted her as a concubine. Cited by Odile Delenda, "Sainte Marie Madeleine et l'application du décret tridentin (1563) sur les saintes images," in Duperray, 1989, 196. On Cardinal Baronius's insistence that Mary Magdalene was not a whore, see Howard Hibbard, *Caravaggio* (New York: Harper and Row, 1983), 51.

46. See Haskins, 248 ff.; Romeo De Maio, "Il mito della Maddalena nella Contrari-forma," in Mosco, 82–83; and Delenda, in Duperray, 1989, 191–210.

47. On Orazio Gentileschi's Fabbriano *Magdalen,* see R. Ward Bissell, *Orazio Gen-tileschi and the Poetic Tradition in Caravaggesque Painting* (University Park: Pennsylvania State University Press, 1981), 143.

48. The *Magdalen* here illustrated, ascribed to Valerio Marucelli, is one of a large group of copies after Correggio's *Magdalen* in Dresden, made by Cristofano Allori and others on the request of Allori's Medici patrons. (See Miles L. Chappell, *Cristofano Al-lori, 1577–1621,* exh. cat., Florence, Palazzo Pitti, July–October 1984 [Florence: Cen-tro Di, 1984], cat. 5.) Other highly eroticized *Magdalen*s of the period include one of Allori's own design (Palazzo Pitti; Mosco, cat. 98), another by Sigismondo Coccopani (Mosco, 171), and an overtly sexual *Magdalen* by Francesco Furini (Kunsthistorisches Museum, Vienna), which was painted in 1633, the very year the artist was ordained as a priest (Haskins, 265).

49. G. P. Bellori, *Le vite de' pittori, scultori ed architetti moderni* (Rome, 1672), quoted in Hibbard, 50–51. For other dimensions of the iconography of the Doria *Magdalen,* see Maurizio Calvesi, "La Maddalena come 'Sposa' nei dipinti del Caravaggio," in Mosco, 147–51; and Pamela Askew, "Caravaggio: Outward Action, Inward Vision," in *Michelangelo Merisi da Caravaggio: La vita e le Opere attraverso i Documenti,* Atti del Convegno Internazionale di Studi, Rome, 1995 (Rome: Logart Press, 1995), 248–69; esp. 248–49.

50. On the Magdalen's popularity, see Haskins, 141–45.

51. Pamela Askew, *Caravaggio's "Death of the Virgin"* (Princeton, N.J.: Princeton University Press, 1990), chap. 6. Through such institutions, as through the increasingly prevalent images of the Magdalen, the Church upheld the ideals of penitence, chastity, and redemption, ideals that, not incidentally, also fostered the social control of prosti-tution. Although the *Death of the Virgin* was no longer in Rome when Artemisia re-turned, having been taken to Mantua by Rubens, its public display in 1607 would have been a memorable event for any artist.

52. Maurizio Calvesi, 1986; see also Frederick J. Cummings, with contributions by James L. Greaves and Meryl Johnson, Luigi Spezzaferro, and Luigi Salerno, "Detroit's 'Conversion of the Magdalen' (the Alzaga Caravaggio)," *Burlington Magazine* 116 (1974): 563–93. The divine validation of Mary's choice is expressed in the orange blossom she holds, symbol of her mystic marriage with Christ. On the mirror as a sign of the contemplative life and an attribute of Wisdom, see Calvesi and Cummings; on the Early Christian association between the Magdalen and Sophia (Divine Wisdom), see Haskins, 48–53, 57.

53. On Caravaggio's *Saint Mary Magdalene in Ecstasy,* painted in the summer of 1606 when the artist was in flight from Rome, see Hibbard, 209–11; and *The Age of Caravaggio,* 1985, cat. 89, entry by Mina Gregori, who considers the version included in the exhibition (private collection, Rome) to be Caravaggio's original. On the two

copies by Louis Finson (one in a private collection in Aix-en-Provence, the other in Marseilles, Musée des Beaux-Arts), see Mosco, 164–65.

54. Hibbard, 211.

55. Haskins, 155, 177–84; and on the Magdalen's general association with weeping, Haskins, 187–91 and chap. 7. On Teresa of Avila's devotion to the Magdalen, see also Askew, 1990, 99–100.

56. Francisco de Hollanda, *Four Dialogues on Painting,* trans. Aubrey F. G. Bell (London, 1928; reprint, Westport, Conn.: Hyperion Press, 1979), 15–18.

57. Barry Wind, "Gesture and Meaning in Two Paintings by Caravaggio," *Source* 16 (1997): 7–11. Characteristically, Caravaggio evoked a humility that was not absolute. Wind suggests that the carved finial of the Doria Magdalen's chair hints at the patrician pedigree fashioned for Mary Magdalene in the *Golden Legend,* which says she was "born of noble station, and came of royal lineage."

58. Askew, 1990, 98–99; the quoted phrase is hers. The *revelatio* suggested by the Magdalen's open eyes is a detail that also departs from every one of the models shortly to be discussed (those of Marcantonio, Michelangelo, and Boschi).

59. On the relevance of Michelangelo's Sistine Chapel ceiling to the creation of Artemisia's 1610 *Susanna,* see Garrard, 1989, 24–25.

60. Henri Zerner (*The French Renaissance in Prints* [Los Angeles: Grunwald Center for the Graphic Arts, 1995], cat. 53) supported Jules Renouvier's attribution of this etching to the Master L. D., now known to be Léon Davent, and placed its execution in France in the mid–sixteenth century. The print is inscribed "Micha.Ange. bonarotanus.Florentinus Sculptor optimus anno aetatis sue 23." Zerner tentatively suggested that anachronistically giving the artist's age as twenty-three (which he was in 1498) may have been a reference to the year Michelangelo's Vatican *Pietà* was commissioned by a French cardinal, perhaps a date of special importance to a French audience. Alternatively, the print could have been based on an earlier image.

61. David Summers ("Form and Gender," *New Literary History* 24 [1993]: 243–71) and other scholars have recognized that the Michelangelo print was inspired by Marcantonio's *Saint Helena.* George Hill (*Portrait Medals of Italian Artists of the Renaissance* [London: P. L. Warner, 1912], 61) plausibly argued that it was drawn from an anonymous copy of Marcantonio's print, without the angel (Bartsch, 14:444–45), whose blank upper field suggested the motif of an empty open window. Marcantonio's pensive woman is based, in turn, upon a figure study by Raphael of Saint Helen (later inscribed "Danae") for the vault of the Stanza d'Eliodoro. On the connection between the Marcantonio print and Raphael's Uffizi drawing, see Konrad Oberhuber, "Eine unbekannte Zeichnung Raffaels in den Uffizien," *Mitteilungen des Kunsthistorischen Institutes in Florenz* 12 (1966): 225–44; and Paul Joannides, *The Drawings of Raphael, with a Complete Catalogue* (Berkeley and Los Angeles: University of California Press, 1983), no. 5.

62. Observed by Henri Zerner (1995, cat. 53), who noted that it shows "how strongly the visionary character of Marcantonio's figure was perceived." See also Colin Eisler, *The Master of the Unicorn: The Life and Work of Jean Duvet* (New York: Abaris Books, 1979), no. 39.

63. On the head resting on the hand as a sign of melancholy since antiquity, and on

the Vogelweide miniature, see Ursula Hoff, "Meditation in Solitude," *Journal of the Warburg and Courtauld Institutes* 1 (1938): 292–94; and André Chastel, "Melancholia in Sonnets of Lorenzo de' Medici," *Journal of the Warburg and Courtauld Institutes* 8 (1945): 61–67. Medieval precedents for the hand-to-mouth pose as a sign of visionary revelation are discussed by A. M. Friend, Jr. ("The Portraits of the Evangelists in Greek and Latin Manuscripts," *Art Studies* 5 [1927]: 115–47, esp. 142 ff.), who traces the type to ancient poet and philosopher images; and André Grabar, "Une fresque visigothique et l'iconographie du silence," *Cahiers archaeologiques* 1 (1946): 124–28. I thank Debra Pincus for the latter references, and for showing me the Vogelweide miniature.

64. Saturn's association with melancholy is discussed at length in Raymond Klibansky, Erwin Panofsky, and Fritz Saxl, *Saturn and Melancholy: Studies in the History of Natural Philosophy, Religion, and Art* (New York: Basic Books, 1964); and Wittkower and Wittkower, 102 ff. On the large cloak as Saturn's attribute, see Gerlinde Lütke Notarp, "Jacques de Gheyn II's *Man Resting in a Field:* An Essay on the Iconography of Melancholy," *Simiolus* 24 (1996): 311–19.

65. For the Raphael print, see Bartsch, 14:496. On the tabula rasa in Vincenzo Carducho's *Diálogos de la Pintura* (1633) and its probable origins in earlier cinquecento Italian art theory, see Garrard, 1989, 367–68.

66. Summers (1993, 245–47) notes that night has long been considered feminine in myth and philosophy, e.g., Hesiod's claim that the world was generated from chaos or night. On the connection of the Medici Chapel *Notte* (and also Duke Lorenzo) with melancholy, see Edith Balas, *Michelangelo's Medici Chapel: A New Interpretation* (Philadelphia: American Philosophical Society, 1995), 66–68. For discussion of melancholy in Michelangelo and as applied to the unrequited passions of the female sculptor Properzia de' Rossi, see Jacobs, 1997, chap. 4.

67. Erwin Panofsky, in Klibansky, Panofsky, and Saxl, 284–373; and Panofsky, *The Life and Art of Albrecht Dürer* (Princeton, N.J.: Princeton University Press, 1955), 156–71. For subsequent bibliography, see Patricia Emison, *The Art of Teaching: Sixteenth-Century Allegorical Prints and Drawings* (New Haven, Conn.: Yale University Art Gallery, 1986), cat. 40.

68. Klibansky, Panofsky, and Saxl, 254–74; see also Wittkower and Wittkower, 98, 102 ff.

69. On the effort to raise the visual arts to liberal arts, see Mary D. Garrard, "The Liberal Arts and Michelangelo's First Project for the Tomb of Julius II (with a Coda on Raphael's 'School of Athens')," *Viator: Medieval and Renaissance Studies* 15 (1984): 337–76.

70. As noted by Summers, 1993, 245–47.

71. Boschi's fresco in the Casino Mediceo (today the Corte d'Appello), *La Pittura addormentata e svegliata da Cosimo II,* is discussed by Anna Rosa Masetti, "Il Casino Mediceo e la pittura fiorentina del seicento, I," *Critica d'Arte* 9 (1962): 1–27, esp. 15 ff.; on Boschi, see Giuseppe Cantelli, *Repertorio della pittura fiorentina del seicento* (Florence: Opus Libri, 1983), 26–27.

72. On the iconography of *Pittura,* the allegory of painting, which is drawn from Cesare Ripa's *Iconologia,* see Garrard, 1989, chap. 6; on the bound mouth, p. 346.

73. Like Artemisia, Boschi supplied a painting for the ceiling at Casa Buonarroti

(1622); see Adriaan W. Vliegenthart, *La Galleria Buonarroti, Michelangelo e Michelangelo il Giovane* (Florence: Istituto Universitario Olandese di Storia dell'Arte, 1976), pl. 16 and pp. 126 ff. Artemisia's move from Florence to Rome, where she is first documented in March 1621 (see Bissell, 1999, cat. 12), appears to have occurred before the Casino Mediceo frescoes were painted. The event of Cosimo's death in February 1621 was the motive for the Casino Mediceo series; payments to the artists began in November 1621. The implicit reference to Boschi's *Pittura* in the *Magdalen,* however, suggests that Artemisia may have remained in Florence long enough to see, if not Boschi's *Pittura* fresco, then his preparatory drawing for it, which could have dated from the beginning of the project (Uffizi, no. 9431 F; Masetti, fig. 28). It is also possible that Artemisia revisited Florence after the decoration of the Casino Mediceo and before she painted the Seville *Magdalen.*

74. See Garrard, 1989, chap. 6, esp. 358 ff., for discussion of this painting's iconography, and 84–88, for my dating and connection of the work to the self-portrait Artemisia painted in 1630 for Cassiano del Pozzo. (As suggested below, it is also possible that the Kensington Palace *Self-Portrait* was painted for the duke of Alcalá.) Bissell (1999, 65–67, and cats. 25 and 42) connects the 1630 self-portrait commission for Cassiano with the double portrait of La Pittura painting the image of a male sitter (see Fig. 33), discussed below, and he considers the Kensington Palace picture to date from 1638–39 and to represent the allegory of painting but not Artemisia herself. The 1638 dating of the Kensington Palace painting has been supported by Roberto Contini and Elizabeth Cropper; supporters of the 1630 dating include Oliver Millar, Richard Spear, Barbro Werkmaster, and Susanna Stolzenwald (see Bissell, cat. 42, for citations).

75. On the attributes of Pittura according to Cesare Ripa's *Iconologia,* see Garrard, 1989, 337–39.

76. John Spike has informally attributed the work to Artemisia; I have disagreed, proposing instead an artist such as Sigismondo Coccopani or Giovanni Battista Guidoni. For one thing, right-handed artists who paint themselves painting usually do not bother to re-reverse the mirror image and so come out looking left-handed, which is not the case here. Moreover, the eyes in self-portraits usually stare directly at the viewer/mirror. In favor of attribution to Artemisia, however, is her assimilation, while in Florence, of a style quite close to that of the Casa Buonarroti group. And of course no one had more reason to present Artemisia as Pittura than the artist herself. Bissell (1999, cat. X-21) also doubts the attribution to Artemisia, and he has unknowingly echoed my own opinion in proposing G. B. Guidoni as the author.

77. Just beneath the oval frame appear the words "Artem. Pinxit" and "H. [Hieronymus] David F." Jérôme David (1605–1670) was born and trained in Paris; he worked in Rome from 1623 until his death, producing engravings that were in large part celebrity portraits based on his own drawings and works by other artists. On the Gentileschi engraving, see Garrard, 1989, 64.

78. In the anonymous portrait medal now in Berlin (see Garrard, 1989, fig. 50), Artemisia also has rather unruly hair. Noting the repetition of the pearl necklace, I believe this image may have been an adaptation to profile of the lost painting upon which the engraving was based. Since the unruly hair appears in other Artemisian figures, such as the *Lute Player* of 1610–12, the artist may have considered this sign of creativity

appropriate for music as well as painting. Orazio's *Young Woman with a Violin,* ca. 1612, now in Detroit, has similarly flowing, unrestrained locks. At the Florentine court Artemisia was in contact with musicians such as the composer Francesca Caccini, although (according to the music historian Suzanne G. Cusick, who has studied the archival records in connection with Caccini) the "Signora Artimisia" who sang one evening in 1615 may not have been the painter, as I previously speculated. A painting ascribed to Artemisia, *Self-Portrait of the Artist Playing the Lute,* which sold at Sotheby's, London, on 9 July 1998, is in my view not a self-portrait, though it may represent a female musician at the Florentine court.

79. Garrard, 1989, 339, and for the Fontana medal, fig. 296.

80. The legend reads ARTEMISIA GENTILESCHI FAMOSISSIMA PITTRICE ACCAD. NE' DESIOSI.

81. Lapierre, 470.

82. Bissell, 1999, 38–39, and cat. 20. The *impresa* of the Venetian academy contained emblems of the arts. Loredan wrote two love letters to Artemisia in 1626–27 (see Bissell, 1999, appendix 3 B), and Bissell argues that he was the author of the verses published anonymously in Venice in 1627 that are addressed to paintings by Artemisia (L-1, L-54, and L-105). With Pietro Michiele, Loredan composed the defamatory posthumous epitaphs to Artemisia (discussed in Chapter 2; see also Garrard, 1989, 137).

83. EN PICTURAE MIRACULUM / INVIDENDUM FACILIUS QUAM IMITANDUM. Pliny (*Natural History,* 35:63) presents this as Zeuxis's epigram on his own work; Plutarch (*Moralia,* 346a) attributes it to Apollodorus. I am grateful to Leonard Barkan for pointing out the source of this quotation in Pliny and for the preceding references, and to Irving Lavin for his perceptive observation that the quotation as applied to Gentileschi has gendered overtones.

84. On the exceptional woman artist as a social "marvel," see Garrard, 1994, 566 ff.

85. See Mary D. Garrard, "Artemisia Gentileschi's *Self-Portrait as the Allegory of Painting,*" *Art Bulletin* 62 (1980): 97–112, appendix, for arguments against this being a work by Artemisia, even though the face appears to be an idealized version of her own. For the argument that the Corsini/Barberini portrait was painted by Artemisia (which I continue to find unconvincing) and for discussion of the relation between the Corsini/Barberini and Kensington Palace pictures, see Bissell, 1999, cat. 25; see also Claudio Strinati and Rossella Vodret, *Caravaggio and His Italian Followers, from the Collections of the Galleria Nazionale d'Arte Antica di Roma,* exh. cat., Wadsworth Atheneum, Hartford, Conn., 23 April–26 July 1998 (Venice: Marsilio Editori, 1998), cat. 19. Bissell sustains his earlier identification of the Corsini/Barberini portrait with Cassiano's commissioning of an Artemisia self-portrait in 1630 and proposes that the picture came to Palazzo Barberini sometime before 1637, as a gift from Cassiano to his friend Francesco Barberini. (It should be noted, however, that the picture was acquired at auction by the state in 1935; its transfer from Palazzo Corsini to its present location in Palazzo Barberini does not constitute evidence of prior Barberini ownership.) To answer the obvious question, why Cassiano would have parted so soon with his treasure, Bissell suggests that Artemisia painted a replacement for the Barberini gift, a self-portrait that did not, however, reach Cassiano's hands but was instead taken by her in 1638 to England, where it may have become a companion piece to the *Allegory of Painting* in

Kensington Palace (which cannot be a self-portrait, according to this logic). It is an argument that rather seriously violates the rule of Occam's razor.

86. But consider Bissell's preference for separating self-portraits from allegories, note 74. The other Artemisia portrait in the duke's collection could have been the lost painting upon which the David engraving was based. Alexandra Lapierre (478) has ingeniously argued for a direct link between works in the collections of Alcalá and Charles I through Artemisia's brother Francesco Gentileschi, who was an art agent. Noting that Francesco was in Genoa in the spring of 1637, the time when the duke of Alcalá's collection was sold there, Lapierre suggests that he might have purchased some of his sister's paintings from the Alcalá estate on behalf of the king. (He had made a buying trip in Italy for Charles I in 1627–28.) Neither the *Self-Portrait* nor the "Pintura," however, appears in the inventory made in 1639 by Abraham Van der Doort, as one would then expect (though other paintings by Artemisia are mentioned); the two works are named only in the 1649 inventory.

87. Garrard, 1989, 369–70.

88. See Antonio Domínguez Ortiz, Alfonso E. Pérez Sánchez, and Julián Gállego, *Velázquez,* exh. cat., Metropolitan Museum of Art, New York, 3 October 1989–7 January 1990 (New York: Harry N. Abrams, 1989), cat. 16. According to this source, suggested dates for the Prado portrait range from 1630 to 1632; José Camón Aznar (1964) and Jonathan Brown (1986) have argued strongly for 1630. If Velázquez painted it during his Italian journey in 1630, the picture could not represent his wife, Juana Pacheco, who remained in Spain. No documented portraits of Doña Juana exist. The catalogue's authors note the discrepancy between the woman's contemporary dress and hairstyle and the normatively classical garb and turban of a sibyl; they suggest she might as well represent History, Painting, or Drawing. The object held by the woman has been variously identified as a sibylline tablet, a canvas, and a palette (this last in an inventory of 1786). A related image is Velázquez's *Woman as Sibyl* of the 1640s, in Dallas (Ortiz, Pérez Sánchez, and Gállego, cat. 31), whose subject has also been identified as Pittura. On the connection of Artemisia's *Self-Portrait as the Allegory of Painting* with Velázquez's *Las Meninas* and Carducho's *Diálogos de la Pintura* and the relation between Velázquez and Carducho, see Garrard, 1980, 109–10, and 1989, 367–70.

89. For example, the Magdalen is discussed as a personification of contemplation by Saint Francis of Sales, *Treatise on the Love of God* (cited by Askew, 1990, 98).

90. As Luigi Salerno noted (*I dipinti del Guercino* [Rome: Ugo Bozzi, 1988], 164), Notte's posture derives generally from the description in Ripa's *Iconologia* of Meditation reflecting on a passage in a book on her knee, her hand supporting her head, and the related description of Melancholy (Pensiveness). By contrast, Ripa describes Night quite differently, as a woman making a fire and lighting a candle by it.

91. See Bissell, 1999, fig. 74, for the Cigoli, and cat. 11 for other scholars who identify it as Artemisia's source. Bissell mentions Guercino's picture and its related drawing as also derived from Cigoli, and from a related engraving of the theme by Philips Galle of 1610. Although Cigoli's and/or Galle's design was most likely a general compositional type echoed by both artists, the versions by Artemisia and Guercino share the frontal and planar orientation of Sisera's body and the curved yoke and pushed-up sleeve of Jael's dress, and in these respects depart from both sources. On Guercino's lost *Jael and*

Sisera, known only in a copy recorded in a photograph in the Cini Foundation, Venice, see Sir Denis Mahon, *Il Guercino (Giovanni Francesco Barbieri, 1591–1666: Catalogo critico dei disegni* (Bologna: Edizioni Alfa, 1969), nos. 49–52. One is inclined to see Artemisia as the originator of the image because of her carefully detailed figures, seemingly directly studied. Mahon ("Guercino and Cardinal Serra: A Newly Discovered Masterpiece,"*Apollo* 114 [1981]: 170–75) interprets Guercino's preparatory drawings as alternatives for a single composition, yet the four designs establish four distinct narrative moments, and may represent plans for a series. No. 52, corresponding to Guercino's lost painting, is the most tightly drawn of the group and could have been sketched after Artemisia's *Jael.*

92. *The Toilet of Venus,* ca. 1622–23, Renaissance, Calif., Goethe Academy (Salerno, cat. 93); and *Venus, Mars, Cupid and Time,* ca. 1624–25, Dunham Massey, Altrincham (Stamford Collection) (Salerno, no. 109; David M. Stone, *Guercino: Catalogo completo dei dipinti* [Florence: Cantini, 1991], no. 103). By the time Guercino painted the *Venus, Mars and Cupid* of 1633, now at Modena (Salerno, cat. 151), he had reverted to a rather more idealized female figure type, though he had not yet abandoned the relative naturalism of his early period. Other suggestive points of contact between the artists include Guercino's *Semiramis* of 1624, in Boston, as it relates to Artemisia's *Judith* of ca. 1625, in Detroit. Guercino's figure is an Artemisian type, while the uncalled-for crown worn by Artemisia's heroine echoes that of Guercino's figure.

93. Fetti's figure was also the visual model for Guercino's *Penitent Magdalen with Two Angels* of 1622 (Rome, Pinacoteca Vaticana), offering another instance of the crossing of types. See Sir Denis Mahon, ed., *Giovanni Francesco Barbieri Il Guercino, 1591–1666,* with entries by Prisco Bagni, Diane De Grazia, Mahon, and Fausto Gozzi (Bologna: Nuovo Alfa Editoriale, 1991), cat. 54.

94. Fetti's kneeling, meditating figure, linked with Melancholy by her attributes of globe, compass, and dog (collectively symbolizing the rational faculties), has been interpreted as a derivative of Dürer's print, intended to express a similarly pessimistic view of the limits of intellectual endeavor (Panofsky, in Klibansky, Panofsky, and Saxl, 363–64). For other literature, see Mosco, 199. The figure's visual resemblance to a Magdalen has been noted (Eduard A. Safarik, with Gabriello Milantoni, *Fetti* [Milan: Electa, 1990], cat. 123), and a lost *Penitent Magdalen* by Correggio has been proposed as its source (Mosco, 198). Fetti in fact repeated the pose of his *Melancholy* in his Doria Pamphilj *Magdalen* (though he used it for other themes as well; see Safarik, cat. 123). Pamela Askew found Fetti's model in Andrea Andreani's chiaroscuro of 1591, *Woman Meditating on a Skull,* with *vanitas* attributes ("Domenico Fetti's Use of Prints: Three Instances," in *Tribute to Wolfgang Stechow,* ed. Walter L. Strauss, *Print Review* no. 5 [spring 1976] [New York: Pratt Graphics Center and Kennedy Galleries, 1976], 15 n. 8).

95. Castiglione's figure of Meditation or Melancholy is reading a musical score, accompanied by a broken lute, a palette and brushes, and a compass; above her we see an armillary sphere, a dog and cat, and a square. These attributes of intellectual and artistic achievement sustain the iconography of Melancholy as seen in Dürer and Fetti. See Klibansky, Panofsky, and Saxl, 374 ff.; and Ann Percy, *Giovanni Benedetto Castiglione, Master Draughtsman of the Italian Baroque* (Philadelphia: Philadelphia Museum of Art, 1971), 142, cat. E 14.

96. E.g., Safarik, cat. 123. Certain paintings emphasize this link, for example, the *Allegorical Figure* by Guido Cagnacci (*The Age of Correggio and the Carracci: Emilian Painting of the Sixteenth and Seventeenth Centuries,* exh. cat., Washington, D.C., National Gallery of Art; New York, Metropolitan Museum of Art; Bologna, Pinacoteca Nazionale [Cambridge: Cambridge University Press, 1986], cat. 29), which fuses Magdalenean iconography of skull and cross (the latter painted out) with a snuffed candle and a fading flower, conventional symbols of mortality and vanity. Relevant too is John T. Spike's suggestion that the figure in Artemisia's Pitti *Magdalen* may have originally been intended as a Vanitas (see note 38).

97. The locus classicus for this basically unchallenged interpretation of the Medici Chapel dukes is Erwin Panofsky, "The Neoplatonic Movement and Michelangelo," in *Studies in Iconology: Humanistic Themes in the Art of the Renaissance* (New York: Harper and Row, 1962 [originally published 1939]), 171–230, esp. 208–12. At least since Vasari, the helmeted figure with his chin resting on his hand was called *il pensieroso* or *pensoso,* a seeming acknowledgment of his association with contemplation. Richard C. Trexler and Mary Elizabeth Lewis ("Two Captains and Three Kings: New Light on the Medici Chapel," in *Michelangelo: Selected Scholarship in English,* ed. William E. Wallace [New York: Garland, 1995], 3:197–283) argue that Vasari's identification of the *pensoso* with Lorenzo, duke of Urbino, and the other figure with Giuliano, duke of Nemours, reversed the statues' intended identities; this reading, however, does not challenge the typological polarity of the two figures. In an article that came into my hands after I completed this manuscript, Judith W. Mann connects Artemisia's Pitti *Magdalen* with Michelangelo's Medici Chapel *Lorenzo;* she too notes the parallel between the Magdalen and the *pensoso* duke as paradigms of the contemplative life (Judith W. Mann, "Caravaggio and Artemisia: Testing the Limits of Caravaggism," *Studies in Iconography* 18 [1997]: 161–85).

98. Garrard, 1989, 358.

99. Julianna Schiesari, "The Gendering of Melancholia: Torquato Tasso and Isabella di Morra," in *Refiguring Woman: Perspectives on Gender and the Italian Renaissance,* ed. Marilyn Migiel and Juliana Schiesari (Ithaca, N.Y.: Cornell University Press, 1991), 244 and passim. Schiesari's argument is elaborated in her *Gendering of Melancholia: Feminism, Psychoanalysis, and the Symbolics of Loss in Renaissance Literature* (Ithaca, N.Y.: Cornell University Press, 1992). See also Lynn Enterline, *The Tears of Narcissus: Melancholia and Masculinity in Early Modern Writings* (Stanford, Calif.: Stanford University Press, 1995). Enterline interprets the male melancholic's relationship to femininity differently from Schiesari, while affirming that gender politics are at stake in the very concept of melancholy. See also Julia Kristeva, "On the Melancholic Imaginary," in Schlomith Rimmon-Kenan, ed., *Discourse in Psychoanalysis and Literature* (London: Methuen, 1987), a key text for both writers.

100. Such an identification on Michelangelo's part is shown, for example, in a poem: "He who made time from nothing . . . made two of one, giving the high sun to one, to the other the nearer moon. In that instant, chance, fate, and fortune came to each of us; and *I was assigned to the domination of night, even at birth and in the cradle. And so, imitating my very self, I am as the night, which is all the darker as it grows*" (James M. Saslow, *The Poetry of Michelangelo: An Annotated Translation* [New Haven, Conn.: Yale

University Press, 1991], no. 104; cited by Summers, p. 249, his translation; italics mine). In no. 103 the poet argues that night, the time for human procreation, is more sacred than daytime, when plant seeds are germinated by the sun, since "man is worth more than any other fruit." Summers obliquely notes Michelangelo's self-identification with feminine fecundity in mentioning the artist's use of the pose of Night in his Leda drawing. Robert S. Liebert proposed that Michelangelo identified with the female Leda in sexual terms (*Michelangelo: A Psychoanalytic Study of His Life and Images* [New Haven, Conn.: Yale University Press, 1983], 248–61).

101. See Carole Slade, *St. Teresa of Avila: Author of a Heroic Life* (Berkeley and Los Angeles: University of California Press, 1995).

102. See Slade, chap. 5, on Teresa's founding of monastaries and missions and her direct role in their construction, design, and furnishing. Ultimately, the Church would find Teresa's visions the least threatening way to explain her. On Teresa's defense of women and her protest against the devaluation of daughters in her *Foundations,* see Slade, 112–13. On Teresa's powerful personality and subversive books, see Alison Weber, *Teresa of Avila and the Rhetoric of Femininity* (Princeton, N.J.: Princeton University Press, 1990).

103. The independent efforts by Ficino and Freud to glorify masculine melancholy are linked by Schiesari, 1991, 239–46. The relevant texts are *The Letters of Marsilio Ficino,* trans. members of the Language Department of the School of Economic Science, London (London: Shepard-Walwyn, 1978; reprint, New York: Gingko Press, 1985), 2:33–34; and Sigmund Freud, "Mourning and Melancholy," in *The Standard Edition of the Complete Psychological Works of Sigmund Freud* (London: Hogarth Press and the Institute of Psycho-Analysis, 1995–96), 14:243–58.

CHAPTER 2

1. The painting, in oil on canvas, measures 161.5 × 123 cm. Its provenance and other technical elements are discussed below. Mina Gregori published the work as by Artemisia Gentileschi in 1968, refuting a standing attribution to Caravaggio (see note 46 below). Both R. Ward Bissell (1968, 167) and Ann Sutherland Harris (in Ann Sutherland Harris and Linda Nochlin, *Women Artists: 1550–1950* [New York: Knopf, 1976], 121) called it "possibly Artemisia." Their qualified support of the attribution is echoed by Contini and Papi (1991, 113), who note the Artemisian lighting of the anatomy but do not find the attribution completely justified, suggesting instead an artist in the Vouet circle. In Garrard, 1982, and Garrard, 1989, 202–4, the attribution is rejected. It was reaffirmed by Hugh Brigstocke and John Somerville in *Italian Paintings from Burghley House,* exh. cat., with a foreword by Lady Victoria Leatham (Alexandria, Va.: Art Services International, 1995), cat. 20. R. Ward Bissell (1999, cat. X-42) has rejected the attribution on the grounds that despite its superb quality, its style does not fit any stage of Artemisia's development as we currently know it.

2. Garrard, 1989, chap. 3, esp. 204–9, based on Garrard, 1982. For Artemisia's testimony in the rape trial, see Garrard, 1989, 413–18.

3. But see Bissell, 1999, 7, for whom Annibale's engraving presents Susanna struggling with her "painful options."

4. On Petrarch's garden as a snare in the *Trionfo d'Amore* and Boccaccio's symbolic gardens in the *Decameron, Amorosa Visione,* and *Teseida,* see Paul F. Watson, *The Garden of Love in Tuscan Art of the Early Renaissance* (Cranbury, N.J.: Associated University Presses, 1979), 30 ff.

5. Watson, 74, notes that the Vulgate text, with no mention of fountains, describes the Susanna story as set in an orchard, a setting "intended as a symbol of the erotic attractions of Susanna in the bath and as an allusion to the amorous thoughts of her accusers." Watson observes that the artist of the tondo "contrasts the allure of chastity with the dangers of sensuality, an opposition in which the Garden of Love plays an ambiguous role."

6. For discussion of Dante's *Rime petrose,* see Henry Staten, *Eros in Mourning: Homer to Lacan* (Baltimore: Johns Hopkins University Press, 1995), 92 ff. The Siren appears in *Purgatorio,* 19.

7. See M. B. Ogle, "The Classical Origin and Tradition of Literary Conceits," *American Journal of Philology* 34 (1913): 125−53; and Lance K. Donaldson-Evans, *Love's Fatal Glance: A Study of Eye Imagery in the Poets of the "Ecole Lyonnaise"* (University, Miss.: Romance Monographs, 1980). I thank Nancy Lodge for these references.

8. Pietro Bembo, *Gli Asolani* (1505); this translation from *Pietro Bembo's Gli Asolani,* trans. Rudolf B. Gottfried (Freeport, N.Y.: Books for Libraries Press, 1971), 56 and 87.

9. The set-up is echoed later, when Orlando dreams of a Petrarchan *locus amoenus* in which a bright-eyed temptress deploys a net to snare her lover. A useful discussion of these themes in *Orlando Furioso* is found in Albert Russell Ascoli, *Ariosto's Bitter Harmony: Crisis and Evasion in the Italian Renaissance* (Princeton, N.J.: Princeton University Press, 1987), esp. 164−66, 192−94, and 307−9.

10. On the Petrarchan origins of Armida as temptress, see Naomi Yavneh, "The Ambiguity of Beauty in Tasso and Petrarch," in Turner, 1993, 133−57. A good overview of the progressive allegorization of the garden as menacing is given by A. Bartlett Giamatti, *The Earthly Paradise and the Renaissance Epic* (Princeton, N.J.: Princeton University Press, 1966), who writes (p. 6): "In the enchanted gardens of Ariosto, Tasso and Spenser, Alcina, Armida and Acrasia are lineal descendants of Homer's Circe. They are sorceresses, and what is true of them is true of their gardens: the more attractive they appear, the more dangerous they are. Thus, the beautiful place, sought for centuries, becomes a trap to be avoided."

11. Marco Boschini, *La Carta del Navegar Pitoresco* [Venice, 1672], ed. A. Pallucchini (Venice: Istituto per la collaborazione culturale, 1966), 442 ff., esp. 445. See Mary D. Garrard, "Artemisia Gentileschi's *Corisca and the Satyr,*" *Burlington Magazine* 135 (1993): 34−38.

12. See James M. Saslow, *The Poetry of Michelangelo: An Annotated Translation* (New Haven, Conn.: Yale University Press, 1991), nos. 112 ff., and Intro., 18−19. On the aggressive-eye topos, see Donaldson-Evans, chap. 1.

13. The subtextual presence of Venus, evoked in the Anadyomenean pose of many Susannas (Annibale Carracci, Domenichino, Rubens, the Burghley *Susanna*) may in-

directly support her interpretation as an enchantress. Giamatti (126 n. 2) points out that in Petrarch and in later Renaissance epics, Venus began to acquire some of Circe's traits.

14. Sandra Cavallo and Simona Cerutti, "Female Honor and the Social Control of Reproduction in Piedmont between 1600 and 1800," trans. Mary M. Gallucci, in *Sex and Gender in Historical Perspective,* ed. Edward Muir and Guido Ruggiero (Baltimore: Johns Hopkins University Press, 1990), 73–109.

15. Julian Pitt-Rivers, "Honor and Social Status," in *Honor and Shame: The Values of Mediterranean Society,* ed. J. G. Peristiany (Chicago: University of Chicago Press, 1966), 19–78, esp. 41–47.

16. Stephanie H. Jed, *Chaste Thinking: The Rape of Lucretia and the Birth of Humanism* (Bloomington: Indiana University Press, 1989), intro., esp. 7.

17. On the cuckolded husband as victim and ritually defiled object of contempt, see Pitt-Rivers, 45–46.

18. Rubens, in his version of the theme, suggests that Susanna entrapped the Elders through such pictorial means as the lady's coquettish gaze over her shoulder and the apple tree that alludes to temptation. In principle, this interpretation is theologically impeccable, since it analogizes the temptation of Susanna with that of Eve by the serpent. Yet since Eve's larger identity includes her own temptation of Adam and the initiation of the Fall, the visual metaphor actually works to situate Susanna in the long line of Eve's dangerously seductive daughters. See Garrard, 1989, 193–94.

19. As an anonymous reader of this manuscript observed, Susanna's upward gaze could be interpreted as directed prayerfully toward heaven. This is a possible reading, one that surely applies to other Susanna paintings, but I believe that here it cannot trump the erotic interpretation, given other features of the composition.

20. Brigstocke and Somerville, cat. 20, with relevant literature.

21. A similarly accomplished landscape frames the central figure of Artemisia's *Aurora* of ca. 1625–27, presenting the same problem that we find in the Burghley *Susanna* of accounting for Artemisia's skillful handling of a genre in which she had no known training. The landscape of the *Aurora* may have been painted by an artist other than Artemisia. As discussed below, this remains a possibility for the *Susanna* as well, though differences in the rendering of sky and leaves indicate that her collaborator was not the same artist in the two paintings. The Princeton *Venus and Cupid,* which I have dated in the early 1630s and Bissell dates 1625–27, includes a fluidly painted landscape insert that is even more dramatically at stylistic odds with the figures and may also reflect another hand. (The simple blue sky of the Pommersfelden *Susanna* is not properly a landscape.)

22. Personal communication with Ann Harris on the occasion of the symposium that she helped organize, "Italian Baroque Paintings from Burghley House," held at the Frick Art and Historical Center, Pittsburgh, Pa., 8 April 1995. I thank her for inviting me to participate, and thus giving me the opportunity and incentive to pursue this study of the Burghley *Susanna.*

23. For the Spada *Lute Player,* see Garrard, 1989, pl. 3. Although Bissell (1999, cat. X-28) doubts this attribution to Artemisia and though opinion has been divided, there is a core of support for the attribution. See Bissell for the literature.

24. An exception to this flat inertness is the slightly darker set of folds that surrounds the woman's hip and falls over her thigh; this more plastic and energized passage may be a remnant of Artemisia's original composition, as discussed later in this chapter.

25. At my request, Burghley House kindly granted permission to subject the painting to laboratory analysis at a convenient stop on its American tour. This was carried out by David A. Miller, senior conservator, Indianapolis Museum of Art, whose expertise has revealed a great deal about the painting. I thank Lady Victoria Leatham and Jon Culverhouse for courtesies extended from Burghley House; I am also grateful for the invaluable assistance of DeCourcy E. McIntosh, director of the Frick Art and Historical Center, Pittsburgh; and Lynn Rogerson of Art Services International.

26. David A. Miller, Technical Examination Report on *Susanna and the Elders,* Artemisia Gentileschi, 19 August 1995. As Miller pointed out, the balusters are similar to those seen in Artemisia's *Bathsheba* paintings, though they also appear in many *Susanna*s of the period, for example, by Domenichino and Rubens (Garrard, 1989, figs. 160, 161, and 163).

27. David Miller thought this shape was a fountain, whose small scale would indicate an original placement in the middle distance, far from the heroine. Once the position of Susanna crouching with her feet in a basin was established, however, this fountain would have been misplaced. Conversely, Michael Cowell, the conservator at Burghley House who was responsible for the cleaning of the *Susanna,* interpreted it as a tree, which is perhaps more plausible, although no other signs of landscape in the original composition are visible in X-ray.

28. According to Sarah Fisher, senior conservator, National Gallery of Art, Washington, D.C., this figure is not more clearly legible because no lead white was used in painting him. I am grateful to Fisher for reviewing the X-rays and technical report with me, to help answer my recent questions.

29. In Sarah Fisher's opinion, the figure of Susanna may have been shifted down and leftward early in the process of execution and the first position for the figure developed only by the contour line, since no second face or other anatomy is visible in the X-ray.

30. Miller's observations, based on X-ray and infrared analysis. Bissell (1999, cat. X-42) gives other details of Miller's report, having evidently had independent access to the technical analysis I commissioned.

31. The lower lid of Susanna's right eye, moreover, merely an arc in the X-ray, has become a shallow S-curve in the painting. I should emphasize that this reading of the eyes in the X-ray is my own and would not necessarily be endorsed by the conservators.

32. Sarah Fisher reached this conclusion, noting in the first composition a buildup of pigment close to the edge of the Elder's back and below, close to the balustrade's lintel. A similar buildup of pigment appears in the present sky alongside the top of the present wall, and at the point where the sky meets the uppermost Elder's hand and the tree trunk.

33. Unfortunately, because X-rays were not made of the full right side of the painting, we cannot see what might lie under the present Elder on the right.

34. Moravská Galerie, Brno, Czech Republic; for discussion of this damaged and overpainted picture, which is signed and dated "Artemisia Gentileschi 1649," see Bissell, 1968, 164; and Contini and Papi, 1991, 76.

35. This is David Miller's conclusion.

36. The consistency was stressed by both conservators, Miller and Fisher.

37. This overlapping of paint was noted by Bissell, 1999, cat. X-42.

38. According to David Miller, the signature, inscription, and date are contemporary with the painting of the wall to the left of Susanna, the "A" overlapping part of the earlier composition that was not painted out.

39. David Miller commented on the unusual darkness of the signature, while noting that it did not appear to have been strengthened; Sarah Fisher explained the implications of this observation.

40. Artemisia used the name Lomi while in Florence, because it was better known in Tuscany. As Bissell explains (1999, 398–99), Orazio had substituted his father's surname, Gentileschi, for his mother's name, Lomi, on his arrival in Rome. His brother, usually known as Aurelio Lomi, also appears in documents as Aurelio Gentileschi or Aurelio di Giovanbat. Lomi Gentileschi. Examples offered by Bissell (cat. X-42) indicate that the latter form was usual for the names in combination; in the Burghley *Susanna* signature, this order is reversed. Bissell also points out that Artemisia never preceded a date with A.D. or any variant. With the single exception of the *Minerva* (which I have dated in the Florentine period but Bissell may correctly date later), all signed pictures painted in Florence bear the name Lomi; the *Susanna* of 1610 and all signed works done in Rome and Naples after 1620 are signed Gentileschi. A transitional exception is the *Jael and Sisera,* dated 1620 and probably painted in Rome, which is signed Artemisia Lomi. The signature could be explained if the work had a Florentine patron, however, as Contini and Papi suggest (1991, cat. 17). Bissell (1999, cat. X-42) also observes that there is not a single signed painting by Artemisia, or letters by the artist, or inventory citations, in which both the names Lomi and Gentileschi appear.

41. Michael Cowell, the conservator who cleaned the *Susanna* and revealed the signature on the wall, noted the traces of the earlier signature. That the earlier signature was not detected in David Miller's examination of the painting is explained by Cowell as indicating that it was painted in an earth pigment or ivory black, which would render it transparent in X-ray. A "trace of another signature" was in fact mentioned in an earlier draft of the catalogue entry written by Hugh Brigstocke (which I had the opportunity to read), but this sentence did not appear in the final text.

42. I thank Michael Cowell and Jon Culverhouse, house manager of Burghley House, for their careful reinspection of the painting and confirmation of the legibility and size of these letters. They (and other viewers not told what to expect) read the initial *A,* followed immediately by an *R* and later by an *S*. That there are no visible traces of letters in the interval between the *R* and *S* or after the *S* is probably to be explained by the thickness of overpainting in these passages.

43. In the majority of her signed works—the Pommersfelden *Susanna,* the Florentine *Magdalen, Minerva, Jael and Sisera,* the Kensington Palace *Self-Portrait as the Allegory of Painting,* and *Clio*—Artemisia's signature is attached to a depicted object.

44. Bissell reports that according to Somerville and Brigstocke, the ninth earl's written list may not accurately represent earlier acquisitions, even though it purports to have been based on an "old catalogue," and that the *Susanna* was probably purchased by the ninth earl, since "it does not appear in the 1738 inventory and no one was buying such

pictures between the 5th and 9th Earls." Bissell, however, notes that nine Burghley paintings in the recent exhibition known or believed to have been bought by the fifth earl (John Cecil), who compiled an inventory in 1688, do not appear in the inventory of 1738. In view of these discrepancies, Bissell doubts the "reliability of the early information."

45. The entry in the earl's list reads as follows: "Susannah and ye Elders by Arta: Gentileschi from ye Barbarini Pallace at Rome." For subsequent inventory citings, see Brigstocke and Somerville, cat. 20. According to Hugh Brigstocke, who wrote the catalogue entry, the picture was probably bought by the earl in Rome. This would have been after 1763, the year that Brownlow Cecil (1725–93) went to Italy.

46. Mina Gregori, "Su Due Quadri Caravaggeschi a Burghley House," *Festschrift Ulrich Middeldorf* (Berlin: Walter De Gruyter and Company, 1968), 1:414–21. Bissell notes that Gregori reaffirmed the Gentileschi attribution in 1984, dating the work in the years "between" Artemisia's Florentine and second Roman periods.

47. For the Barberini "donna con amore," see Marilyn Aronberg Lavin, *Seventeenth-Century Barberini Documents and Inventories of Art* (New York: New York University Press, 1975), Inventory of Cardinal Antonio Barberini, 1644, 4, inv. 44, p. 165. This is probably the painting Artemisia mentions having sent to Cardinal Antonio in a letter to their common friend Cassiano dal Pozzo on 21 January 1635 and may be identical with the *Venus and Cupid* now in Princeton (Garrard, 1989, 83 and 109). Again in 1637, when Artemisia needed money for her daughter's wedding, she planned to offer two of her paintings to Francesco and Antonio Barberini: a *Woman of Samaria with Christ and Twelve Apostles* and a *Saint John the Baptist in the Desert* (letter to Cassiano of 24 October 1637; Garrard, 1989, no. 13). These paintings have not been traced.

48. Francesco and Antonio Barberini were made cardinals by their uncle Maffeo Barberini on his ascension to the papacy as Urban VIII in 1623. Francesco began collecting only in 1625, when during his first diplomatic mission the king of France gave him a set of tapestries designed by Rubens. See Francis Haskell, *Patrons and Painters: A Study in the Relations between Italian Art and Society in the Age of the Baroque* (New York: Knopf, 1963), 43–44; and Lavin, 1975.

49. The Burghley House *Susanna* measures 7.2 × 5.5 Roman palmi. Lavin, 1975, 701–2, lists the *Susanna*s in Barberini collections as follows: (1) by "Carracci," 4 (width) × 3 (height) palmi; (2) by Passignano, a work measuring 7 × 5½ palmi, which included Susanna, the two Elders, a fountain, and a lion's head (although the lion's head and Passignano attribution would exclude it, this painting is closest in dimensions to the Burghley picture; it entered the collection of Francesco Barberini in 1627); (3) a work placed in the "libraria vecchio" in 1634, unattributed (but listed in an inventory as by Baglione); (4) a version in a white frame, no dimensions or artist given, listed in an inventory of Antonio Barberini, 1644; (5) a version 3½ (height) × 5 (width) palmi; (6) a version 4 × 2 ½ palmi; (7) a version on copper, 1½ palmi in height; (8) and (9) two prints by Rubens.

50. The *Susanna* in a white frame, no. 4 in note 49. No *terminus post quem* can be established from this inventory for works listed in it; the two preceding inventories of

works owned by Antonio concern works moved from Bagnaia (1633–35) and Decorative Arts (1636–40).

51. The picture is unlikely to have been acquired for the Barberini after 1700 (Lavin's publication covers only the seventeenth century), since little collecting seems to have occurred after that date. Bissell (1999, cat. X-42) concluded independently that the Barberini provenance is an "unsubstantiated claim."

52. This inventory, dated 2 November 1623, was published by Carolyn H. Wood, "The Ludovisi Collection of Paintings in 1623," *Burlington Magazine* 134 (1992): 522, entry 284: "Una Susanna Con li vecchi alta p[alm]i 8 Cornice nere profilate e rabescate d'oro di m[an]o di artimitia" (a Susanna and the Elders, eight palmi in height, with a molded black frame, ornamented with gold arabesques).

53. Wood, 516, named Artemisia's Pommersfelden *Susanna* as "perhaps" the picture cited in the inventory. The measurements are given in Roman palmi (22.34 cm), and according to Klara Garas, who had earlier published the second inventory of this collection, usually included the frames (Klara Garas, "The Ludovisi Collection of Pictures in 1633—I," *Burlington Magazine* 109 [1967], 289 n. 27). Eight Roman palmi would be 178.72 cm; the Pommersfelden *Susanna* measures 170 cm, leaving a skimpy 8.72 cm (about 3½ inches) for the upper and lower sections of frame. The slightly smaller vertical measurement of the Burghley Susanna (161.5 cm) would leave a more ample and proportionate 17.2 cm (6¾ inches) for the frame's two sections. This cannot be considered a conclusive argument, however, since, as Garas notes, many of the dimensions given in the inventory were only approximate.

54. See Klara Garas, "The Ludovisi Collection of Pictures in 1633—II," *Burlington Magazine* 109 (1967): 339–48, for the complete inventory of 1633.

55. Wood, 515.

56. For this *Susanna* and its documentation, see Garrard, 1989, 111. The Castle Museum, Nottingham, has a copy of the Burghley *Susanna* in its present form, of virtually the same size and with the same color structure (it measures 162.6 × 121.9 cm). Brendan Cassidy, in an unpublished catalogue of the museum collection that he graciously shared with me, connected this painting with the *Susanna* by Artemisia Gentileschi that was owned by Charles I and proposed that it might be her own copy of the Burghley *Susanna*. Judging the Nottingham picture only from a photograph, I do not consider it a credible attribution to Artemisia. Yet it is unusual that both *Susanna*s should wind up in England (as Cassidy noted), in collections some 50 km apart. Most likely the Nottingham painting is a copy of the picture at Burghley House, made in England in the later seventeenth or the eighteenth century.

57. For the Ludovico Carracci *Susanna* of 1616, National Gallery, London, see note 78 below. Artemisia's figure can also be connected with the winged putto surmounting a fountain in the *Piramus and Thisbe* by the Florentine Gregorio Pagani, a work cited by Bissell as a possible compositional model for Artemisia's *Aurora* (1999, 222 and fig. 88). In both these examples, it should be noted, the fountain is located in the background, not in the same plane as Susanna.

58. The metaphoric association of flowers and girls is ancient. For examples in Sappho, Catullus, Claudian, and eventually Andrew Marvell, see Giamatti, 47 n. 49.

Renaissance Italian usage preserved the link between natural and female sexual fertility in using the word *natura* to signify female genitalia (as, for example, in the Gentileschi-Tassi rape trial testimony).

59. Prado no. 420. I reproduce one of two versions of this theme by Titian in the Prado, both of which contain the satyr fountain. The picture here represented in a detail was already in Madrid in 1626, but the variant version (produced with workshop participation) was in Venice around 1622, when it was recorded in Van Dyck's "Italian Sketchbook." Since Artemisia is not known to have visited Venice before 1626, however, some four years after the date inscribed on the Burghley *Susanna,* she may not have known Titian's composition directly. See Harold E. Wethey, *The Paintings of Titian,* vol. 3, *The Mythological and Historical Paintings* (London: Phaidon Press, 1975), cats. 47 and 50. On the erotic iconography of these pictures, see Rona Goffen, *Titian's Women* (New Haven, Conn.: Yale University Press, 1997), 159–66; and on the satyr fountain as emblem of the musician's lustful passion, see Elise L. Goodman, "Petrarchism in Titian's *The Lady and the Musician,*" *Storia dell'Arte* 49 (1983): 179–86, esp. 185.

60. Laura Anna Stortoni, ed., *Women Poets of the Italian Renaissance: Courtly Ladies and Courtesans,* trans. Stortoni and Mary Prentice Lillie (New York: Italica Press, 1997), 104–13. *Il Discorso sopra il principio di tutti i canti di Orlando Furioso* (1608, its ninth reprint), is dedicated to Veronica Gambara, whom Bacio Terracina extols, lodging a complaint against the misogynist suppression of women writers: "Were there more women here on earth like you / To put a halt to those too many writers / Who, unrestrained, publish against us women / Much cruel writing, filled with bitter venom: / Then might our names reach oriental shores—/ Our names and fame, adorned with well-earned honors. / But since we have not ventured to oppose them, / They hold our writings in too low esteem. . . ."

61. Andreini's *Mirtilla,* first published in 1588, was quite successful; subsequent editions were published in 1594, 1598, 1602, 1605, and 1616 (Stortoni and Lillie, 222). With this analogy in mind, it is difficult to accept Bissell's insistence as he argues against my feminist reading of Artemisia's *Corisca* (1999, 76–77) that "in the seventeenth century, to be familiar with the text was not to be in the least inclined to find redeeming values in Corisca."

62. Garrard, 1994.

63. Baldesar Castiglione, *Il Cortegiano,* bk. 3, sec. 17; cited and similarly interpreted by Finucci, 1992, 23.

64. Garrard, 1989, no. 7 (of 22 May 1635), p. 381.

65. See, for example, H. Diane Russell, *Claude Lorrain, 1600–1682,* exh. cat. (Washington, D.C.: National Gallery of Art, 1982), 52–53.

66. On the collaboration of Guercino and Tassi at Palazzo Lancellotti and Casino Ludovisi, see Salerno, cats. 83 and 85; Stone, cat. 78; and Mahon, 1991, 47–55.

67. Codazzi supplied architectural backgrounds for a number of artists; the architecture in Artemisia's *Martyrdom of Saint Januarius* (1636–37) and the Columbus *Bathsheba* (early 1640s) is his work. Gargioli (also called Micco Spadaro) painted the landscape background in Artemisia's Columbus *Bathsheba,* according to De Dominici (see Garrard, 1989, 121). Artemisia may also have collaborated with Bernardo Cavallino in

producing a *Triumph of Galatea* in the late 1640s; see Józef Grabski, "On Seicento Painting in Naples: Some Observations on Bernardo Cavallino, Artemisia Gentileschi, and Others," *Artibus et Historiae* 6 (1985): 23–63; and Garrard, 1989, 122–27. An analogy for two artists' hands on the same canvas is the *Saint Cecilia and an Angel* (ca. 1617–18, Washington, National Gallery of Art), which was begun by Orazio Gentileschi and perhaps left unfinished, then completed by another artist, probably Lanfranco. See Diane De Grazia and Erich Schleier, "St. Cecilia and an Angel: 'The Heads by Gentileschi, the rest by Lanfranco,'" *Burlington Magazine* 136 (1994): 73–78.

68. Psychologists report that post–traumatic stress disorder may take the form of avoidance of (or arousal in response to) stimuli recalling the event. See Cathy Caruth, ed., *Trauma: Explorations in Memory* (Baltimore: Johns Hopkins University Press, 1995), intro., esp. 4 ff.

69. On Guercino's *Cleopatra* (Pasadena, Norton Simon Museum), see Salerno, cat. 79. This type of earring, a pear-shaped pearl with gold mountings, appears frequently in Artemisia's paintings; we rarely see the type depicted by other contemporary artists. Analogous facial types can be seen in Guercino's *Death of Dido* of 1630–31 (Rome, Palazzo Spada).

70. Haskell, 120–21. Bissell, however, argues the opposite (1999, 8).

71. See, for example, Orazio's letter of 1612 to Cristina of Lorraine, the mother of Cosimo II de' Medici, offering the dowager grand duchess paintings by his daughter and boasting of her skills (Garrard, 1989, 36). We do not know that the Gentileschi ever succeeded in selling the 1610 *Susanna*. On the role of art dealers in early seicento Rome, see Haskell, 120–21; and for the strategies of Guido Reni and other artists in marketing their work through middlemen, see Spear, 1997, chap. 12.

72. Haskell, 4 ff.

73. See Cropper, 1993, however, on Artemisia's financial and legal difficulties in this period.

74. I cannot accept Bissell's arguments for redating the *Lucretia* to ca. 1611 and for removing the *Cleopatra* from Artemisia's oeuvre altogether (see Chapter 1, note 7). But in any case, both pictures came from Palazzo Pietro Gentile. The identity of the Gonfaloniere remains obscure; my tentative identification of the man as Pietro Gentile has been challenged by Papi in Contini and Papi, 1991, cat. 21; and by Bissell, 1999, cat. 13.

75. The Roman census of 1624 described Artemisia as living on Via del Corso as head of a household consisting of herself, a daughter, and two servants (see Garrard, 1989, 63). She must have parted ways with her husband shortly before. A document adduced by Jacques Bousquet ("Valentin et ses compagnons: Réflections sur les Caravagesques français à partir des archives paroissiales romaines," *Gazette des Beaux-Arts* 11 [1978]: 101–14) shows that in 1622 Artemisia and her husband, Pietro Antonio Stiattesi, and their daughter Palmira lived on the Corso. That only one child is named in these documents suggests that the three other children now known to have been born in Florence (Cropper, 1993) must not have survived infancy. Palmira (born 1627; named Prudentia in baptismal records) was the daughter for whom Artemisia sought a dowry in 1636/

37; the daughter who married a knight of Saint James in 1649 appears to have been yet another daughter, probably born after Artemisia's separation from Stiattesi. See Bissell, 1999, appendix 2, for a fuller account of this still murky picture.

76. For Artemisia's exchange of letters with the duke of Modena (December 1639– May 1640), see Garrard, 1989, nos. 15a and 15b. A letter to Ferdinando II de' Medici (20 July 1635) is published by Roberto Fuda, "Un'inedita lettera di Artemisia Gentileschi a Ferdinando II de' Medici," *Rivista d'Arte* 41 (1989): 167–71. In sending pictures as gifts to wealthy potential patrons, Artemisia may have been practicing a strategy used by others. Guido Reni, according to his biographer, Malvasia, made gifts of pictures to "men of means," hoping to receive more for them than if he had set a price (Spear, 1997, 212). Unlike Artemisia, however, Guido seems not to have had trouble getting paid. In 1635 Artemisia asked her friend Galileo to help get the Medici court to pay for two large paintings, sent but not acknowledged (Garrard, 1989, no. 9). She observed to Galileo that the same thing had happened when she sent a work to Charles of Lorraine, duke of Guise and Joyeuse.

77. Garrard, 1989, no. 16.

78. Lodovico's *Susanna* (National Gallery, London) is signed and dated 1616; see *The Age of Correggio and the Carracci*, cat. 115. See also cat. 119, a version of the theme by Sisto Badalocchio ca. 1610, ascribed previously to Annibale and then to Agostino Carracci, on account of an inscription on the balustrade (A. CAR.BON.F) that has been determined to be a later addition to enhance the work's value. A sign of the continuing strength of the type of Annibale's earlier *Susanna* print is the variant that Badalocchio later created, adopting elements from Lodovico's *Susanna*.

79. Although this scenario does not explain the ultraviolet evidence suggesting that the signature might be a later addition, it is important to recall that, according to the conservators, the signature is consistent in technique and craquelure with the painting as a whole. Its darker appearance in ultraviolet could (but does not necessarily) imply a substantially later date for the signature.

80. The existence of such a dynamic can be inferred from its modern replay. My feminist interpretation of these paintings (Garrard, 1989, chap. 4) was early challenged by Richard Spear (1989), who interpreted the Pommersfelden *Susanna* as a sensuous and eroticized image painted for the visual pleasure of a masculine market. Similarly, Bissell (1999, 121) complains that in order to find feminist meaning in the London *Cleopatra* (his pl. 15), one must privilege the queen's ordinary face over the "sensual appeal of the nude body." The difference between my perspective and these—echoing the differently gendered identity positions of Artemisia and her male patrons—points to the subjectivity of beholders. I would further observe that artists can be matter-of-fact when depicting their own sex's anatomy and at the same time produce unintended sexual responses in viewers. Few of the many images in art in which men's penises are visible were intended primarily to be erotic.

81. On the documented practice in literature, art, and folklore whereby women have avoided risk by encoding subversive messages, see Joan N. Radner and Susan S. Lanser, "Strategies of Coding in Women's Cultures," in *Feminist Messages: Coding in Women's Folk Culture*, ed. Joan Newlon Radner (Urbana: University of Illinois Press, 1993), 1–30. Although Radner and Lanser's analysis focuses on nineteenth- and twen-

tieth-century examples, the strategies discussed—ironic mimicry, appropriation, and the exaggeration of features so as (in Maya Angelou's words) to turn the "stereotype against the stereotyper"—precisely echo those of Artemisia described here. In dealing with the question of intention, Radner and Lanser usefully draw upon the work of Meir Sternberg to argue that intentionality may be inferred "from the performance-in-context, which includes what we know of the performer and her circumstances but does not rely on the performer's own word for its guarantee."

82. George Hersey, "Female and Male Art: *Postille* to Garrard's *Artemisia Gentileschi*," in *Parthenope's Splendor: Art in the Golden Age in Naples,* ed. Jeanne Chenault Porter and Susan Scott Munshower (University Park: Pennsylvania State University Press, 1993), 323–34.

83. As Hersey points out, Marino's use of the word *umori* rather than *acque* to describe the fountain brings bodily fluids to mind, setting up an analogy between Susanna's knife-stabbing of herself and the penis-stabbing of the threatened rape. I would add that the word *umore* also underlines the metaphoric identity of the garden setting with the body of the female victim.

84. See Bernadine Barnes, *Michelangelo's "Last Judgment": The Renaissance Response* (Berkeley and Los Angeles: University of California Press, 1998), intro., developing a point made by T. J. Clark (*Image of the People: Gustave Courbet and the 1848 Revolution* [1973; Berkeley and Los Angeles: University of California Press, 1999]).

85. The sexual stigmatizing of Artemisia emerges in the rape trial testimony; see Garrard, 1989, appendix B.

86. See Garrard, 1989, 173, for the text in translation; and Bissell, 1999, cat. L-105 for the full Italian text and a slightly varying translation. Bissell identifies the author of these verses as Gianfrancesco Loredan, Artemisia's Venetian admirer (see Chapter 1, note 82).

87. This description is not likely to refer to the Burghley House *Susanna*, as Hersey suggests, for among other discrepancies, the Burghley *Susanna does* lift her eyes upward. If, as seems likely, the Venetian poet alluded to the Pommersfelden *Susanna*, the painting was probably in Venice, either because it had gone to a Venetian patron or because Artemisia had the picture with her when she was there in the late 1620s (implying that it had found no buyer). Bissell (1999, cat. L-105) believes that the poem alludes to a lost work (of which, however, there is no other evidence).

88. The Italian word *vergognosa* can mean either "bashful" or "shameful." Despite Bissell's inclination to translate the word as "shy," the context clearly requires it to mean "shameful." There is no reason why a merely bashful woman would dare not look to heaven; guilt or shame is more likely to produce that response.

89. See Garrard, 1989, 137; Hersey, 330.

90. Even Orazio may have attested pictorially to Artemisia's defense of her sexual innocence at the trial. He has long been thought to have modeled the features of the *Portrait of a Young Woman as a Sibyl* in Houston on his daughter. As Ann Guité noted in the press kit for the Tassi-Gentileschi exhibition sponsored by the Richard L. Feigen Gallery in the spring of 1998, where this painting was shown, casting Artemisia as a sibyl would imply Orazio's wish to present her as having told the truth.

91. In this connection, the contention of John Spike (1991, as in Chapter 1,

note 38) that the calligraphic signature in Artemisia's Florentine *Magdalen* was added by another hand would offer another example of an added, later affirmation (in this case accurate) of her authorship. Other Artemisia "signatures" that appear on quite unconvincing attributions (e.g., a *Saint Catherine of Alexandria* in a private collection in Pavia, signed and dated 1631) should be reconsidered in the light of, and also as signs of, the market for her paintings that was evidently fed as much by her signature as by her paintings.

92. It is to the credit of Burghley House that they have valued their Artemisia during a period when most institutions and collectors considered the artist distinctly second-rate, preferring Orazio over Artemisia attributions whenever possible. Their commitment to the picture even before the signature was revealed has been fully justified, even under the conditions I have outlined, for if my arguments are correct, the Burghley *Susanna* has turned out to be an important document of interventions performed upon this woman artist's pictures.

93. Elizabeth S. Cohen, "No Longer Virgins: Self-Presentation by Young Women in Late Renaissance Rome," in *Refiguring Woman: Perspectives on Gender and the Italian Renaissance,* ed. Marilyn Migiel and Juliana Schiesari (Ithaca, N.Y.: Cornell University Press, 1991) details the testimonies of twelve female rape victims in Rome in 1602–4, drawn from the same court proceedings as Artemisia's trial. Their common circumstances are striking: the description of heavy bleeding (an effort to document the violent act, since rape charges had to be supported by evidence of violation, to prove that the sex had not been voluntary); judicial torture to attest their veracity; and proof of the deflowering. In Rome at that time, rape of nonvirgins was rarely prosecuted, a fact that sheds light on Orazio Gentileschi's strategy in falsifying his daughter's age. For had it been known that at the time of the rape Artemisia was no longer a minor, aged nineteen, not fifteen, her claim of virginity would have been more fragile, the prospect of bringing Tassi to trial less likely. Like Artemisia, some of the women report their belief that the rape imposed on them obligations of future sexual favors. Artemisia's insistence that Tassi had pledged to marry her was not inconsistent with the charge of rape, as is sometimes claimed, but rather reflected long-standing Mediterranean practice in which the promise of marriage justified sexual intimacy, as the first stage of a long-term commitment. As in her case, the facts of personal relationships can be subtle; some of the women were raped by men they loved.

94. If my reading of Susanna's eyes in the X-ray is accurate, as discussed earlier in this chapter, the disengaged stare that is visible also in the Spada *Lute Player* could be connected with the state of dissociation said by psychologists to accompany and to follow trauma. According to Caruth (1995, 6), "In trauma the greatest confrontation with reality may also occur as an absolute numbing to it . . . [and] immediacy, para-doxically enough, may take the form of belatedness." I am not necessarily proposing that Artemisia re-experienced her trauma while painting the Burghley *Susanna*—though the theory of latency, or delayed reaction, would accommodate it—yet it is extraordinary that she inscribed in the face of her protagonist, long before psychological theory was known, a vivid image of how a trauma victim might feel.

1. See Judith Butler's discussion of "disidentification" in *Bodies That Matter* (New York: Routledge, 1993), 112.

2. Despite the probability that the date 1622 inscribed on the Burghley *Susanna* is a later addition, Artemisia's original painting was most likely painted very near that year, for the stylistic and circumstantial reasons discussed in Chapter 2.

3. See Bissell, 1999, 43–54. In removing the *Lucretia* to the 1610s and taking the *Cleopatra* and Burghley *Susanna* out of Artemisia's oeuvre, Bissell essentially eliminates naturalistic female figures from the early 1620s, leaving a group of reclining nudes (some of them new, and not entirely persuasive, attributions) to represent the decade at its end. And as a consequence he must treat the Detroit *Judith* and *Aurora* (of 1623–25 and 1625–27, respectively, by his dating), as well as the Seville *Magdalen,* which he assigns to the mid-1620s, as anomalous responses to diverse patrons' wishes.

4. By contrast, the Magdalen theme disappears from Artemisia's established oeuvre after the Alcalá version, a point in favor of her private attachment to the theme and her unwillingness to sexualize the image for profit. I do not take into account three new *Penitent Magdalen* paintings Bissell (1999) has attributed to Artemisia, because I find each a problematic attribution: (1) a half-length figure in a private collection, Los Angeles, dated 1615–16 (cat. 9); (2) a reclining figure in a private collection in Naples, dated ca. 1627–29 (cat. 21); and (3) a seated figure in the National Gallery, Oslo, dated early 1640s? (cat. 43).

5. The *Bathsheba* now in Columbus, painted for Luigi Romeo, baron of San Luigi, was described by De Dominici as hanging with its now-lost pendant *Susanna.* A *Susanna* recently sold at auction (Sotheby's, London, 6 December 1995) may be the missing picture (see Bissell, 1999, cat. 38). Artemisia painted a large *Bathsheba* and *Susanna* for Averardo de' Medici in 1652; the *Bathsheba* has been identified with the Florentine (Pitti) version; its pendant may be the signed and dated *Susanna* in Brno. See Bissell, 1999, cat. 50; Garrard, 1989, 121; 130–31; Contini and Papi, cat. 27.

6. Diana Fuss, *Identification Papers* (New York: Routledge, 1995), 2. The dangers and possibilities of identification, as well as the noncorrespondence of identities and identifications, are explored by Eve Kosofsky Sedgwick in her influential books *Between Men: English Literature and Male Homosocial Desire, Epistemology of the Closet,* and *Tendencies* (cited by Fuss, 6).

7. On reception theory in general, especially the studies of Wolfgang Kemp, see Mieke Bal and Norman Bryson, "Semiotics and Art History," *Art Bulletin* 73 (1991): 174–208, esp. 184–88.

8. Michael Ann Holly, "Past Looking," *Critical Inquiry* 16 (winter 1990): 388. Holly is speaking of the ways that an entire historical period might "prefigure" its own historiography, but the principle can also apply to an individual example.

9. See Steven Orso, *Philip IV and the Decoration of the Alcázar of Madrid* (Princeton, N.J.: Princeton University Press, 1986), 55 and 107–10, whose description I quote. Artemisia's lost *Hercules* for the Spanish king (presumably comparable in size to Rubens's pendant, which measures 246 × 267 cm) may be identical with a *Hercules Spinning*

named in a 1699 inventory of the collection of Carlo de Cardenas, conte di Acerra and marchese di Laino; this picture measured 8 × 9 palmi, or 211 × 238 cm. The Neapolitan Cardenas family was of Spanish origin; Carlo was a grandee of Spain (Labrot, 1992, 206).

10. This conclusion must remain hypothetical, since most of her works, particularly those after about 1630, are known only by name.

11. Merlot offered her explanation in a descriptive leaflet released by Miramax Zoë, "Preliminary Notes 8/11/97." I am grateful to Professor Lynne Johnson for giving me a copy of this publication. I understand that at a screening in Los Angeles, Merlet, when asked why she had not relied on recent scholarship in making the film, replied that she wanted it to be her "personal" conception.

12. Robin Masi described it this way in an art history listserve communication of winter 1998; her impassioned critique first brought the film to my notice. At a symposium on it sponsored by the Feigen Gallery in May 1998, Simon Schama also spoke of it as the second rape of Artemisia.

13. In May–June 1998 the international press gave extensive coverage to both the film and the controversy it sparked in the United States. For a discussion of the film and the critical response to it, see Mary D. Garrard, "Artemisia's Trial by Cinema," *Art in America* 10 (October 1998): 65–69.

14. *Los Angeles Times*, 27 May 1998 (Merlet); *Newsweek*, 25 May 1998 (Miramax).

WORKS CITED

Adams, Laurie Schneider. *Art And Psychoanalysis.* New York: HarperCollins, 1993.

The Age of Caravaggio. Exh. cat. New York: Metropolitan Museum of Art; Milan: Electra Editrice, 1985. Foreword by Philippe de Montebello, with introductory essays by Luigi Salerno, Richard E. Spear, and Mina Gregori.

The Age of Correggio and the Carracci: Emilian Painting of the Sixteenth and Seventeenth Centuries. Exh. cat. Washington, D.C., National Gallery of Art; New York, Metropolitan Museum of Art; Bologna, Pinacoteca Nazionale. Cambridge: Cambridge University Press, 1986.

Allen, Beverly, Muriel Kittel, and Keala Jewell, eds. *The Defiant Muse: Italian Feminist Poems from the Middle Ages to the Present.* New York: Feminist Press, 1986.

Ascoli, Albert Russell. *Ariosto's Bitter Harmony: Crisis and Evasion in the Italian Renaissance.* Princeton, N.J.: Princeton University Press, 1987.

Askew, Pamela. "Domenico Fetti's Use of Prints: Three Instances." In *Tribute to Wolfgang Stechow,* edited by Walter L. Strauss, 14–23. [*Print Review,* no. 5, spring 1976.] New York: Pratt Graphics Center and Kennedy Galleries, 1976.

———. *Caravaggio's "Death of the Virgin."* Princeton, N.J.: Princeton University Press, 1990.

———. "Caravaggio: Outward Action, Inward Vision." In *Michelangelo Merisi da Caravaggio: La vita e le Opere attraverso i Documenti,* 248–69. Atti del Convegno Internazionale di Studi, Rome, 1995. Rome: Logart Press, 1995.

Bal, Mieke. "Seeing Signs: The Use of Semiotics for the Understanding of Visual Art." In *The Subjects of Art History: Historical Objects in Contemporary Perspective,* edited by Mark A. Cheetham, Michael Ann Holly, and Keith Moxey, 74–93. Cambridge: Cambridge University Press, 1998.

Bal, Mieke, and Norman Bryson. "Semiotics and Art History." *Art Bulletin* 73 (1991): 174–208.

Balas, Edith. *Michelangelo's Medici Chapel: A New Interpretation.* Philadelphia: American Philosophical Society, 1995.

Baldinucci, Filippo. *Opere di Filippo Baldinucci.* Milan: Società tipografica de' Classici italiani, 1802–12.

Barnes, Bernadine. *Michelangelo's "Last Judgment": The Renaissance Response.* Berkeley and Los Angeles: University of California Press, 1998.

Bembo, Pietro. *Pietro Bembo's Gli Asolani.* Translated by Rudolf B. Gottfried. Freeport, N.Y.: Books for Libraries Press, 1971.

Benson, Pamela. *The Invention of the Renaissance Woman: The Challenge of Female Independence in the Literature and Thought of Italy and England.* University Park: Pennsylvania State University Press, 1992.

Bissell, R. Ward. "Artemisia Gentileschi—a New Documented Chronology." *Art Bulletin* 50 (1968): 153–68.

———. *Orazio Gentileschi and the Poetic Tradition in Caravaggesque Painting.* University Park: Pennsylvania State University Press, 1981.

———. *Artemisia Gentileschi and the Authority of Art: Critical Reading and Catalogue Raisonné.* University Park: Pennsylvania State University Press, 1999.

Borea, Evelina. "Caravaggio e la Spagna: Osservazioni su una mostra a Siviglia." *Bollettino d'arte* 59 (1974): 46–47.

Boschini, Marco, *La Carta del Navegar Pitoresco* [Venice, 1672]. Edited by A. Pallucchini. Venice: Istituto per la collaborazione culturale, 1966.

Bousquet, Jacques. "Valentin et ses compagnons: Réflections sur les Caravagesques français à partir des archives paroissiales romaines." *Gazette des Beaux-Arts* 11 (1978): 101–14.

Brigstocke, Hugh, and John Somerville, with a foreword by Lady Victoria Leatham. *Italian Paintings from Burghley House.* Exh. cat. Alexandria, Va.: Art Services International, 1995.

Broude, Norma, and Mary D. Garrard, eds. *The Expanding Discourse: Feminism and Art History.* New York: HarperCollins, 1992.

Brown, Jonathan, and Richard L. Kagan. "The Duke of Alcalá: His Collection and Its Evolution." *Art Bulletin* 69 (1987): 231–55.

Butler, Judith. *Bodies That Matter.* New York: Routledge, 1993.

Calvesi, Maurizio. "La Maddalena come 'Sposa' nei dipinti del Caravaggio." In *La Maddalena tra Sacro e Profano,* edited by Marilena Mosco, 147–51. Milan: Arnoldo Mondadori Editore, 1986.

Cantelli, Giuseppe. *Repertorio della pittura fiorentina del seicento.* Florence: Opus Libri, 1983.

Caruth, Cathy, ed. *Trauma: Explorations in Memory.* Baltimore: Johns Hopkins University Press, 1995.

Cassidy, Brendan. Entry from Catalogue of the Foreign Oil Painting Collection at Nottingham Castle Museum.

Castiglione, Baldesar. *The Book of the Courtier.* Edited and translated by Charles S. Singleton. New York: Doubleday, 1959.

Cavallo, Sandra, and Simona Cerutti. "Female Honor and the Social Control of Reproduction in Piedmont between 1600 and 1800." Translated by Mary M. Gallucci. In *Sex and Gender in Historical Perspective,* edited by Edward Muir and Guido Ruggiero, 73–109. Baltimore: Johns Hopkins University Press, 1990.

Chappell, Miles L. *Cristofano Allori, 1577–1621.* Exh. cat. Florence, Palazzo Pitti, July–October 1984. Florence: Centro Di, 1984.

Chastel, André. "Melancholia in the Sonnets of Lorenzo de' Medici." *Journal of the Warburg and Courtauld Institutes* 8 (1945): 61–67.

Chiarini, Marco, and Claudio Pizzorusso, eds. *Sustermans: Sessant'anni alla corte dei Medici.* Florence: Centro Di, 1983.

Cohen, Elizabeth S. "No Longer Virgins: Self-Presentation by Young Women in Late Renaissance Rome." In *Refiguring Woman: Perspectives on Gender and the Italian Renaissance,* edited by Marilyn Migiel and Juliana Schiesari, 169–91. Ithaca, N.Y.: Cornell University Press, 1991.

Contini, Roberto, and Gianni Papi. *Artemisia.* Exh. cat. Florence, Casa Buonarroti, 18 June–4 November 1991. Rome: Leonardo–De Luca Editori, 1991.

Contreras, Juan Miguel Serrera. "Nobleza y coleccionismo en la Sevilla del siglo de oro." In Contreras, *Nobleza, coleccionismo y mecenazgo,* 45–62. Seville: Real Maestranza de Caballeria, 1998.

Cropper, Elizabeth. "The Beauty of Woman: Problems in the Rhetoric of Renaissance Portraiture." In *Rewriting the Renaissance: The Discourses of Sexual Difference in Early Modern Europe,* edited by Margaret W. Ferguson, Maureen Quilligan, and Nancy J. Vickers, 175–90. Chicago: University of Chicago Press, 1986.

———. "New Documents for Artemisia Gentileschi's Life in Florence." *Burlington Magazine* 135 (1993): 760–61.

Cummings, Frederick J., with contributions by James L. Greaves and Meryl Johnson, Luigi Spezzaferro, and Luigi Salerno. "Detroit's 'Conversion of the Magdalen' (the Alzaga Caravaggio)." *Burlington Magazine* 116 (1974): 563–93.

De Grazia, Diane, and Erich Schleier. "St. Cecilia and an Angel: 'The Heads by Gentileschi, the rest by Lanfranco.'" *Burlington Magazine* 136 (1994): 73–78.

Delenda, Odile. "Sainte Marie Madeleine et l'application du décret tridentin (1563) sur les saintes images." In *Marie Madeleine dans la mystique, les arts et les lettres,* edited by Eve Duperray, 191–209. Paris: Beauchesne Éditeur, 1989.

De Maio, Romeo, "Il mito della Maddalena nella Contrariforma. " In *La Maddalena tra Sacro e Profano,* edited by Marilena Mosco, 82–83. Milan: Arnoldo Mondadori Editore, 1986.

Donaldson-Evans, Lance K. *Love's Fatal Glance: A Study of Eye Imagery in the Poets of the "Ecole Lyonnaise."* University, Miss.: Romance Monographs, 1980.

Duperray, Eve, ed. *Marie Madeleine dans la mystique, les arts et les lettres.* Actes du colloque international, Avignon, 20–22 July 1988. Paris: Beauchesne Éditeur, 1989.

Eisler, Colin. *The Master of the Unicorn: The Life and Work of Jean Duvet.* New York: Abaris Books, 1979.

Emison, Patricia. *The Art of Teaching: Sixteenth-Century Allegorical Prints and Drawings.* New Haven, Conn.: Yale University Art Gallery, 1986.

Enterline, Lynn. *The Tears of Narcissus: Melancholia and Masculinity in Early Modern Writings.* Stanford, Calif.: Stanford University Press, 1995.

Ficino, Marsilio. *The Letters of Marsilio Ficino.* Translated by members of the Language Department of the School of Economic Science, London. London: Shepard-Walwyn, 1978. Reprint. New York: Gingko Press, 1985.

Finucci, Valeria. *The Lady Vanishes: Subjectivity and Representation in Castiglione and Ariosto.* Stanford, Calif.: Stanford University Press, 1992.

Freud, Sigmund. "Mourning and Melancholy." In *The Standard Edition of the Complete Psychological Works of Sigmund Freud,* vol. 14, 243–58. London: Hogarth Press and the Institute of Psycho-Analysis, 1995–96.

Friend, A. M., Jr. "The Portraits of the Evangelists in Greek and Latin Manuscripts." *Art Studies* 5 (1927): 115–47.

Fuda, Roberto. "Un'inedita lettera di Artemisia Gentileschi a Ferdinando II de' Medici." *Rivista d'Arte* 41 (1989): 167–71.

Fulton, Christopher. "The Boy Stripped Bare by His Elders: Art and Adolescence in Renaissance Florence." *Art Journal* 56 (1997): 31–40.

Fuss, Diana. *Identification Papers.* New York: Routledge, 1995.

Garas, Klara. "The Ludovisi Collection of Pictures in 1633—I." *Burlington Magazine* 109 (1967): 287–89.

———. "The Ludovisi Collection of Pictures in 1633—II." *Burlington Magazine* 109 (1967): 339–48.

Garrard, Mary D. "Artemisia Gentileschi's *Self-Portrait as the Allegory of Painting.*" *Art Bulletin* 62 (1980): 97–112.

———. "Artemisia and Susanna." In *Questioning the Litany: Feminism and Art History,* edited by Norma Broude and Mary D. Garrard, 146–71. New York: Harper and Row, 1982.

———. "The Liberal Arts and Michelangelo's First Project for the Tomb of Julius II (with a Coda on Raphael's 'School of Athens')." *Viator: Medieval and Renaissance Studies* 15 (1984): 337–76.

———. *Artemisia Gentileschi: The Female Hero in Italian Baroque Art.* Princeton, N.J.: Princeton University Press, 1989.

———. "Artemisia Gentileschi's *Corisca and the Satyr.*" *Burlington Magazine* 135 (1993): 34–38.

———. "Here's Looking at Me: Sofonisba Anguissola and the Problem of the Woman Artist." *Renaissance Quarterly* 47 (1994): 556–622.

———. "Artemisia's Trial by Cinema." *Art in America* 10 (October 1998): 65–69.

Giamatti, A. Bartlett. *The Earthly Paradise and the Renaissance Epic.* Princeton, N.J.: Princeton University Press, 1966.

Goffen, Rona. *Titian's Women.* New Haven, Conn.: Yale University Press, 1997.

Goodman, Elise L. "Petrarchism in Titian's *The Lady and the Musician.*" *Storia dell'Arte* 49 (1983): 179–86.

Grabar, André. "Une fresque visigothique et l'iconographie du silence." *Cahiers archaeologiques* 1 (1946): 124–28.

Grabski, Józef. "On Seicento Painting in Naples: Some Observations on Bernardo Cavallino, Artemisia Gentileschi, and Others." *Artibus et Historiae* 6 (1985): 23–63.

Greenblatt, Stephen. *Renaissance Self-Fashioning: From More to Shakespeare.* Chicago: University of Chicago Press, 1980.

Gregori, Mina. "Su Due Quadri Caravaggeschi a Burghley House." In *Festschrift Ulrich Middeldorf,* 1:414–21. Berlin: Walter De Gruyter and Company, 1968.

Harris, Ann Sutherland, and Linda Nochlin. *Women Artists: 1550–1950.* New York: Alfred A. Knopf, 1976.

Haskell, Francis. *Patrons and Painters: A Study in the Relations between Italian Art and Society in the Age of the Baroque.* New York: Alfred A. Knopf, 1963.

Haskins, Susan. *Mary Magdalen: Myth and Metaphor.* New York: Harcourt, Brace and Company, 1993.

Hersey, George. "Female and Male Art: *Postille* to Garrard's *Artemisia Gentileschi.*" In *Parthenope's Splendor: Art in the Golden Age in Naples,* edited by Jeanne Chenault Porter and Susan Scott Munshower, 323–34. University Park: Pennsylvania State University Press, 1993.

Hibbard, Howard. *Caravaggio.* New York: Harper and Row, 1983.

Hill, George. *Portrait Medals of Italian Artists of the Renaissance.* London: P. L. Warner, 1912.

Hoff, Ursula. "Meditation in Solitude." *Journal of the Warburg and Courtauld Institutes* 1 (1938): 292–94.

Hollanda, Francisco de. *Four Dialogues on Painting.* Translated by Aubrey F. G. Bell. London, 1928. Reprint. Westport, Conn.: Hyperion Press, 1979.

Holly, Michael Ann. "Past Looking." *Critical Inquiry* 16 (1990): 371–96.

Iversen, Margaret. "Saussure v. Peirce: Model for a Semiotics of Visual Art." In *The New Art History,* edited by A. L. Rees and Frances Borzello, 82–94. Atlantic Highlands, N.J.: Humanities Press International, 1988.

Jacobs, Fredrika H. "Woman's Capacity to Create: The Unusual Case of Sofonisba Anguissola." *Renaissance Quarterly* 47 (1994): 74–101.

———. *Defining the Renaissance Virtuosa.* Cambridge: Cambridge University Press, 1997.

Jed, Stephanie H. *Chaste Thinking: The Rape of Lucretia and the Birth of Humanism.* Bloomington: Indiana University Press, 1989.

Joannides, Paul. *The Drawings of Raphael, with a Complete Catalogue.* Berkeley and Los Angeles: University of California Press, 1983.

Jordan, Constance. *Renaissance Feminism: Literary Texts and Political Models.* Ithaca, N.Y.: Cornell University Press, 1990.

Kemp, Martin. " *'Ogni dipintore dipinge sè':* A Neoplatonic Echo in Leonardo's Art Theory." In *Cultural Aspects of the Italian Renaissance: Essays in Honour of Paul Oskar Kristeller,* edited by Cecil H. Clough, 311–23. New York: Alfred F. Zambelli, 1976.

Klibansky, Raymond, Erwin Panofsky, and Fritz Saxl. *Saturn and Melancholy: Studies in the History of Natural Philosophy, Religion, and Art.* New York: Basic Books, 1964.

Kosmer, Ellen. "The 'Noyous Humoure of Lecherie.'" *Art Bulletin* 57 (1975): 1–8.

Kristeva, Julia. "On the Melancholic Imaginary." In *Discourse in Psychoanalysis and Literature,* edited by Schlomith Rimmon-Kenan, 104–23. London: Methuen, 1987.

Labalme, Patricia. "Venetian Women on Women: Three Early Modern Feminists." *Archivio veneto* 152 (1981): 81–109.

Labrot, Gérard, with Antonio Delfino. *Collections of Paintings in Naples, 1600–1780.* Edited by Carol Togneri Dowd and Anna Cera Sones. Provenance Index of the Getty Art History Information Program, Documents for the History of Collecting, Italian Inventories I. Munich: K. G. Saur, 1992.

Lapierre, Alexandra. *Artemisia: Un duel pour l'immortalité.* Paris: Robert Laffont, 1998.

Lavin, Marilyn Aronberg. *Seventeenth-Century Barberini Documents and Inventories of Art.* New York: New York University Press, 1975.

Liebert, Robert S. *Michelangelo: A Psychoanalytic Study of His Life and Images.* New Haven, Conn.: Yale University Press, 1983.

Lippincott, Kristen. Review of *Artemisia Gentileschi: The Female Hero in Italian Baroque Art,* by Mary D. Garrard. *Renaissance Studies* 4 (1990): 444–48.

Longhi, Roberto, "Gentileschi padre e figlia," *L'Arte* 19 (1916): 245–314.

Maclean, Ian. *The Renaissance Notion of Woman.* Cambridge: Cambridge University Press, 1980.

Mahon, Sir Denis. *Il Guercino (Giovanni Francesco Barbieri), 1591–1666: Catalogo critico dei disegni.* Bologna: Edizioni Alfa, 1969.

———. "Guercino and Cardinal Serra: A Newly Discovered Masterpiece." *Apollo* 114 (1981): 170–75.

———, ed. *Giovanni Francesco Barbieri Il Guercino, 1591–1666.* With entries by Prisco Bagni, Diane De Grazia, Denis Mahon, and Fausto Gozzi. Bologna: Nuovo Alfa Editoriale, 1991.

Malvern, Marjorie M. *Venus in Sackcloth: The Magdalen's Origins and Metamorphoses.* Carbondale: Southern Illinois University Press, 1975.

Mann, Judith W. "Caravaggio and Artemisia: Testing the Limits of Caravaggism." *Studies in Iconography* 18 (1997): 161–85.

Masetti, Anna Rosa. "Il Casino Mediceo e la pittura fiorentina del seicento, I." *Critica d'Arte* 9 (1962): 1–27.

Mosco, Marilena, ed. *La Maddalena tra Sacro e Profano.* Milan: Arnoldo Mondadori Editore, 1986.

Notarp, Gerlinde Lütke. "Jacques de Gheyn II's *Man Resting in a Field:* An Essay on the Iconography of Melancholy." *Simiolus* 24 (1996): 311–19.

Oberhuber, Konrad. "Eine unbekannte Zeichnung Raffaels in den Uffizien." *Mitteilungen des Kunsthistorischen Institutes in Florenz* 12 (1966): 225–44.

Ogle, M. B. "The Classical Origin and Tradition of Literary Conceits." *American Journal of Philology* 34 (1913): 125–53.

Orso, Steven. *Philip IV and the Decoration of the Alcázar of Madrid.* Princeton, N.J.: Princeton University Press, 1986.

Ortiz, Antonio Domínguez, Alfonso E. Pérez Sánchez, and Julián Gállego. *Velázquez.* Exh. cat. Metropolitan Museum of Art, New York, 3 October 1989–7 January 1990. New York: Harry N. Abrams, 1989.

Panofsky, Erwin. "The Neoplatonic Movement and Michelangelo." In Panofsky, *Studies in Iconology: Humanistic Themes in the Art of the Renaissance,* 171–230. New York: Harper and Row, 1962 [originally published 1939].

———. "The History of Art as a Humanistic Discipline." In Panofsky, *Meaning in the Visual Arts,* 1–25. Garden City, N.Y.: Doubleday, 1955.

———. *The Life and Art of Albrecht Dürer.* Princeton, N.J.: Princeton University Press, 1955.

Papi, Gianni. Review of *Artemisia Gentileschi and the Authority of Art: Critical Reading and Catalogue Raisonné,* by R. Ward Bissell. *Burlington Magazine* 142 (2000): 450–53.

Percy, Ann. *Giovanni Benedetto Castiglione, Master Draughtsman of the Italian Baroque.* Philadelphia: Philadelphia Museum of Art, 1971.

Pitt-Rivers, Julian. "Honor and Social Status." In *Honor and Shame: The Values of Mediterranean Society,* edited by J. G. Peristiany, 19–78. Chicago: University of Chicago Press, 1966.

Pollock, Griselda. *Differencing the Canon: Feminist Desire and the Writing of Art's Histories.* London: Routledge, 1999.

———. Review of *Artemisia Gentileschi: The Female Hero in Italian Baroque Art,* by Mary D. Garrard. *Art Bulletin* 72 (1990): 499–505.

Pope, Arthur. *The Language of Drawing and Painting.* Cambridge, Mass.: Harvard University Press, 1949.

Radner, Joan N., and Susan S. Lanser. "Strategies of Coding in Women's Cultures." In *Feminist Messages: Coding in Women's Folk Culture,* edited by Joan Newlon Radner, 1–30. Urbana: University of Illinois Press, 1993.

Ratti, Carlo Giuseppe. *Instruzione di quanto può vedersi di più bello in Genova in Pittura, Scultura, ed Architettura ecc.* 2d ed. Genoa: I. Gravier, 1780.

Regan, Mariann Sanders. *Love Words: The Self and the Text in Medieval and Renaissance Poetry.* Ithaca, N.Y.: Cornell University Press, 1982.

Riegl, Alois. *Late Roman Art Industry.* Translation and notes by Rold Winkes. Rome: G. Bretschneider, 1985.

Rigolot, François. "Magdalen's Skull: Allegory and Iconography in *Heptameron* 32." *Renaissance Quarterly* 47 (1994): 57–73.

Rosenthal, Margaret F. "Venetian Women Writers and Their Discontents." In *Sexuality and Gender in Early Modern Europe: Institutions, Texts, Images,* edited by James Grantham Turner, 107–32. Cambridge: Cambridge University Press, 1993.

Russell, H. Diane. *Claude Lorrain, 1600–1682.* Exh. cat. Washington, D.C.: National Gallery of Art, 1982.

Safarik, Eduard A., with Gabriello Milantoni. *Fetti.* Milan: Electa, 1990.

Salerno, Luigi. *I dipinti del Guercino.* Rome: Ugo Bozzi, 1988.

Saslow, James M. *The Poetry of Michelangelo: An Annotated Translation.* New Haven, Conn.: Yale University Press, 1991.

———. " 'Disagreeably Hidden': Construction and Constriction of the Lesbian Body in Rosa Bonheur's *Horse Fair.*" In *The Expanding Discourse: Feminism and Art History,* edited by Norma Broude and Mary D. Garrard, 187–205. New York: HarperCollins, 1992.

Saxer, Victor. *Le culte de Marie Madeleine en Occident: Des origines à la fin du Moyen Âge.* Auxerre: Publications de la Société des fouilles archéologiques et des monuments historiques de l'Yonne; Librairie Clavreuil, 1959.

Schiesari, Julianna. "The Gendering of Melancholia: Torquato Tasso and Isabella di Morra." In *Refiguring Woman: Perspectives on Gender and the Italian Renaissance,* edited by Marilyn Migiel and Juliana Schiesari, 233–62. Ithaca, N.Y.: Cornell University Press, 1991.

———. *The Gendering of Melancholia: Feminism, Psychoanalysis, and the Symbolics of Loss in Renaissance Literature.* Ithaca, N.Y.: Cornell University Press, 1992.

Schwarz, Heinrich. "The Mirror in Art." *Art Quarterly* 15 (1952): 97–118.

Seymour, Charles, Jr. *Michelangelo's David: A Search for Identity.* Pittsburgh: University of Pittsburgh Press, 1967.

Shapin, Steven. *The Scientific Revolution.* Chicago: University of Chicago Press, 1996.

Shrimplin-Evangelidis, Valerie. "Michelangelo and Nicodemism: The Florentine *Pietà.*" *Art Bulletin* 71 (1989): 57–67.

Slade, Carole. *St. Teresa of Avila: Author of a Heroic Life.* Berkeley and Los Angeles: University of California Press, 1995.

Solomon, Nanette. "The Art Historical Canon: Sins of Omission." *In (En)gendering Knowledge: Feminists in Academe,* edited by Joan Hartmann and Ellen Messer-Davidow, 222–36. Knoxville: University of Tennessee Press, 1991.

Spear, Richard E. Review of *Artemisia Gentileschi: The Female Hero in Italian Baroque Art,* by Mary D. Garrard. *Times Literary Supplement,* 2–8 June 1989, 603–4.

———. *The "Divine" Guido: Religion, Sex, Money, and Art in the World of Guido Reni.* New Haven, Conn.: Yale University Press, 1997.

Spike, John T. "Florence, Casa Buonarroti, Artemisia Gentileschi," *Burlington Magazine* 133 (1991): 732–34.

Staten, Henry. *Eros in Mourning: Homer to Lacan.* Baltimore: Johns Hopkins University Press, 1995.

Stone, David M. *Guercino: Catalogo completo dei dipinti.* Florence: Cantini, 1991.

Stortoni, Laura Anna, ed. *Women Poets of the Italian Renaissance: Courtly Ladies and Courtesans.* Translated by Stortoni and Mary Prentice Lillie. New York: Italica Press, 1997.

Strinati, Claudio, and Rossella Vodret. *Caravaggio and His Italian Followers, from the Collections of the Galleria Nazionale d'Arte Antica di Roma.* Exh. cat. Wadsworth Atheneum, Hartford, Conn., 23 April–26 July 1998. Venice: Marsilio Editori, 1998.

Summers, David. "Form and Gender." *New Literary History* 24 (1993): 243–71.

Tervarent, Guy de. *Attributs et symboles dans l'art profane, 1450–1600.* Geneva: Librairie E. Droz, 1958.

Trexler, Richard C., and Mary Elizabeth Lewis. "Two Captains and Three Kings: New Light on the Medici Chapel." In *Michelangelo: Selected Scholarship in English,* edited by William E. Wallace, 3:197–283. New York: Garland, 1995.

Turner, James Grantham, ed. *Sexuality and Gender in Early Modern Europe: Institutions, Texts, Images.* Cambridge: Cambridge University Press, 1993.

Valdivieso, Enrique. *Catálogo de las pinturas de la catedral de Sevilla.* Sevilla: Enrique Valdivieso Autor y Editor, 1978.

Vliegenthart, Adriaan W. *La Galleria Buonarroti, Michelangelo e Michelangelo il Giovane.* Florence: Istituto Universitario Olandese di Storia dell'Arte, 1976.

Watson, Paul F. *The Garden of Love in Tuscan Art of the Early Renaissance.* Cranbury, N.J.: Associated University Presses, 1979.

Weber, Alison. *Teresa of Avila and the Rhetoric of Femininity.* Princeton, N.J.: Princeton University Press, 1990.

Wethey, Harold E. *The Paintings of Titian.* Vol. 3, *The Mythological and Historical Paintings.* London: Phaidon Press, 1975.

Wheelock, Arthur K., Jr., Susan J. Barnes, Julius S. Held, et al. *Anthony van Dyck.* Exh. cat. Washington, D.C.: National Gallery of Art, 1990.

Wind, Barry. "Gesture and Meaning in Two Paintings by Caravaggio." *Source* 16 (1997): 7–11.

Wittkower, Rudolf, and Margot Wittkower. *Born under Saturn: The Character and Conduct of Artists: A Documented History from Antiquity to the French Revolution.* New York: W. W. Norton and Company, 1963.

Wood, Carolyn H. "The Ludovisi Collection of Paintings in 1623." *Burlington Magazine* 134 (1992): 515–23.

Yavneh, Naomi. "The Ambiguity of Beauty in Tasso and Petrarch." In *Sexuality and Gender in Early Modern Europe: Institutions, Texts, Images,* edited by James Grantham Turner, 133–57. Cambridge: Cambridge University Press, 1993.

Zerner, Henri. *The French Renaissance in Prints.* Los Angeles: Grunwald Center for the Graphic Arts, 1995.

INDEX

Page numbers in italic refer to illustrations

Accademia dei Desiosi, 57

Active *versus* contemplative life, 35, 38, 66, 73

Adams, Laurie Schneider, 125n1, 130n42

Alcalá, duke of. *See* Ribera, Fernando Afám de

Alcina, 82

Allegory, 9, 65; of painting, 55–61, 74

Allori, Cristofano, 137n48

Andreani, Andrea, 143n94

Andreini, Isabella, 99–100, 152n61

Anguissola, Sofonisba, 100, 127n12

Apollodorus, 141n82

Architectural backgrounds, 102, 152n67

Ariosto, Lodovico, 82, 99, 146n9

Aristotle, 7

Armida, 82

Askew, Pamela, 44, 48, 143n94

Attribution, xvii, 2, 4–5, 7, 9, 11, 14, 56, 74–75, 77, 95, 111, 126n3, 128nn20–22, 132n7, 135n30, 140n76, 141nn, 145n1, 147n23, 156n91, 157nn3–4

Audience: distinguished from public, 109; and reception of art, 119

Aznar, José Camón, 142n88

Baglione, Giovanni, 11

Bal, Mieke, 125n1

Baldinucci, Filippo, 6, 126n7

Barberini, Cardinal Antonio, 96, 150–51nn47–49, 51

Barberini, Cardinal Francesco, 96, 141n85, 150–51nn47–49, 51

Barberini, Maffeo (Pope Urban VIII), 150n48

Barbieri, Giovanni Francesco. *See* Guercino

Bargello Tondo, Master of the, *Susanna and the Elders,* Florence, Serristori Collection, 81, *83*

Barkan, Leonard, 141n83

Barnes, Bernadine, 109

Beauty, feminine, 7–9, 11, 14, 15, 38, 72, 77, 112, 117, 118, 119, 121, 123

Beauty, masculine, 127n15

Bellori, Giovanni Pietro, 43

Bembo, Pietro, 81–82

Biffi, Alessandro di, 14, 128n23

Bissell, R. Ward, 2, 11, 14, 16, 17, 27, 29, 57, 116, 123, 126nn3, 7–8, 127n14, 128nn21–22, 27, 130n44, 132nn6–7, 134–35nn22, 25, 30,

Bissell, R. Ward (*continued*)
140–42nn76, 82, 85–86, 91, 145n1,
147nn21, 23, 149–50nn40, 44, 46,
151n51, 152n61, 153n74, 155nn86–
87, 157nn3–4

Boccaccio, Giovanni, *Decameron,* 81,
146n4

Bologna, Pinacoteca, *Portrait of a Gon-
faloniere,* Artemisia Gentileschi, 87,
106, 132n7

Bonheur, Rosa, 9, 127n18

Borea, Evelina, 127–28n20, 128n22

Borromeo, Carlo, 44

Boschi, Fabrizio, *Allegory of Painting
Awakened by Grand Duke Cosimo II
de' Medici,* Florence, Corte d'Appello,
55, *56,* 139–40n73

Boschini, Marco, 83

Brigstocke, Hugh, 145n1, 149nn41, 44,
150n45

Brno, Moravska Galerie, *Susanna and the
Elders,* Artemisia Gentileschi, 92–93,
93

Brown, Jonathan, 25, 27, 131–32n4,
133n13, 142n88

Budapest, Szépmüvészeti Museum, *Jael
and Sisera,* Artemisia Gentileschi, 64,
67, 102, 107, 117, 132–33n8, 143n91

Butler, Judith, 157n1

Caccini, Francesca, 141n78

Cagnacci, Guido, 144n96

Calvesi, Maurizio, 45

Capecelatro, Ettore, 33, 34, 134–
35nn24–25

Capitalism, 130n34

Caravaggio, Michelangelo Merisi da:
attribution of work to, 95; and
influence on Artemisia Gentileschi,
14, 19, 32, 39, 42–43, 45–46, 47–48,
73, 116; and self-projection, 18–19,
22

Caravaggio, Michelangelo Merisi da,
Works: *Conversion of the Magdalen,*
Detroit, Institute of Arts, 45, *45, 47,*

48; *David with the Head of Goliath,*
Rome, Galleria Borghese, 18–19, *20;
Death of the Virgin,* Paris, Louvre, 44–
45, *44, 47; Repentant Magdalen,* Rome,
Galleria Doria-Pamphilj, 43, *43,* 47

Cardenas, Carlo de, 158n9

Carducho, Vincenzo, 61, 142n88

Caro, Annibale, 127n12

Carracci, Annibale, *Susanna and the
Elders,* Washington, D.C., National
Gallery of Art, 77, 79, *80,* 99

Carracci, Ludovico, *Susanna and the
Elders,* London, National Gallery, *98,*
99, 106

Caruth, Cathy, 156n94

Cassidy, Brendan, 151n56

Castiglione, Baldassare, *Book of the
Courtier,* 101

Castiglione, Giovanni Battista, *Melan-
choly, or Meditation,* Frankfurt am
Main, Städelsches Kunstinstitut, 65,
69, 143n95

Catalogue raisonné, 2, 123

Catherine of Siena, 47

Catholic Church, 29, 41, 130n37,
137n51, 145n102

Cattaneo family, Genoa, 135n29

Cavallino, Bernardo, 152–53n67

Cavallo, Sandra, 84

Cecil, Brownlow, ninth earl of Exeter,
95, 150n45

Cecil, John, fifth earl of Exeter, 150n44

Cerutti, Simona, 84

Charles I, king of England, 60, 97,
127n13, 142n86, 151n56

Chastity, 85, 137n51

Cigoli, Lodovico, 64, 142n91

Circe, 81, 83, 84

Coccopani, Sigismondo, 137n48,
140n76

Codazzi, Viviano, 102, 152n67

Cohen, Elizabeth S., 156n93

Collaboration, artistic, 86, 101–2, 104–
5, 152–53n67

Colluraffi, Antonio, 132n5

Connoisseurship, xvii, xviii, xxii, 1–5, 9, 25
Consistency, artistic, 5
Contemplativeness, 35, 45, 47, 48, 63, 66–67, 73, 74
Contini, Roberto, 2, 127n19, 128nn22, 27–28, 145n1, 149n40
Corisca, 83, 84
Correggio, 143n94
Council of Trent, 41, 84
Counter-Reformation, 42, 130n37
Courtship, 84, 101
Cowell, Michael, 148n27, 149nn41, 42
Craft: allied with art, 69–70; distinguished from art, 54, 67
Creativity, artistic, 50, 52, 54, 61–63, 66, 70, 72, 73, 74, 115, 116, 117, 122. *See also* Imagination; Inspiration
Cruel Lady, Dante's, 81, 84
Cultural norms, 16, 17, 22, 112
Culverhouse, Jon, 148n25, 149n42
Cusick, Suzanne G., 141n78

Dante, 81, 84, 146n6
Davent, Léon, *Michelangelo at the Age of Twenty-Three,* London, British Museum, 48–49, 49, 50, 138nn60–61
David, Jérôme, *Portrait Engraving of Artemisia Gentileschi,* London, British Museum, 55–58, 59, 61, 62, 117, 140n77, 142n86
De Lauretis, Teresa, xx
Desire, masculine, 84, 85, 99
Detroit, Institute of Arts: *Conversion of the Magdalen,* Michelangelo Merisi da Caravaggio, 45, 45, 47, 48; *Judith and Her Maidservant with the Head of Holofernes,* Artemisia Gentileschi, 27, 33, 87, 112, 117, 132n7, 143n92, 157n3; *Young Woman with a Violin,* Orazio Gentileschi, 141n78
Difference, xx–xxi, 3, 129n34
Donna crudele, 81, 83, 84
Dorothy of Montau, 47
Dubufe, Edward-Louis, 127n18

Dumonstier le Neveu, Pierre, drawing of the hand of Artemisia Gentileschi with paintbrush, London, British Museum, 7, 8, 127n14
Dürer, Albrecht, *Melencolia I,* Washington, D.C., National Gallery of Art, 51–52, 53, 143nn94–95
Duvet, Jean, *Revelation of Saint John Evangelist,* Washington, D.C., National Gallery of Art, 49, 50

Economic relations, 3, 4, 17, 130n34
Ego formation, 18
El Escorial, Museo de Pintura y Arquitectura, *Madonna and Child,* attributed to Artemisia Gentileschi, 9, 11, 127–28n20
Enterline, Lynn, 144n99
Entrapment, sexual, 81, 84, 86
Eroticism: and Mary Magdalene, 35, 38, 39, 40–42, 45, 137n48; and Susanna, 77, 99, 113, 154n80
Essentialism, xix–xx
Este, Duke Francesco I de' (duke of Modena), 106
Expressionism, 18

Fabbriano, S. Maria Maddalena, *Penitent Magdalen,* Orazio Gentileschi, 41–42, 41
Femininity: and contemplation, 74; and creativity, 55, 62, 73, 117; and identity, 1, 2, 6–9, 11, 14–15, 22–23, 74, 108; and inspiration, 57, 117; and melancholy, 72, 74, 144n99; and mourning, 74; and mysticism, 47; and night, 72, 144–45n100
Feminism, xxi–xxii, 1, 4, 6, 15–18, 22, 72, 73, 74, 99–100, 107, 108, 112, 116, 121, 122, 123, 128n28, 129n32, 129–30n34, 130n37, 152n61, 154n80
Fetti, Domenico: *Magdalen,* Rome, Galleria Doria-Pamphilj, 143n94; *Melancholy,* Paris, Louvre, 65, 68, 143nn93–95

Ficino, Marsilio, 52, 74, 145n103

Film, biographical, 1, 121–22, 158nn11–13

Finson, Louis, *Magdalen in Ecstasy,* Marseille, Musée des Beaux-Arts, 46–47, *46*

Finucci, Valeria, 14–15

Fisher, Sarah, 134nn16–17, 21, 148nn28–29, 32, 149nn36, 39

Florence, Casa Buonarroti: *Allegory of Inclination,* Artemisia Gentileschi, 9, *10,* 107, 117; *Artemisia* exhibition, (18 June–4 November 1991), 2, 9, 127n17

Florence, Cathedral, *Deposition,* Michelangelo Buonarroti, 18, *19*

Florence, Corte d'Appello (formerly Casino Mediceo), *Allegory of Painting Awakened by Grand Duke Cosimo II de' Medici,* Fabrizio Boschi, 55, *56*

Florence, Medici Chapel: *Lorenzo de' Medici, Duke of Urbino,* Michelangelo Buonarroti, 66, *70,* 144n97; *Night,* Michelangelo Buonarroti, 50–51, *53,* 55

Florence, Palazzo Pitti: *Madonna and Child,* attributed to Artemisia Gentileschi, 11, *13,* 14; *Maria Maddalena of Austria as Mary Magdalen,* Justus Sustermans, 35, *37; Penitent Magdalen,* Artemisia Gentileschi, 35, *36,* 38–39, 87, 106–7, 132n7, 135n30, 136n38, 144nn96–97, 149n43, 156n91; *Penitent Magdalen,* Titian, 40, *40,* 41; *Saint Mary Magdalene in the Desert,* attributed to Valerio Marucelli, 42, *42*

Florence, Serristori Collection, *Susanna and the Elders,* Master of the Bargello Tondo, 81, *83*

Florence, Uffizi, *Judith Slaying Holofernes,* Artemisia Gentileschi, 7, 19–20, *21,* 29, 33, 87, 109, 112, 117, 122, 132–33nn7–8, 134nn

Fontana, Lavinia, 57

Formalism, xviii, 3, 4, 18

Fountain of Love, 81, 86

Francesca, Piero della, 17

Francis of Sales, Saint, 48

Frankfurt am Main, Städelsches Kunstinstitut, *Melancholy, or Meditation,* Giovanni Battista Castiglione, 65, *69*

Freud, Sigmund, 74, 130n44, 145n103

Furini, Francesco, 137n48

Fuss, Diana, 118

Galileo Galilei, 16, 57

Galle, Philips, 142n91

Garas, Klara, 151n53

Garden of Love, 79–82, 146nn5, 10

Gargiolo, Domenico, 86, 102, 135n24, 152n67

Garzoni, Giovanna, 126n7

Gender, xvii, xviii, 1, 2, 6–7, 14–15, 18, 23, 47, 72, 73, 74, 106, 107, 112–13, 118, 119, 123, 129n34. *See also* Identity

Genius, 3, 57

Genoa, Palazzo Cattaneo-Adorno, *Lucretia,* Artemisia Gentileschi, 9, 27, 32, 33–34, 87, 89, 107, 117, 132n7, 135n26

Gentile, Pietro, 34, 106, 133n9, 153n74

Gentileschi, Artemisia: artistic identity of, xviii, 1, 2, 5–9, 11, 14–15, 17, 22–23, 57, 58–60, 74, 108, 118, 121; attribution of works to, xvii–xviii, 4–5, 7, 9, 11, 14, 15, 56, 74–75, 77, 95, 111, 126n3, 128nn20–22, 132n7, 135n30, 140n76, 141nn, 145n1, 147n23, 156n91, 157nn3–4; and beauty, 7–9, 11, 14, 15, 109, 112, 118, 119, 123; Boschi's influence on, 55; Caravaggio's influence on, 14, 19, 32, 39, 42–43, 45–46, 47–48, 73, 116, 132n6; and catalogue raisonné, 2, 123; and collaborations with other artists, 86, 101–2, 104–5, 152–53n67; and concession to masculine art world, 110–13, 115, 116, 118, 119–21, 122; and connoisseurship, 1–2,

4–5, 25; daughter of, 150n47, 153–
54n75; defamatory epitaphs addressed
to, 110, 141n82; depicted as the alle-
gory of painting, 27, 55–61, *58–59,
61–62, 71;* and dramatizations, 1,
121–22, 158nn11–13; and exhibition
catalogues, 2, 95; and exhibitions,
25, 126n2; father's promotion of, 105,
153n71; and feminism, 1, 6, 15–18,
22, 72, 100, 107, 108, 112, 116, 121,
122, 123, 128n28, 129n32, 129–
30n34, 152n61, 154n80; financial
difficulties of, 38; and Florentine
style, 32–33, 39, 140n76; and friend-
ship with Galileo, 57; and gender, 2,
6–7, 14–15, 18, 23, 106, 107, 112–
13, 118, 119, 123; Guercino's relations
with, 64–65, 86, 101–6, 143nn91–
92; heroizing of, xx, 1; hiring of other
artists by, 86; and identification with
Mary Magdalene, xviii, 35, 38–39,
45–46, 55, 62–63, 73, 74, 116; and
identification with Pittura, 55, 57, 59,
60, 61, 68; and irony, 101; and land-
scape backgrounds, 86–87, 101, 102,
135n24, 147n21, 152n67; Lomi sur-
name used by, 94, 95, 107, 149n50;
love letters addressed to, 141n82;
Marcantonio Raimondi's influence
on, 54–55, 64; and marketing of
works, 15, 17, 27, 33, 72, 96, 105,
106, 107, 108, 110, 116, 118, 122,
123, 153n71; marriage of, 38, 153n75;
and membership in the Accademia dei
Desiosi, 57; Michelangelo's influence
on, 19, 48, 55, 64; monographic stud-
ies of, 2; and parody, 100, 106, 115,
121; and patronage, 7, 33, 35, 38–39,
55, 72, 96, 101, 105–6, 110, 116, 120,
121, 154n76; and portraiture, 6, 7–8,
55–61, *58–59, 61–62,* 140–41nn,
152n86; public identity of, 109–13,
116, 118, 119, 121; and rape, 1, 20,
22, 38, 77, 102, 109, 110, 111, 112–
13, 119, 121–22, 123, 130n44; replicas

created by, 7, 25, 28–29, 31–34; and
residence in Florence, 32, 38–39, 48,
55, 140n76, 141n78, 149n40; and resi-
dence in Naples, 27, 60, 116, 132n5;
and residence in Rome, 32, 39, 42–
43, 58, 77, 106, 109, 140n73; and resi-
dence in Venice, 27, 58, 132nn5–6;
and self-contradiction, 22, 23, 117;
and self-portraiture, 7, 18, 27, 55, 68–
70, *71,* 72, 74, 117, 127n13, 140n76,
141–42nn; and self-projection, 18–
20, 22, 23, 62–63; and sexual harass-
ment, 77, 109; social conditions faced
by, 20, 22, 23, 109, 110; Venetian po-
ems addressed to, 7–8, 109, 141n82,
155nn86–87; Veronese's influence
on, 54–55, 64, 132n6

Gentileschi, Artemisia, Works: *Allegory
of Inclination,* Florence, Casa Buon-
arroti, 9, *10,* 107, 117; *Aurora,* for-
merly in collection of Giovanni Luigi
Arrighetti, 7, 27, 127n14, 147n21,
151n57, 157n3; *Cleopatra,* formerly
Milan, Amadeo Morandotti, 9, 11,
27, *28,* 29, 64, 107, 117; *Cleopatra,*
London, private collection, 27, 117,
132nn6–7, 154n80; *Corisca and the
Satyr,* private collection, 83–84, 100,
119, 152n61; *Esther before Ahasuerus,*
New York, Metropolitan Museum of
Art, 27, 132n6; *Jael and Sisera,* Buda-
pest, Szépmüvészeti Museum, 64, *67,*
102, 107, 117, 132–33n8, 143n91;
*Judith and Her Maidservant with the
Head of Holofernes,* Detroit, Institute
of Arts, 27, 33, 87, 112, 117, 132n7,
143n92, 157n3; *Judith Slaying Holo-
fernes,* Florence, Uffizi, 7, 19–20, *21,*
29, 33, 87, 109, 112, 117, 122, 132–
33nn7–8, 134nn; *Judith Slaying Holo-
fernes,* Naples, Museo di Capodi-
monte, 7, 32, 33, 133n8; *Lucretia,*
Genoa, Palazzo Cattaneo-Adorno, 9,
27, 32, 33–34, 39, 64, 87, 89, 107,
117, 132n7, 135n26, 157n3; *Lucretia*

Gentileschi, Artemisia, Works (*continued*)
(now lost; formerly Naples, Imperiale
collection), 33–34; *Lute Player,* Rome,
Spada Gallery, 14, 87, 91, 128n22,
156n94; attributed to, *Madonna and
Child,* El Escorial, Museo de Pintura
y Arquitectura, 9, *11,* 127–28n20; at-
tributed to, *Madonna and Child,* Flor-
ence, Palazzo Pitti, 11, *13,* 14; attrib-
uted to, *Madonna and Child,* Rome,
Spada Gallery, 9, *12,* 14; *Mary Magda-
lene as Melancholy,* private collection,
25, 27, 28–29, 31, *31* (detail), 32–35,
47, 62, 132n7, 133–34nn, 135n28;
Mary Magdalene as Melancholy, Seville,
Cathedral, xvii–xviii, 25, *26,* 27–29,
30 (detail), 31–33, 35, 39, 45–46,
47–48, 54–55, 57, 61–63, 64–68,
70, 72–74, 102, 112, 115–18, 121,
131nn, 132n7, 133nn10–13, 140n73,
157n3; *Penitent Magdalen,* Florence,
Palazzo Pitti, 35, *36,* 38–39, 87, 106–
7, 132n7, 135n30, 136n38, 144nn96–
97, 149n43, 156n91; *Portrait of a Gon-
faloniere,* Bologna, Pinacoteca, 87,
106, 132n7; *Self-Portrait as the Allegory
of Painting,* London, Kensington Pal-
ace, 27, 55, *56,* 60, 61, 68–70, *71,*
72, 74, 112, 117, 140n74, 141–42nn,
149n43; *Sleeping Venus,* Princeton,
Johnson Collection, 117; *Susanna and
the Elders,* Brno, Moravská Galerie,
92–93, *93; Susanna and the Elders,*
Pommersfelden, Schloss Weissenstein,
4–5, 7, 77, *79, 79,* 85, 87, 93, 96,
105, 107, 109, 110, 111, 113, 147n21,
149n43, 151n53, 154n80; *Susanna and
the Elders,* with alterations by another
artist, Stamford (Lincolnshire), En-
gland, Burghley House Collection,
xvii–xviii, 75, 85–87, *88,* 89–108,
90–92, 110, 111–12, 113, 115–18,
121, 123, 126n3, 145n1, 147–51nn,
155n87, 156nn; *Tarquin and Lucretia,*
Potsdam, Neues Palais, *120,* 121

Gentileschi, Artemisia, Works, other
works mentioned: *Andromeda,* 120;
Bathsheba (various), 117, 118, 120,
148n26, 152n67, 157n5; *Clio,* 149n43;
Diana, 120; *Fame,* 97; *Hercules and
Omphale,* 119, 157–58n9; *Martyrdom
of Saint Januarius,* 162n67; *Minerva,*
149nn; *Potiphar's Wife,* 120; *Tarquin
and Lucretia,* 97; *Triumph of Galatea,*
153n67; *Venus and Cupid,* 132n7,
147n21
Gentileschi, Francesco, 142n86
Gentileschi, Orazio: attribution of
works to, 5, 7, 11, 126n3, 128n21,
132n7; and exhibition catalogue, 2;
and patronage, 106; promotion of
Artemisia by, 105, 153n71; and rape
trial, 155n90, 156n93
Gentileschi, Orazio, Works: *Penitent
Magdalen,* Fabbriano, S. Maria Mad-
dalena, 41–42, *41; Portrait of a Young
Woman as a Sibyl,* Houston, 155n90;
(completed by Lanfranco) *Saint Cecilia
and an Angel,* Washington, D.C., Na-
tional Gallery of Art, 153n67; *Young
Woman with a Violin,* Detroit, Insti-
tute of Arts, 141n78
Giamatti, A. Bartlett, 146–47nn10, 13,
151n58
Gregori, Mina, 95–96, 137n53, 145n1,
150n46
Gregory I, Saint (Gregory the Great), 35
Gregory XV, Pope, 64, 96, 102
Grimaldi family, Genoa, 135n29
Guarini, Giovanni Battista, 83
Guercino (Giovanni Francesco Barbieri),
64–65, 86, 101–6, 142–43nn91–93
Guercino, Works: *Aurora,* Rome, Villa
Ludovisi, 64; *Cleopatra,* Pasadena,
Norton Simon Foundation, 104, *104,*
153n69; *Elijah Fed by Ravens,* London,
National Gallery, 102–3, *103; Et in Ar-
cadio Ego,* 102; *Jael and Sisera,* Venice,
Fondazione Giorgio Cini, 39, 64, *66,*
102; *King David with Violin,* Rouen,

103; *Notte,* Rome, Villa Ludovisi, 64–
65, *65,* 102; *Penitent Magdalen with Two
Angels,* Rome, Pinacoteca Vaticana,
143n93; *Semiramis,* Boston, 143n92;
Venus, Mars and Cupid, Modena,
143n92
Guerrieri, Giovanni Francesco,
128n22
Guidoni, Giovanni Battista, 140n76
Guité, Ann, 155n90

Harris, Ann Sutherland, 86, 133n10,
145n1, 147n22
Haskell, Francis, 105
Haskins, Susan, 136nn34–35, 43
Heidelberg, Universitätsbibliothek,
miniature from the "Grosse Heidel-
berger Liederhandschrift," Walther
von der Vogelweide, 49, *51*
Heraclitus, 54
Heroic biography, xx, 1, 3, 4
Hersey, George, 108–9, 110, 155nn83,
87
Hibbard, Howard, 47
Holly, Michael Ann, 119, 157n8
Homer, 81, 127n14
Honor, 84–85
Humanism, 4

Iconography of Mary Magdalene: con-
templativeness, 35, 45, 47, 48, 66–67,
73, 74; creativity, 62, 63, 66, 70, 72,
116; melancholy, 62–63, 65–66, 72–
74; mortality, 144n96; mysticism, 46–
47; penitence, 41–42, 43, 47, 119;
sexuality, 35, 37–38, 39, 40–42, 44,
45, 116, 119, 137n48; vanity, 38, 43,
46, 65, 144n96
Identification, with portrayed characters,
xviii, 35, 38–39, 45–46, 55, 57, 59,
60, 61–63, 68, 73, 74, 116, 118
Identity: active *versus* passive, 22; artistic,
xviii, 1, 2, 5–9, 11, 14–15, 22–23,
57, 58–60, 74, 108, 118, 121; forma-
tion of, 18, 118, 121, 131n46; social,

5, 22; unitary *versus* differentiated, 22.
See also Femininity; Masculinity
Ideology, xxi, 14–15, 23, 131n46
Imagination, artistic, 50, 55
Imperiale, Davide, 33–34, 135nn
Individualism, 3, 4
Individuality, 5
Infrared reflectography, 89, 90, *90,*
148nn
Inspiration, artistic, 55, 57, 72, 73, 117.
See also Creativity; Imagination
Irony, 100, 101

Jacobs, Fredrika, 126n9
Jed, Stephanie, 85
John of the Cross, Saint, 47
Johnson, Lynne, 158n11
Judgment: critical, 17–18; qualitative, 3
Judith, story of, 19–20, 109, 115

Kagan, Richard, 25, 27, 131–32n4
Kempe, Margery, 47

Laboratory analysis, xviii, 7, 29, *30–31,
32, 88,* 89–95, *90, 92,* 148n25
Lacan, Jacques, 18
Landscape backgrounds, 86–87, 101,
102, 135n24, 147n21, 152n67
Lanfranco, Giovanni, 153n67
Lanser, Susan S., 154–55n81
Lapierre, Alexandra, 57, 132n5, 142n86
Lavin, Irving, 141n83
Leatham, Lady Victoria, 148n25
Leonardo da Vinci, 127n15
Lewis, Mary Elizabeth, 144n97
Liberal arts, 54, 65
Liebert, Robert S., 145n100
Lippincott, Kristen, 129n34
Lodge, Nancy, 146n7
London, British Museum: drawing of
the hand of Artemisia Gentileschi
with paintbrush, Pierre Dumonstier
le Neveu, 7, *8; Michelangelo at the Age
of Twenty-Three,* Léon Davent, 48–49,
49, 50; Portrait Engraving of Artemisia

London, British Museum (*continued*)
Gentileschi, Jérôme David, 55−58, *59,* 61, 62, 117

London, Kensington Palace, *Self-Portrait as the Allegory of Painting,* Artemisia Gentileschi, 27, 55, 56, 60, 61, 68−70, *71, 72,* 74, 112, 117, 140n74, 141−42nn, 149n43

London, National Gallery: *Elijah Fed by Ravens,* Guercino, 102−3, *103; Saint Helena,* Paolo Veronese, 54−55, *54; Susanna and the Elders,* Ludovico Carracci, *98,* 99, 106

Longhi, Roberto, 2

Loredan, Gianfrancesco, 57, 141n82, 155n86

Lucretia, story of, 85, 108, 115, 119

Ludovisi, Cardinal Alessandro, 102, 105

Ludovisi, Cardinal Ludovico, 96−97, 106, 111

Luther, Martin, 41

Luxuria, 38

Madrid, Prado: *Las Meninas,* Diego Velázquez, 60; *Venus and Organist,* Titian, 99, *100; A Woman as a Sibyl,* Diego Velázquez, 60−61, *62,* 142n88

Mahon, Sir Denis, 143n91

Mann, Judith W., 126n2, 127n20, 129n34, 144n97

Mannerism, 18

Maria of Austria, Empress, 27

Maria Maddalena of Austria (m. Cosimo II de' Medici), 35, *37*

Marino, Giovanni Battista, 108−9, 119, 155n83

Market, art, 3, 15, 17, 27, 33, 42, 72, 96, 105, 106, 107, 108, 110, 116, 118, 122, 123, 153n71

Marseille, Musée des Beaux-Arts, *Magdalen in Ecstasy,* Louis Finson, 46−47, *46*

Martha of Bethany, 35, 37, 38, 45, 66, 67, 73

Marucelli, Valerio, (attributed to,) *Saint Mary Magdalene in the Desert,* Florence, Palazzo Pitti, 42, *42,* 137n48

Mary of Bethany, 37, 73

Mary Magdalene: as conflation of scriptural characters, 35, 37−38; Artemisia Gentileschi's identification with, xviii, 35, 38−39, 45−46, 55, 62−63, 73, 74, 116. *See also* Iconography

Masculinism, xx, xxi, 6, 7, 9, 14, 16, 17, 74, 77, 80, 85, 106, 108, 112, 113, 118, 122

Masculinity: and creativity, 55, 73; and desire, 84, 85, 99; and honor, 84−85; and identity, 19, 22; and inspiration, 57; and melancholy, 72, 73, 74, 144n99, 145n103

Masi, Robin, 158n12

McIntosh, DeCourcy E., 148n25

Medal, of Lavinia Fontana, 57

Medici, Averardo de', 157n5

Medici, Cosimo de', 18

Medici, Cosimo II de', grand duke of Tuscany, 33, 35, 55, 105, 109, 140n73

Medici, Ferdinando II de', 106

Medici, Lorenzo de', 66

Melancholy, 48−52, *49−54,* 54−55, 57, 62−63, 65−66, 72−74, 144n99, 145n103

Merlet, Agnès, 121−22, 158n11

Michelangelo Buonarroti: femininity identified with night by, 72, 144−45n100; Flemish painting disparaged by, 47; as influence on Artemisia Gentileschi, 19, 48, 55, 64; poetry of, 84; and self-projection, 18, 22, 52, 130n37; as subject of Davent's etching, 48−49, *49, 50,* 138nn60−61

Michelangelo Buonarroti, Works: *Deposition,* Florence, Cathedral, 18, *19; Lorenzo de' Medici, Duke of Urbino,* Florence, Medici Chapel, 66, *70,* 144n97; *Night,* Florence, Medici

Chapel, 50–51, *53,* 55, 64; self-image as prophet Jeremiah, Vatican, Sistine Chapel, 52

Michiele, Pietro, 57, 141n82

Milan, Amadeo Morandotti, *Cleopatra,* Artemisia Gentileschi, 9, 11, 27, *28, 29,* 107, 117

Miller, David A., 148nn25–27, 30, 149nn35–36, 38–39, 41

Miramax Zoë, 122, 158nn11, 14

Mirror stage, 18

Misogyny, 22

Modestini, Mario, 7

Mysticism, 47, 73

Naples, Museo di Capodimonte, *Judith Slaying Holofernes,* Artemisia Gentileschi, 7, 32, 33, 133n8

Nardo, Mariotto di, *Garden of Love,* private collection, 81, *82*

Narrative, 4–5, 6, 119

Naturalism, 87, 143n92, 157n3

Neoplatonism, 40, 136n43

New York, Metropolitan Museum of Art: *Esther before Ahasuerus,* Artemisia Gentileschi, 27, 132n6; *Saint Helena,* Marcantonio Raimondi, 49, *49,* 54, 138n61

Oberhuber, Konrad, 126n4

Originality, artistic, 7, 121

Orlando, 146n9

Orso, Steven, 120, 157n9

Pagani, Gregorio, 151n57

Panofsky, Erwin, 6, 144n97

Papi, Gianni, 2, 14, 127n19, 128nn22–23, 27–28, 145n1, 149n40, 153n74

Paris, Louvre: *Death of the Virgin,* Michelangelo Merisi da Caravaggio, 44–45, *44,* 47; *Melancholy,* Domenico Fetti, 65, *68,* 143nn93–95

Parody, 99–101, 106, 115, 121

Pasadena, Norton Simon Foundation, *Cleopatra,* Guercino, 104, *104*

Patriarchy, 80, 85, 113, 123. *See also* Masculinism

Patronage, 7, 33, 35, 38–39, 55, 72, 96, 101, 105–6, 110, 116, 120, 121, 137n48, 154n76

Peircian index, 39, 48

Penitence, 41–42, 43, 47, 119, 137n51

Petrarch, 49, 81, 146–47nn4, 9–10, 13

Philip IV, king of Spain, 119

Pia, Emilia, 101

Pincus, Debra, 139n63

Pliny, 58, 60, 141n82

Plutarch, 141n82

Pollock, Griselda, xix–xxi, 125n2, 129–30n34

Pommersfelden, Schloss Weissenstein, *Susanna and the Elders,* Artemisia Gentileschi, 4–5, 7, 77, 79, *79,* 85, 87, 93, 96, 105, 107, 109, 110, 111, 113, 147n21, 149n43, 151n53, 154n80

Pope, Arthur, 134n18

Portraiture, 6, 7–8, 55–61, *58–59, 61–62,* 126n7, 140nn76–78, 141n85, 142n86

Postmodernism, 2–3

Potsdam, Neues Palais, *Tarquin and Lucretia,* Artemisia Gentileschi, *120,* 121

Pozzo, Cassiano dal, 60, 141n85, 150n47

Princeton, Johnson Collection, *Sleeping Venus,* Artemisia Gentileschi, 117

Psychological relations, 4, 6, 18, 74, 113, 118, 129n30, 153n68, 156n94

Psychological vs. psychoanalytic, 130–31n44

Public: and Artemisia Gentileschi's identity, 109–13, 116, 118, 119, 121; distinguished from audience, 109; and reception of art, 119

Qualitative judgment, 3

Radiography. *See* X-ray analysis

Radner, Joan N., 154–55n81

Raimondi, Marcantonio, as influence on Artemisia Gentileschi, 54–55, 64

Raimondi, Marcantonio, Works: *Raphael Sanzio of Urbino,* Vienna, Graphische Sammlung Albertina, 50, *52; Saint Helena,* New York, Metropolitan Museum of Art, 49, *49,* 54, 138n61

Rape, 85, 89, 112–13, 156n93; of Artemisia Gentileschi, 1, 20, 22, 77, 102, 109, 110, 111, 112–13, 119, 121–22, 123, 130n44, 156n93

Raphael, 5, 52, 138n61

Reception theory, 118–19

Reni, Guido, 153n71, 154n76

Replicas, 7, 25, 28–29, 31–34

Ribera, Fernando Afám de, duke of Alcalá, 27, 33, 60, 72, 106, 127n13, 132n5, 142n86

Riegl, Alois, 134n18

Ripa, Cesare, 57, 64, 142n90

Rogerson, Lynn, 148n25

Romano, Giulio, 5

Rome, Galleria Doria-Pamphilj: *Magdalen,* Domenico Fetti, 143n94; *Repentant Magdalen,* Michelangelo Merisi da Caravaggio, 43, *43,* 47

Rome, Palazzo Lancellotti, 102, 156n66

Rome, Pinacoteca Vaticana, *Penitent Magdalen with Two Angels,* Guercino, 143n93

Rome, Spada Gallery: *Lute Player,* attributed to Artemisia Gentileschi, 14, 87, 91, 128n22, 156n94; *Madonna and Child,* attributed to Artemisia Gentileschi, 9, *12,* 14

Rome, Villa (Casino) Ludovisi: *Aurora,* Guercino, 64; *Notte,* Guercino, 64–65, *65,* 102, 156n66

Romeo, Dr. Luigi, 120, 157n5

Rubens, Peter Paul, 79, 119, 137n51, 147n18, 150n48

Ruffo, Don Antonio, 7, 106, 120, 127n13, 128n20

Salerno, Luigi, 142n90

Salomon, Nanette, 125n2

Saslow, James, 127n18

Saturn, as god of melancholy, 50–51, 54, 66

Schama, Simon, 158n12

Schiesari, Julianna, 72

Science, 16, 129n30

Self-contradiction, 22, 23

Self-portraiture, 7, 18, 27, 55, 68–70, *71,* 72, 74, 117, 127nn12–13, 140n76, 141–42nn

Self-projection, 18–20, 22, 23, 52, 62–63, 130n37

Seville, Casa de Pilatos, 131n3

Seville, Cathedral, *Mary Magdalene as Melancholy,* Artemisia Gentileschi, xvii–xviii, 25, *26,* 27–29, *30* (detail), 31–33, 35, 45–46, 47–48, 54–55, 57, 61–63, 64–68, 70, 72–74, 102, 112, 115–18, 121, 131nn, 132n7, 133nn10–13, 140n73, 157n3

Sexual harassment, 5, 77, 109, 110

Sexuality: and courtship, 84; and honor, 84–85; and Mary Magdalene, 35, 37–38, 39, 40–42, 44, 45, 116, 119, 137n48; and public identity, 108, 109–13, 116, 119; and Susanna, 79–86, 99

Shakespeare, William, 81

Shame, 85, 89, 109–10, 119

Shapin, Steven, 129n30

Shearman, John, 126n4

Siren, Dante's, 81

Social constructionism, 4

Social relations, xviii, 3–4, 5, 20, 22, 23, 130n34

Sociology of art, 3, 4

Somerville, John, 145n1, 149n44

Spada family, 14, 128n23

Spadaro, Micco. *See* Gargiolo, Domenico

Spear, Richard, 128n20, 129n34, 154n80

Spike, John, 7, 136n38, 140n76, 144n96, 155–56n91

Stamford (Lincolnshire), England, Burghley House Collection, *Susanna*

and the Elders, Artemisia Gentileschi, with alterations by another artist, xvii–xviii, 75, 85–87, *88,* 89–108, *90–92,* 110, 111–12, 113, 115–18, 121, 123, 126n3, 145n1, 147–51nn, 155n87, 156nn

Sternberg, Meir, 155n81

Suicide, 89, 108, 115, 119

Summers, David, 50–51, 139n66, 145n100

Susanna, story of, 79–86, 108, 115, 119, 147n18

Sustermans, Justus, *Maria Maddalena of Austria as Mary Magdalen,* Florence, Palazzo Pitti, 35, *37*

Tassi, Agostino, 64, 77, 102, 121–22, 138n55, 156n93

Tasso, Torquato, 82, 99, 146n10

Taste, 3, 106–7

Teresa of Avila, Saint, 47, 73, 145n102

Terracina, Laura Bacio, 99, 152n60

Terribilità, 7

Thematic narrative, 5

Titian: *Penitent Magdalen,* Florence, Palazzo Pitti, 40, *40,* 41; *Venus and Organist,* Madrid, Prado, 99, *100*

Trexler, Richard C., 144n97

Valdivieso, Enrique, 131n3, 134n14

Van der Doort, Abraham, 97, 142n86

Van Dyck, Anthony, 119

Vanitas, 38, 43, 46, 65, 144n96

Vasari, Giorgio, 130n37, 144n97

Vatican, Sistine Chapel, painting of prophet Jeremiah, Michelangelo Buonarroti, 52

Velázquez, Diego: *Las Meninas,* Madrid, Prado, 60, 142n88; *A Woman as a Sibyl,* Madrid, Prado, 60–61, *62,* 142n88

Venice, Fondazione Giorgio Cini, *Jael and Sisera,* Guercino, 39, 64, *66*

Venus, 40, 64, 79, 99, 113, 136nn43–44, 146–47n13

Veralli family, 128n23

Veronese, Paolo, as influence on Artemisia Gentileschi, 54–55, 64, 132n6

Veronese, Paolo, Works, *Saint Helena,* London, National Gallery, 54–55, *54*

Victimization, 77, 84, 109, 110, 111, 112–13, 115–16, 122

Vienna, Graphische Sammlung Albertina, *Raphael Sanzio of Urbino,* Marcantonio Raimondi, 50, *52*

Visionary figures, 47, 48–49, *49–50,* 51, 55, 67, 70, 72, 139n63

Walther von der Vogelweide, miniature from the "Grosse Heidelberger Liederhandschrift," Heidelberg, Universitätsbibliothek, 49, *51*

Washington, D.C., National Gallery of Art: *Melencolia I,* Albrecht Dürer, 51–52, *53,* 143nn94–95; *Revelation of Saint John Evangelist,* Jean Duvet, 49, *50; Saint Cecilia and an Angel,* Orazio Gentileschi, 153n67; *Susanna and the Elders,* Annibale Carracci, 77, 79, *80,* 99

Watson, Paul F., 146n5

Wind, Barry, 47, 138n57

Wölfflin, Heinrich, 40

Women: and alienation, 112; and alterity, xxi, 22, 74; and difference, xx–xxi; and empowerment, 22; and honor, 84–85; masculine works parodied by, 99–101; and mysticism, 47, 73, 145n102; and social relations, 20, 130n34; and victimization, 77, 84, 110, 112–13. *See also* Femininity; Gender

Wood, Carolyn H., 97, 151nn52–53

X-ray analysis, xviii, 7, 29, *30–31,* 32, *88,* 89–95, *92,* 148nn, 149nn

Zerner, Henri, 138nn60, 62

Zeuxis, 141n82

Text:	11/15 Bembo
Display:	Charlemagne
Design:	Ina Clausen
Composition:	G & S Typesetters, Inc.
Printing and binding:	Malloy
Index:	Andy Joron